Praise for Portraits

'John Berger tedaches us how to think, how to feel, how to stare at things until we see what we thought wasn't there. But above all, he teaches us how to love in the face of adversity. He is a master'

Arundhati Roy, author of *The God of Small Things*

'A volume whose breadth and depth bring it close to a definitive self-portrait of one of Britain's most original thinkers'

Financial Times

'John Berger throws a long shadow across the literary landscape; in that shade so many of us have taken refuge, encouraged by his work that you can be passionately, radically political and also concerned with the precise details of artistic production and everyday life, that the beautiful and the revolutionary belong together, that you can chart your own course and ignore the herd, that you can make words on the page sing and liberate minds that way. Like so many writers, I owe him boundless gratitude and regard news of a new book as encouragement that the most important things are still possible. The gifts are huge, and here's another one coming'

Rebecca Solnit, author of *Men Explain Things to Me*

'In this extraordinary new book, John Berger embarks on a process of rediscovery and refiguring of history through the visual narratives given to us by portraiture. Berger's ability for storytelling is both inci-sive and intriguing. He is one of the greatest writers of our time'

Hans Ulrich Obrist, author of *Ways of Curating*

'One of the most influential intellectuals of our time'

Sean O'Hagan, *Observer*

LANDSCAPES:
John Berger on Art

by
John Berger

Edited with an Introduction by Tom Overton

VERSO
London • New York

First published by Verso 2016
© John Berger 2016
Translation, Chapter 5, from *Poems on the Theatre* by
Bertolt Brecht © Anya Bostock and John Berger 2016
Introduction © Tom Overton 2016

1 3 5 7 9 10 8 6 4 2

Verso
UK: 6 Meard Street, London W1F 0EG
US: 20 Jay Street, Suite 1010, Brooklyn, NY 11201
versobooks.com

Verso is the imprint of New Left Books

ISBN-13: 978-1-78478-584-0
ISBN-13: 978-1-78478-587-1 (US EBK)
ISBN-13: 978-1-78478-586-4 (UK EBK)

British Library Cataloguing in Publication Data
A catalogue record for this book is available from the British Library

Library of Congress Cataloging-in-Publication Data

Names: Berger, John, author. | Overton, Tom, editor.
Title: Landscapes : John Berger's writing on art / John Berger ; edited with
 an introduction by Tom Overton.
Description: Brooklyn : Verso, 2016.
Identifiers: LCCN 2016019158| ISBN 9781784785840 (hardback) | ISBN
 9781784785871 (ebook)
Subjects: LCSH: Art.
Classification: LCC N7445.2 .B467 2016 | DDC 700 – dc23
LC record available at https://lccn.loc.gov/2016019158

Typeset in Electra by Hewer Text UK Ltd, Edinburgh
Printed and bound by CPI Group (UK) Ltd, Croydon CR0 4YY

Contents

Contents

Introduction:

Down with Enclosures

WHAT DOES IT mean for a piece of writing to be *on* or *about* art? This book's companion volume, *Portraits*, was one answer, assembling the variety of approaches John Berger has taken to individual artists. A timeline structured by dates of birth and death made space for evaluations and re-evaluations of lives and works by the light of different written forms, and changed historical and personal contexts.

Their structure meant excluding texts such as 'The Moment of Cubism' (1966–8), in which Berger argues that, though there might be individuals we associate with developments in art between 1907 and 1914,

> Cubism cannot be explained in terms of the genius of its exponents. And this is emphasised by the fact that most of them became less profound artists when they ceased to be Cubists. Even Braque and Picasso never surpassed the work of their Cubist period: and a great deal of their later work was inferior.

This extract is *about* art in the sense that the author is trying to reveal what circulates and forms it – searching for the conditions from which it arises, or the climate into which it was received. Berger came to intellectual maturity in a post-war London subculture of refugees from

European fascism, and the pieces of writing in which he looks beyond England and processes the thought of Brecht, Lukács, Benjamin, Frederick Antal, Max Raphael, Rosa Luxemburg and James Joyce are other omissions from *Portraits*.

Another aspect of the relationship between 'The Moment of Cubism' and art is that, by documenting a startlingly fertile period of history in which 'there was no longer any essential discontinuity between the individual and the general', Berger inaugurated such a period in his own work.

The essay appeared in the March–April 1967 edition of *New Left Review*. Later that April, it was followed by an extract in *New Society* from *A Fortunate Man* – a new book, made with the photographer Jean Mohr, which described the life of a GP in the Forest of Dean through a series of fictionalised case histories. As a work somewhere between biography and portraiture, *A Fortunate Man* shares an outlook with 'No More Portraits', the August 1967 *New Society* essay in which Berger announced: 'We can no longer accept that the identity of a man can be adequately established by preserving and fixing what he looks like from a single viewpoint in one place.'

At the time, Berger was also writing G. (1972), a novel about modernism, published at the moment of postmodernism. The work turned this insight into a motif, repeated throughout the book: 'Never again will a single story be told as though it were the only one.'

Berger repeated entire chunks of text from G. in his most famous book and TV series about art, *Ways of Seeing*. The title announced a pluralistic approach, and reflected the collaborative way in which it was made (with Mike Dibb, Sven Blomberg, Chris Fox and, in the episode on the male gaze, Eva Figes, Barbara Niven, Anya Bostock, Jane Kenrick and Carola Moon). At the end, part-way between soliciting disagreement and pre-empting it, Berger expressly shows the book and series to be a meeting of makers and audience: 'I hope you will consider what I arrange, but please, be sceptical of it.'

Berger was again trying to live up to what he had identified in 'The Moment of Cubism': a 'new scientific view of nature which rejected simple causality and the single permanent all-seeing viewpoint'. This struck him as an encouragement to greater self-reflexivity: 'The Renaissance artist imitated nature. The Mannerist and Classic artist

reconstructed examples from nature in order to transcend nature. The Cubist realised that his awareness of nature was part of nature.'

All the way through his writing life, Berger has written texts that take this broader, more synoptic approach to an historical period, past or present. *Landscapes* suggested itself as an obvious title around which to organise them. Like *Portraits*, it seeks sympathy with the tenor of Berger's technique, because it is an animating, liberating metaphor rather than a rigid definition (some texts could have argued their way into either book, not least because it is so often artists who teach us how to look at art). It frees us to consider texts across genres. There are poems here as well as uncategorisable prose. And though this second volume can be read alongside the first, a landscape can be more than simply the backdrop, or 'by-work', of a portrait.

The word landscape is also, like many of the texts in this book, a record of the horizons of writing being broadened. The *Oxford English Dictionary* records various 'landschap' and 'landskip' forms being adopted from Dutch in the 1590s, before the spelling 'landscape' arrived in 1605. At that point, John Barrell points out,[1] it was a piece of jargon specific to painting. But though Christopher Marlowe (1564–93) wrote of 'Valleys, groves, hills and fields' as apparently autonomous units of land, by the 1630s John Milton (1608–74) could write in 'L'Allegro':

> Streit mine eye hath caught new pleasures
> Whilst the Lantskip round it measures.
> Russet Lawns, and Fallows Gray,
> Where the nibling flocks do stray .

In *Landscape and Memory* (1995), Simon Schama argues that 'landscapes are culture before they are nature – constructs of the imagination projected onto wood and water and rock'. The best place to explore this in Berger's work is the discussion of Gainsborough's *Mr and Mrs Andrews* (1727–28) in *Ways of Seeing*. Here, Berger made the painting pivot between the traditions of portraiture and landscape as part of a

1 John Barrell, *The Dark Side of the Landscape: The Rural Poor in English Painting 1730–1840* (Cambridge: CUP, 1980), p.1.

broader argument that oil painting became a dominant form because it corresponded to a certain phase of capitalism – a way of turning the visible world into tangible property. Again with an eye to plural *ways* of seeing, Berger packed a variety of different perspectives into this description. Kenneth Clark's *Landscape into Art* (1949) provided him with a quote weighing up two of Gainsborough's opinions on the painting of landscape, from a famous letter about 'being sick of portraits and wishing to take his Viol de Gamba and walk off to some sweet village where he can paint landscips' to another in which the painter writes:

> Mr Gainsborough presents his humble respects to Lord Hardwicke, and shall always think it an honour to be employed in anything for His Lordship; but with regard to *real views* from Nature in this country, he has never seen any place that affords a subject equal to the poorest imitations of Gaspar or Claude.

In the TV version of *Ways of Seeing*, the director Mike Dibb superimposed a 'Trespassers Keep Out' sign on the tree above the heads of Mr and Mrs Andrews, emphasising Berger's point that the couple wanted to be painted in the land they owned because it defined their gentility. Only those with property could vote, and the poachers on their land could be deported.

Berger's conclusions raised varied criticisms. The book incorporated the artist and art historian Lawrence Gowing's written objections to Berger imposing himself between the ordinary art lover 'and the visible meaning of a good picture':

> May I point out that there is evidence to confirm that Gainsborough's Mr and Mrs Andrews were doing something more with their stretch of country than merely owning it. The explicit theme of a contemporary and precisely analogous design by Francis Hayman suggests that the people in such pictures were engaged in philosophic enjoyment of 'the great Principle . . . the genuine Light of uncorrupted and unperverted *Nature*'.

Berger's counterargument was that one form of enjoyment does not preclude the other. If the couple are enjoying nature

philosophically, they are only able to do so because they are not distracted by the possibility of being chased off it with shotguns and horse whips.

Also in 1972, the academic John Barrell published *The Idea of Landscape and the Sense of Place*. In 1980 he followed it with *The Dark Side of the Landscape*, in which he asked whether, when looking at the works of Gainsborough, Constable and George Morland, we 'identify with the interests of their customers and against the poor they portray'.[2]

Barrell and Berger each developed their ideas on landscape through critiquing the other's. They share some of the same motivations – Berger declared himself 'still among other things a Marxist' as late as 2005,[3] Barrell is a 'leftist'. But their differences become clearer in Berger's review of *The Dark Side of the Landscape*, which concludes 'Mightn't the slogan be: Down with Enclosures! Intellectual as well as rural?' Berger found 'the English academic role (so dependent upon the voice and syntax)' preserved in the book, and lamented its tendency 'to encourage specialisation at the price of isolation'. On balance, he thought,

> John Barrell's book is a brilliant reading of certain sets of pictorial conventions (signs) and how they changed during a given historical period. But it gives little indication of knowledge, or even curiosity, about the two practices which lie, as it were, on either side of the sign. In this case the practice of painting on one side, and the practice of poor or landless peasants on the other. And so, though the book discloses and denounces an ideological practice, it contributes to and confirms the closed intermediary space in which such ideology operates.

These two practices are forms of work. Berger's preoccupation with the work done by artists was shaped early in life. As a teenager, Berger wrote vivid short stories about the music hall and the French

2 Barrell, *The Dark Side of the Landscape*, p. 91, contains measured criticism of Berger's writings on land.

3 John Berger, 'Ten Dispatches about Place', in *Hold Everything Dear: Dispatches on Survival and Resistance* (London: Verso, 2008), p. 121.

Resistance. But, as he describes in 'To Take Paper, to Draw', he went to art school (the Central and then Chelsea schools) rather than university, and, though he gave up painting around the age of thirty, his writing seems always to be accompanied by drawing. Sometimes this is purely imaginative, in much the way that say Ruskin's or Hazlitt's criticism is often nuanced by the experience of having made art. In the case of Berger's *Bento's Sketchbook* (2011), or 'A Gift for Rosa Luxemburg' (2015, collected here), the companionship of drawing is, though the term seems counterintuitive, literal: Berger's drawings are reproduced alongside the text.

We have to be careful here not to oversimplify the relative merits of practising and non-practising critics. In 'The Function of Criticism', T. S. Eliot described moving from 'the extreme position that the *only* critics worth reading were the critics who practised, and practised well, the art of which they wrote' to demand for 'a very highly developed sense of fact' – for critics who could offer 'interpretation' in the sense of 'putting the reader in possession of facts which he would otherwise have missed'. Berger's critical dialogue with Barrell was bound up with his most sustained engagement with the idea of landscape, the *Into Their Labours* trilogy (1979–91).[4] Through imaginative, fictional writing, these three books – *Pig Earth*, *Once in Europa* and *Lilac and Flag* – engage with the work of the peasants among whom he went to live in the 1970s, and whose companionship he has called 'my university'.[5] The 'Historical Afterword', extracted here, gives an outline of the approach to history that the trilogy takes. This is a landscape in the sense my title proposes: metaphorical perhaps, but equally alive to those who control both the appearance and the actuality of the terrain, and to those who live in it. *A Fortunate Man* puts it like this,

4 Barrell reviewed Berger's *Keeping a Rendezvous* (1992) with a roughly equal mixture of compliment and criticism. Despite their reservations, each writer found selective quotations of his review being used on the next edition of the other's book.

5 As I explored in the introduction to *Portraits*, Courbet and Millet also played a key role in the development of this work.

Sometimes a landscape seems to be less a setting for the life of its inhabitants than a curtain behind which their struggles, achievements and accidents take place. For those who, with the inhabitants, are behind the curtain, landmarks are no longer only geographical but also biographical and personal.

<div align="center">CR</div>

BERGER'S WORK IS an invitation to reimagine; to see in different ways. Accordingly, the texts here are divided into two parts. The first collates a range of pieces that tell us about the individuals – not necessarily visual artists – who have shaped Berger's thought. Some – Antal, Raphael – are straightforwardly art critics; others – Brecht, Barthes, Benjamin – do not fit easily into that category, but nevertheless demonstrate how early Berger came to much of what now constitutes the expanded art-school reading list. They all play their role in shaping the self-definition as a storyteller with which, as I noted in the Introduction to *Portraits*, Berger frames the diversity of his written output. To consider these relationships as ones of influence would be inconsistent with this self-definition. Rather than the collective, collaborative act of storytelling, the idea of 'influence' seems more associated with the individualism of novel writing, and a capitalist logic of debt and restitution that Berger rejects.

The remainder of this section freely explores the limits of how writing can be *about* art, and the way in which Berger had been led by his painter's eye towards storytelling. It ends with 'The ideal critic and the fighting critic', a kind of manifesto for how to put these examples into practice. By the end of Part I we see how, particularly in 'Kraków', the felt presences of Joyce, Márquez, and the tradition that now includes writers like W. G. Sebald, Arundhati Roy, Ali Smith and Rebecca Solnit have led Berger to tell the story of one of his very first teachers, his '*passeur*', Ken, in the way that he does. The section's title, 'Redrawing the Maps', originally comes from Geoff Dyer's suggestion that 'it is not enough simply to lobby for Berger's name to be printed more prominently on an existing map of literary reputations; his *example* urges us fundamentally to alter its shape'.[6]

6 Geoff Dyer, 'Editor's Introduction', *The Selected Essays of John Berger* (London: Bloomsbury, 2001), p. xii.

In 2012, as part of the celebration of the fortieth anniversary of *Ways of Seeing* and *G.*, 'Redrawing the Maps' was the name given to a 'free school' in London that brought together an astonishingly broad range of people loosely inspired by Berger's work to teach and learn from each other. With none of the rigidity the word might imply, Part I is a kind of syllabus, while Part II represents its application. The title of the latter is taken from one of Berger's poems, 'Terrain'. Here, the list of guides and maps gives way to the territory Berger uses them to navigate. Laid out in roughly chronological order, these pieces become less categorisable as they proceed, and less obviously 'art writing' about landscape. Yet 'The Third Week of August 1991' is among other things an attempt to understand the meaning of public sculpture in post-Soviet Europe. 'Stones' (2003) refracts contemporary Ramallah and its visual culture through some of the earliest sculpture – a cairn in Finistère. Finally, 'Meanwhile' (2008), the long essay that concludes the collection, defines our contemporary landscape as a prison. These pieces can be read as a sketch of art history – not that this is ever how Berger would describe his work – or as background for the individual texts of *Portraits*: in the sense of either the period in which they were written or the period they describe. 'Without landmarks', Berger writes in 'Meanwhile', 'there is the great human risk of turning in circles.'

In the recent film *The Seasons: Four Portraits of John Berger* (2016), the actor Tilda Swinton notes that she and Berger share a birthday, 5 November (remember, remember). She reads 'Self Portrait 1914–18' (1970), his poem stressing how much the Great War shaped him, through his father, and the wider world into which he was born in 1926. *Landscapes*, then, is published to mark his ninetieth birthday. But, even alongside *Portraits*, it represents only a part of a much broader and still ongoing achievement – albeit one that it nourishes, and has been nourished by.

One aspect of this achievement which seems especially vital in 2016 is the great arc of Berger's work that connects his decision to share the proceeds of his 1972 Booker Prize with the Black Panthers and his project on migrant workers, *A Seventh Man* (1975), through the *Into Their Labours* trilogy, which explored where these workers came from, and into the present via *And Our Faces, My Heart, Brief as Photos* (1984). There he writes,

Emigration, forced or chosen, across national frontiers or from village to metropolis, is the quintessential experience of our time. That industrialization and capitalism would require such a transport of men on an unprecedented scale and with a new kind of violence was already prophesied by the opening of the slave trade in the sixteenth century. The Western Front and the First World War with its conscripted massed armies was a later confirmation of the same practice of tearing up, assembling and concentrating in a 'no-man's-land'. Later, concentration camps, around the world, followed the logic of the same continuous practice.

If, as Berger writes, 'to emigrate is always to dismantle the centre of the world, and so to move into a lost, disoriented one of fragments', then we are all in great need of new maps.

Tom Overton, 2016

PART I

Redrawing the Maps

1.

Kraków

IT WAS NOT a hotel. It was a kind of *pension* where, at the most, there were four or five guests. In the morning breakfast on a tray was placed on a shelf in the corridor: bread, butter, honey and slices of a sausage which is a specialty of the city. Beside the tray, packets of Nescafé and an electric water heater. Contact with the severe and serene young women who ran the place was minimal.

In the bedrooms all the furniture, made of either oak or walnut, was old and must have dated from before the Second World War. This was in the only Polish city which survived that war without serious destruction to its buildings. In the *pension*, as in a convent or a monastery, there was a sense inside each room that the two windows which gave on to the streets had been contemplatively looked through for several generations.

The building was situated on Miodowa Street in Kazimierz, the old Jewish quarter of Kraków. After breakfast I asked a young woman behind the reception desk where the nearest bankomat was. She regretfully put down the violin case she was holding and picked up a tourist map of the city. On it she marked in pencil where I had to go. It's not far, she sighed, as if she would have liked to send me to the other side of the world. I bowed discreetly, opened and shut the front door, turned right, took the first right again and found myself in the Place Nowy, an open market-square.

CR

I HAVE NEVER been in this square before and I know it by heart, or rather I know by heart the people who are selling things in it. Some of them have regular stalls with awnings to keep the sun off their goods. It is already hot, hot with the blurred, gnat heat of the Eastern European plains and forest. A foliage heat. A heat full of suggestions, that does not have the assurance of a Mediterranean heat. Here nothing is certain. The nearest thing to certainty here is a grandmother.

Other sellers – all of them women – have come from the outlying villages with their own produce in baskets or buckets. They do not have stalls and are sitting on stools they brought with them. A few stand. I wander between them.

Lettuces, red radishes, horseradishes, cut dill like green lace, small knobby cucumbers which in this heat grow in three days, new potatoes, their skins, with a little powdered earth on them, the colour of grandchildren's knees, stick-celery with its cleansing toothbrush smell, cuttings of *liveche*, which the men, drinking vodka, swear is an incomparable aphrodisiac for women as well as men, bunches of young carrots swapping fern jokes, cut roses mostly yellow, cottage cheeses, which the rags pegged to the clothes line in their gardens still smell of, wild green asparagus that the children were sent to look for near the village cemetery.

The professional traders have naturally acquired all the trading tricks for persuading the public that golden opportunities never come twice. The women on their stools, by contrast, propose nothing. They are immobile, expressionless, and rely on their own simple presence to guarantee the quality of what they have brought to sell from their own gardens.

A wooden fence around a plot and a two-roomed house made from logs with a single tiled stove between the two rooms. These women live in *chatas* like this.

I wander between them. Different ages. Different builds. Eyes of different colour. No two women wearing the same kerchief. And each one of them has found, as she bends down to cut chives or pull out dog-tooth weed or pick red radishes, her own way of protecting, of favouring, the small of her back, so that its intermittent aches do not

become chronic. When they were younger it was their hips which absorbed the shock of events, now it is their shoulders which have to do so.

I peer into the basket of a woman who is standing without a stool. The basket is full of pale golden pastries, little pies. They look like carved chessmen, more specifically like castles, castles that could be stood either way up, their regular embrasures always at the top. Each one is ten centimetres tall.

I pick up one of the castles and realise my mistake. It is far too heavy to be made of pastry.

I glance up at the face of the woman. Sixty years old, blue-green eyes. She looks back at me severely, as if at an idiot who has once again forgotten something. *Oscypek*, she says slowly, repeating the proper name of a cheese made from the milk of mountain sheep and smoked in the chimney between the two rooms. I buy three. Then, with the smallest gesture of her head, she suggests I get on my way.

In the centre of the square stands a low building, subdivided into small, round shops. There is a barber's with just enough space for one chair. Several butchers'. A grocer's where you can buy pickled cabbage from a single barrel. A kitchen for soup with a cast-iron stove, and, outside on the paving stones, three wooden tables with benches. At one of the tables sits a man with slightly dejected shoulders, long hands and a high forehead made higher by the fact that he is going bald. His spectacles have thick lenses. He looks at home here this morning, although he is not Polish.

Ken was born in New Zealand and died there. I sit on the bench opposite him. This man, sixty years ago, shared with me what he knew, although he never told me how he learnt what he knew. He never spoke about his childhood or his parents. I had the impression he left New Zealand for Europe when he was young, before he was twenty. Were his parents rich or poor? Maybe it makes as little sense to ask that question of him as it would of the people in this market at this moment.

Distances never daunted him. Wellington, New Zealand, Paris, New York, the Bayswater Road, London, Norway, Spain, and at some moment, I think, Burma or India. He earned his living, variously, as a journalist, a schoolteacher, a dance instructor, an extra in films, a gigolo, a bookseller without a shop, a cricket umpire. Maybe some of

what I'm saying is false, yet it is my way of making a portrait of him for myself as he sits in front of me in the Place Nowy. In Paris he drew cartoons for a newspaper, of this I am certain. I remember distinctly the kind of toothbrushes he liked – ones with extra-long handles, and I remember the size of shoe he took – an eleven.

He pushes his bowl of borsch towards me. Then he takes a handkerchief from his right trouser pocket, wipes the spoon and hands it to me. I recognise the handkerchief of black tartan. The soup is a clear, deep red, vegetable borsch, with a little apple vinegar added to it, Polish-style, to counteract the natural sweetness of the beetroot. I drink some and push the bowl back to him and hand him back the spoon. Not a word has passed between us.

From the bag slung over my shoulder I take out a sketchbook, for I want to show him a drawing I made yesterday from Leonardo's *Lady with an Ermine* in the Czartoryski Museum. He studies it, his heavy glasses slipping a little down his nose.

Pas mal! Yet isn't she too upright? Isn't she in fact leaning more as she takes the corner?

On hearing him speak in this way, which is so indisputably his, my love for him comes back: my love for his journeys; for his appetites, which he set out to satisfy and never suppressed; for his weariness; for his sad curiosity.

A little too upright, he repeats. Never mind, every copy has to change something, doesn't it?

My love for his lack of illusions comes back too. Without illusions, he avoided disillusionment.

When I first met him I was eleven and he forty. For the next six or seven years he was the most influential person in my life. It was with him that I learnt to cross frontiers. In French there is the word *passeur* – often translated as ferryman or smuggler. Yet there is also in the word the connotation of guide, and something of the mountains. He was my *passeur*.

Ken flips backwards through the sketchbook. He had deft fingers and could palm cards skilfully. He tried to teach me Find the Lady: You can always make money with that! he said. Now he puts a finger between two pages and stops.

Another copy? Antonello da Messina?

Dead Christ supported by Angel, I say.

I never saw it, only in reproduction. If I could have chosen to have my portrait painted by any artist in history, I'd have chosen him, he says. Antonello. He painted like he was printing words. Everything he painted had that kind of coherence and authority, and it was during his lifetime that the first printing presses were invented.

He looks down again at the sketchbook.

Not a trace of pity on the angel's face or in his hands, he says, only tenderness. You've caught that tenderness, but not the gravity, the gravity of the first printed words. That's gone for good.

I did it last year in the Prado. Until the guards came to chuck me out!

Anyone has the right to draw there, no?

Yes, but not to sit on the floor.

Then why didn't you draw standing up!

When Ken says this in the Place Nowy, I see him, tall, stooped, standing on the edge of a cliff making a sketch of the sea. Near Brighton, the summer of 1939. He always carried in his pocket a large black graphite pencil called a Black Prince, which, instead of being round, was rectangular like a carpenter's pencil.

I'm too old now, I tell him, to draw for a long time standing up.

He puts down the sketchbook abruptly without glancing at me. He abhorred self-pity. The weakness, he said, of many intellectuals. Avoid it! This was the only moral imperative he ever imparted to me.

He fingers one of the cheeses I have bought.

Her name is Jagusia, he says, nodding towards the woman who sold me the *oscypek*, and she comes from the mountains in Podhale. Her two sons work in Germany. Black labour. Hard for them to get work permits, they're forced to be illegal. *Néanmoins*, they're building a house, a house larger than Jagusia has even dreamt of, not one storey but three, not two rooms but seven!

Néanmoins! French words cropped up in his sentences not out of affectation but because the years he had lived in Paris, before coming to London and the Bayswater Road, were the happiest of his life. It was for the same reason that he sometimes wore a black beret.

Yet Jagusia will refuse, he prophesies, to move out of her *chata*, with the cheesecloths on the line in the garden.

This was the man who made me believe that together we could find music in any city in the world.

What about a beer? he says now in Kraków, pointing towards the far end of the market building, beyond a clothes shop belonging to a fat woman who is sitting smoking in an armchair, surrounded by dresses.

I get up and walk towards her. As she smokes, she tells the story of what happened when she arrived in the Place Nowy; every morning she does this, and every morning the man who sells dried and pickled mushrooms listens to her, his face expressionless. When all the dresses and trousers she has on display are folded up and stacked in the little shop, there is no space for her. On the inside of the door there is a long mirror, since customers sometimes use it as a changing room. Each morning when she opens the shop, she sees herself in this mirror and each morning she is surprised by her size.

I spot the cans of beer on a stall with dried beans, Polish mustard, biscuits, honey-bread and tinned meats. There is also an open chessboard and a game in progress. The grocer behind the stand is playing Black, and a man who looks like a passer-by is playing White. Several pawns, a knight and a bishop have been taken.

The grocer studies the chessboard from a distance, then turns away and gets on with his job until the other one has made his move. The other one hovers above the game and rocks forwards and backwards on his feet, as if he were one of his own bishops, already lifted very slightly off the board between the fingers of a giant player who is cautiously trying out possible moves, being careful not to relinquish the piece until he is certain.

I ask for two beers. White moves his queen diagonally and says Check! Black takes my money and moves a knight. The queen withdraws. A woman customer asks for some of the honey-bread which has sweet candied oranges buried in it. Black cuts the slices and weighs them. White makes a careless move and realises it too late. He swallows hard, for he has an acid taste in his throat. Black takes a castle.

Kraków's Jewish ghetto, on the other side of the Vistula, outside the old city, is from here less than ten minutes' walk over the Powstancôw bridge. The ghetto covered an area of 600m × 400m and was sealed off by walled-up buildings, blockades and barbed wire. In the autumn of 1941, six months after it was sealed off, eighteen thousand people were imprisoned there. Thousands died from disease and malnutrition each month. Only those fit enough to work as slave labour in the German armament

or clothes workshops were permitted to leave for their stints of work. All other Jews found trespassing outside the ghetto were shot, as were any Poles who helped them to pass into Aryan Kraków or who hid them.

Tyskie! Ken applauds when I return to the table. You chose the best beer!

Early training! I say.

He's called Zedrek, Ken says, the man you were watching playing chess. He comes to play with Abram the grocer at least once a week. Zedrek could play a good game if he didn't start drinking vodka so early. I don't think he can stop though. Abram as a small boy survived the war in hiding.

Ken taught me most of the games I know: chess, snooker, darts, billiards, poker, table tennis, backgammon. Chess we played in his bed-sitting rooms, the others in bars. Bridge, which I had learnt before I met him, we played with my parents or when we got invited to some-body's house, which was not often.

I met him in 1937. He was a replacement teacher in the lunatic boarding school to which I had been bundled. In front of the school assembly – fifty bare-kneed, cowed boys, each trying to find, unaided, a sense to life – the apoplectic headmaster threw a dining-room chair at the Latin teacher and Ken, who happened to be between them, caught it with one hand in mid-flight. This is how I first noticed him. He set the chair down on the podium, put his feet up on it, and the boss continued to harangue.

On the final day of that same term I invited him to a caravan my parents had on a beach near Selsey Bill in Sussex. Why not? he said. And he came for a week.

My father was pleased, for, now making a foursome, we could play bridge together.

Shall we play for money, Sir? asked Ken. Otherwise the bids don't count.

Agreed, but the stakes shouldn't be too high, because of John here.

Tuppence a hundred?

I'll go and fetch my purse, said my mother.

Ken shuffled the pack and the cards cascaded between his two hands held far apart. Sometimes the cascade looked like a moving staircase, an escalator or a playing-cards ladder. Once, later, he said to

me, when I was complaining of not being able to go to sleep: Imagine you're shuffling a pack of cards! That's how I go to sleep.

Cut for deal.

My father enjoyed the game, not only because he was a good player, but, more, because the game allowed him to recall certain easy moments with the dead, who otherwise haunted him. When the four of us were playing in Selsey, 'Six Diamonds Doubled' took precedence over 'Five Mortars Lost'. He was playing with us, but also with a roll of infantry officers of which he was the only survivor after four years in the trenches near Vimy Ridge and Ypres.

My mother quickly recognised that Ken belonged to what for her was the special category of 'people who loved Paris'.

Watching the three of us playing quoits on the sand, she foresaw, I'm sure, that the *passeur* was going to take me a long way away and, at the same time, she didn't doubt, I'm equally sure, that, give or take a little, I was capable of looking after myself. Consequently, she offered on Monday, Wash Day, to launder and iron his clothes, and Ken bought her a bottle of Dubonnet.

I accompanied Ken to bars, and, although I was under age, nobody ever objected. Not on account of my size or looks, but on account of my certainty. Don't look back, he told me, don't doubt for a moment, just be surer of yourself than they are.

Once, another drinker started swearing at me – telling me to get my bloody mouth out of his sight – and I suddenly broke down. Ken put his arm round me and took me straight out into the street. There were no lights. This was in wartime London. We walked a long way in silence. If you have to cry, he said, and sometimes you can't help it, if you have to cry, cry afterwards, never during! Remember this. Unless you're with those who love you, only those who love you, and in that case you're already lucky for there are never many who love you – if you're with them, you can cry during. Otherwise you cry afterwards.

All the games he taught me, he played well. Except for his short-sightedness (suddenly it occurs to me, as I write, that all the people I have loved and still love were or are short-sighted), except for his short-sightedness, he moved like an athlete. A similar poise.

Not me. I was clumsy, over-hasty, cowardly, with almost no poise. I had something else though. A kind of determination, which, given my age,

was startling. I would wager all! And for the energy of that rashness, he overlooked the rest. And the gift of his love was the gift of sharing with me what he knew, almost everything he knew, irrespective of my age or his.

For such a gift to be possible the giver and receiver need to be equal, and we, strange incongruous pair that we were, became equal. Probably neither of us understood how this happened. Now we do. We were foreseeing this moment; we were equal then as we are equal now in the Place Nowy. We foresaw my being an old man and his being dead, and this allowed us to be equal.

He puts his long hand around the can of beer on the table and clinks it against mine.

Whenever possible, he preferred gestures to spoken words. Perhaps as a result of his respect for silent written words. He must have studied in libraries, yet for him the immediate place for a book was a raincoat pocket. And the books he pulled out of that pocket!

He did not hand them to me directly. He said the name of the author, he pronounced the title and he placed the book on the corner of the mantelpiece in his bed-sitting room. Sometimes there were several, one on top of the other, so that I might choose. George Orwell, *Down and Out in Paris and London.* Marcel Proust, *Swann's Way.* Katherine Mansfield, *The Garden Party.* Laurence Sterne, *The Life and Opinions of Tristram Shandy.* Henry Miller, *Tropic of Cancer.* Neither of us, for different reasons, believed in literary explanations. I never once asked him about what I failed to understand. He never referred to what, given my age and experience, I might find difficult to grasp in these books. Sir Frederick Treves, *The Elephant Man and Other Reminiscences.* James Joyce, *Ulysses.* (An English edition published in Paris.) There was a tacit understanding between us that we learn – or try to learn – how to live partly from books. The learning begins with looking at our first illustrated alphabet, and goes on until we die. Oscar Wilde, *De Profundis.* St John of the Cross.

When I gave a book back, I felt closer to him, because I knew a little more of what he had read during his long life. Books converged us. Often one book led to another. After George Orwell's *Down and Out in Paris and London*, I wanted to read *Homage to Catalonia.*

Ken was the first person to talk to me about the Spanish Civil War. Open wounds, he said. Nothing can staunch them. I had never heard

the word *staunch* pronounced out loud before. We were at that moment playing billiards in a bar. Don't forget to chalk the cue, he added.

He read to me in Spanish a poem by García Lorca, who had been shot four years earlier, and when he translated it, I believed in my fourteen-year-old mind that I knew, except for a few details, what life was about and what had to be risked! Perhaps I told him so, or perhaps some other rashness of mine provoked him, for I remember him saying: Check out the details! Check them out first not last!

He said this with a note of regret as if somewhere, somehow, he himself had made a mistake about details that he regretted. No, I'm wrong. He was a man who regretted nothing. A mistake for which he had had to pay the price. During his life he paid the price for many things he didn't regret.

Two girls in long white lace dresses are crossing the far end of the Place Nowy. Ten or eleven years old, both tall for their age, both become Honorary Women, both, as they cross the square, stepping out of their childhood.

La Semaine blanche, Ken says. Last Sunday kids across the whole of Poland took their First Communion. And every day this week they do their best to get to a church and take communion once more, particularly the girls – the boys too but they are less noticeable and there are fewer of them – particularly the girls, who want to step out in their white communion dresses once again.

The two girls in the square walk side by side so they can scythe down the glances they are attracting. They're going to the Church of Corpus Christi where there's a famous Madonna in gold leaf, Ken says. All the girls of Kraków would like to take their First Communion in Corpus Christi because the communion dresses their mothers buy there are better cut, have a better length.

It was in the Old Met Music Hall on the Edgware Road, sitting beside him, that I first learnt how to judge claims to style, learnt the rudiments of criticism. Ruskin, Lukács, Berenson, Benjamin, Wölfflin, all came later. My essential formation was in the Old Met, looking down from the gallery onto the triangular stage, surrounded by a noisily receptive and unforgiving public, who judged the stand-up comics, the adagio acrobats, the singers, the ventriloquists, pitilessly. We saw

Tessa O'Shea bring the house down, and we saw her booed off stage, her hair wet with tears.

An act had to have style. The audience had to be won over twice a night. And to do this, the non-stop sequence of gags had to lead to something more mysterious: the conspiratorial, irreverent proposition that life itself was a stand-up act!

Max Miller, 'The Cheeky Chappie' in a silver suit with his hyper-thyroid eyes, played on the triangular stage like an irrepressible sea lion, for whom every laugh was a fish to be swallowed.

I've got my own studios in Brighton, and a woman came to my house on Monday morning – she said, 'Max, I want you to paint a snake on my knee.' I went dead white, honest I did. No, well I'm not strong, I'm not strong. So, listen – I jumped out of bed, see . . . no, listen a minute . . . so I started to paint the snake just above her knee, that's where I started. But I had to chuck it – she smacked me in the face – I didn't know a snake was so long – how long's an ordinary snake?

Each comedian played a victim, a victim who had to win the hearts of all those who had bought tickets, and who were also victims.

Harry Champion came downstage, hands out, begging for help, on the verge of tragedy: 'Life is a very hard thing – you never come out of it alive!' When he said this on a good night, the whole house put itself in the palm of his hand.

Flanagan and Allen rushed on, as if on urgent business and late. Then they showed, at high speed, that the whole world and its urgencies was based on a profound misunderstanding. They were young. Flanagan had soulful, naive eyes; Ches Allen, the straight one, was dapper and correct. Yet together they demonstrated the decrepitude of the world!

If I could sell my taxi I'd go back to Africa and do what I used to do.

What's that?

Dig holes and sell them to farmers!

The microphone is going to kill their art, Ken whispered to me in the gallery. I asked him what he meant. Listen to how they use their voices, he explained. They talk across the whole theatre and we're in the middle of them. If they use a mike, this will stop and the public

will no longer be in the middle. The secret of music hall artists is that they play defenceless, like we all are. A player with a mike is armed! It's another ball game.

He was right. The music hall died during the next decade.

A woman, carrying a basket of wild sorrel, passes the table in the Place Nowy.

Could you make us some sorrel soup? Ken asks me. We could have it tomorrow instead of borsch.

I guess so.

With eggs?

That I've never tried.

Well, he shuts his eyes, you prepare the soup, serve it, and in each bowl, you put a hot hard-boiled egg. You have made sure that beside each bowl there's a knife as well as a spoon. You cut the egg into slices, and you eat it with the green soup. And the mixture of the sharp green acidity and the round comfort of the egg reminds you of something extraordinary and far away.

Of home?

Certainly not, not even for the Poles.

Of what then?

Of survival, perhaps.

It seemed to me that Ken always lived in the same bedsit. In reality, he moved often, but the moves were made when I was away at school, and on returning and going to see him, I would find his same few possessions piled up on a similar table at the foot of a similar bed, behind a door with a key, which opened onto a staircase, overlooked by a landlady, worrying in the same way about the lights being left on.

Ken's room had a gas fire and a tall window. On the mantelpiece above the gas fire he stacked our books. On the table by the window was a large portable wireless (the word radio was rarely used) to which we listened. 2 Sept. 1939: the Panzer divisions of the Wehrmacht invaded Poland without warning this morning at dawn. Six million Poles, half of them Jewish, were going to lose their lives during the next five years.

In the room's wardrobe he kept not only clothes but food: oatmeal biscuits, hard-boiled eggs, a pineapple, coffee. Attached to the gas fire was a gas ring for heating water in a saucepan that he kept on the windowsill. The room smelt of cigarettes, pineapple, and lighter fuel.

The toilet and washbasin were on the landing either above or below. I tended to forget which, and he would shout after me: Up not down!

His two suitcases, which he left open on the floor, were never entirely unpacked. At that time nothing was unpacked, even in people's heads. Everything was in store or in transit. Dreams were kept on luggage racks, in kitbags and in suitcases. In one of the cases open on the floor there was a jar of honey from Brittany, a dark fisherman's sweater, a volume of Baudelaire in French, and a table-tennis bat.

Give you a lead of fifteen plus service! he proposed. Ready? Serve! Fifteen, love. Fifteen, one. Fifteen, two. Fifteen, three. He was beating me like that in 1940.

By 1941 he was still beating me two games out of three, but he was no longer giving me a lead.

He was now working in some capacity, about which he would say nothing, for a foreign service at the BBC. He often came back to the room after work in the small hours of the morning. The bedcover was damasked.

In the mornings we usually took breakfast in a barricaded café near Gloucester Road. Food was rationed. Those without a sweet tooth gave their sugar rations to others. Ken and I drank tea, as it was better than the coffee essence. Over breakfast we read newspapers. Each consisted of four – or at the most six – pages. 9 Sept. 1941: Leningrad cut off by German troops. 12 Feb. 1942: Three German cruisers sail unimpeded through the Straits of Dover. 25 May 1942: The Wehrmacht take 250,000 Soviet prisoners at Kharkov. The Nazis, Ken said, are making the same mistake as Napoleon: they underestimate the power of General Winter. He was right. In late November General Paulus and his 6th Army were surrounded at Stalingrad and in February they surrendered to General Zhukov.

One morning in the middle of April 1943, Ken told me about a London radio broadcast, made the day before, by General Sikorski, the Polish prime minister in exile, who was appealing to Poles in Poland to support the ongoing uprising in the Warsaw ghetto. The ghetto was being systematically annihilated. Sikorski said – Ken spoke slowly – that: 'The greatest crime in the history of mankind is taking place.'

Only during moments of forgetfulness, when thinking about nothing, did the enormity of what was happening make itself felt. The

enormity was then present in the air, under the spring sky, addressing a seventh sense which I still cannot name.

11 July 1943. The British 8th Army and the American 7th Army invade Sicily and take Syracuse.

I think of you as a beginner, Ken whispers, leaning across the table in Kraków, and I suspect that if I read you today I might be disappointed.

About mastery there is something sad, indescribably sad, I reply.

I see you as a beginner.

Still?

More than ever!

With you as teacher?

I didn't teach. You learnt. There's a difference. I let you learn! And there were a few things I learnt from you!

Such as?

Dressing quickly.

Anything else?

How to read well out loud.

You read well out loud yourself, I say.

In the end I discovered how you did it. The secret of your reading out loud. You didn't read the end of the sentence until you got there, that was your secret. You refused to look ahead.

He takes off his glasses as if he has seen and said enough. He knew me well.

Beneath the damasked bedcover, during nights punctuated by air-raid sirens, I sometimes felt a burning in Ken's erect member. The tumescence came unasked and waited like a pain, a pain that had to be staunched, low down in the middle of his long body. Soon afterwards, in the bed damp with spunk and tears from his eyes without glasses, sleep came swiftly to the two of us. Rippled sleep, like sand when the tide is far out.

Let's go and see the pigeons, Ken says, polishing the thick lenses of his glasses with his tartan handkerchief.

We walk towards the northern end of the market. The sun is hot. One more early summer morning added to the pile on the century's desk. We watch two butterflies who came to the centre of the city with the garden vegetables fly upwards in a spiral. The clock on the city cathedral strikes eleven.

Every day, hundreds of Polish visitors climb the spiral stone staircase in the bell tower of the cathedral to look across the Vistula and to touch with a finger the massive tongue of the Zygmunt bell, cast in 1520 and weighing eleven tons. Touching it is said to bring luck in love.

We pass a man selling hairdryers. One hundred and fifty złoty each, which means they have probably been stolen. He is demonstrating one of the dryers and calls out to a passing child: Come here, sweetie, and I'll make you cool! The girl laughs, agrees and her hair fluffs up, billowing. *Slicznie*, she cries.

I'm beautiful, Ken translates, laughing.

Further on I see a crowd of men huddled together. If it weren't for their craning heads and the silence in the air, I would say they were listening to music. When we get closer I understand that they are in fact gathered round a table on which there are a hundred pigeons in wooden pens, five or six to a cage. The birds vary in plumage and size, although all have a glint of bluish slate in their colouring, and in this glint there is something of the sky above Kraków. The pigeons on the table look like sky-samples brought back to earth. Maybe this is why the men seemed to be listening to music.

Nobody knows, Ken says, how homing pigeons find their way home. When they are flying in clear weather, they can see thirty kilometres ahead, yet this doesn't explain their unerring sense of direction. During the siege of Paris in 1870, a million messages to the city's inhabitants were delivered by fifty pigeons. It was the first time that micro-photography had ever been used on that sort of scale. The letters were all reduced, so that hundreds could fit on a tiny film weighing only a gram or two. Then, when the pigeons arrived, the letters were enlarged, copied out and distributed. Strange how things come together in history – colodium film and carrier pigeons!

Some birds have been taken out of their cages and are being expertly examined by the pigeon fanciers. Their crops are being lightly pinched between two fingers, the length of their legs measured, the flat tops of their heads gently pressed by a thumb, their flight feathers extended, and all the while they are being held close against the men's chests, like trophies.

It's hard, don't you think, says Ken taking my arm, to imagine sending news of a total catastrophe by carrier pigeon? The message could

announce a defeat, or it could be an appeal for help, but in that gesture of throwing the pigeon up into the sky, so that it heads for home, isn't there inevitably some hope? Sailors from Ancient Egypt used to release pigeons from their boats on the high seas to tell their families they were on their way home.

I look at the beady red-pupilled eyes of one of the pigeons. He is looking at nothing, because he knows he's held and can't move.

I wonder how the chess game is going, I say. The two of us stroll to the other end of the market.

There are sixteen pieces left on the board. Zedrek has king, bishop and five pawns. He is looking up at the sky as if seeking inspiration. Abram looks at his watch. Twenty-three minutes! he announces.

Chess is not a game you can hurry, comments a customer.

He has one good move, whispers Ken, and I bet he's not going to see it.

Move the bishop to C5, is that it?

No, you idiot, his king to F1.

Tell him then.

Dead men don't move pieces!

Hearing Ken say these words I suffer his death. He, meanwhile, takes his head in his hands, and with them he turns the head left and right, as if it were a searchlight. He waits for me to laugh as I often did at this clown act of his. He doesn't see my anguish. I do laugh.

When I came out of the army at the end of the war, he had disappeared. I wrote to him at the last address I had, and there was no reply. A year later he sent a postcard to my parents – the postcard came from somewhere improbable like Iceland or Jersey – asking whether we might all spend Christmas together, which we did. He came with a woman war-photographer who was, I think, Czech. We played Christmas games, we laughed a lot, he teased my mother about buying all the food on the black market.

Between the two of us there was the same complicity. Neither of us looked away or took the slightest step back. We felt the same love: simply the circumstances had changed. The *passeur* had delivered his charge; the frontiers were crossed.

The years passed. The last time I ever saw him we drove all night with my friend Anant from London to Genève. Driving through a

forest near Châtillon-sur-Seine, we heard Coltrane on the radio playing 'My Favourite Things'. It was during this journey that Ken told me he was returning to New Zealand. He was then sixty-five. I didn't ask him why because I didn't want to hear him say: To die.

Instead I made believe that he would come back to Europe. To which he replied: The best thing there, John, down under, is the grass! There's no grass as green anywhere else in the world. He said this forty years ago. I never knew exactly when or how he died.

In the Place Nowy, among the stolen hairdryers, the honey-bread with its candied orange peel, the woman who chain-smokes and hopes to sell dresses, Jagusia with her basket now almost empty, the black cherries that have to be sold and eaten quickly because they won't last, the barrel of salted herring, the voice of Ewa Demarczyk on a CD singing one of her defiant songs, I suffer his death for the first time.

I do not even glance at where Ken is standing, for he will not be there. I walk alone, past the barber's, past the soup kitchen, past the women sitting on their stools.

Something pulls me back to the pigeons. When I arrive a man turns towards me, and, as if guessing at my distress – is there another country in the world more accustomed to coming to terms with that emotion? – he hands me, without smiling, the carrier pigeon he is holding.

Its feathers feel slightly damp – like satin. The small ones on its breast have a parting in the middle, as on an owl. It weighs nothing for its size. I hold him against my chest.

ભ

I LEFT THE Place Nowy, and found, after asking two passers-by, the bankomat. From there I returned to the *pension* in Miodowa Street and lay down on the bed. It was very hot, hot with the uncertain heat of the eastern plains. Now I could weep. Later I shut my eyes and imagined shuffling a pack of cards.

2.

To Take Paper, to Draw

I SOMETIMES HAVE a dream in which I am my present age, with grown-up children and newspaper editors on the telephone, yet nevertheless have to leave and pass nine months of the year in the school where I was sent as a boy. In the dream, I think of these months as a regrettable exile, but it never occurs to me to refuse to go. In life, I ran away from that school when I was sixteen. The war was on and I went to London. Between the air-raid sirens and amid the debris of bombing I had a single idea: I wanted to draw naked women. All day long.

I was enrolled in an art school – there was not a lot of competition; nearly everyone over eighteen was in the services – and I drew in the daytime and I drew in the evenings. There was an exceptional teacher in the school at the time, an elderly painter, a refugee from fascism named Bernard Meninsky. He said very little and his breath smelt of dill pickles. On the same imperial-sized sheet of paper (paper was rationed; we had two sheets a day), beside my clumsy, unstudied, impetuous drawing, Bernard Meninsky would boldly draw a part of the model's body in such a way as to make clearer its endlessly subtle structure and movement. After he had gone, I would spend the next ten minutes, dumbfounded, looking from his drawing to the model and vice versa.

Thus I learnt to question with my eyes the mystery of anatomy and of love, whilst outside in the night sky, I heard the RAF fighters crossing the city to intercept the German bombers before they reached the coast. The ankle of the foot on which her weight was posed was vertically under the dimple of her neck . . . directly vertical.

When I was in Istanbul recently, I asked my friends if they could arrange for me to meet the writer Latife Tekin. I had read a few translated extracts from two novels she had written about life in the shantytowns on the edge of the city. And the little I had read deeply impressed me with its imagination and authenticity. She herself must have been brought up in a shantytown. My friends arranged a dinner and Latife came. I do not speak Turkish, so naturally they offered to interpret. She was sitting beside me. Something made me tell my friends – no, don't bother, we'll manage somehow.

The two of us looked at each other with some suspicion. In another life I might have been an elderly police superintendent interrogating a pretty, shifty, fierce woman of thirty repeatedly picked up for larceny. In fact, in this our only life, we were both storytellers without a word in common. All we had were our observations, our habits of narration, our Aesopian sadness. Suspicion gave way to shyness.

I took out a notebook and did a drawing of myself as one of her readers. She drew a boat upside down to show she couldn't draw. I turned the paper around so it was the right way up. She made a drawing to show that her drawn boats always sank. I said there were birds at the bottom of the sea. She said there was an anchor in the sky. (Like everybody else at the table we were drinking raki.) Then she told me a story about the municipal bulldozers destroying the houses built in the night on the city's edge. I told her about an old woman who lived in a van. The more we drew, the quicker we understood. In the end we were laughing at our speed – even when the stories were monstrous or sad. She took a walnut and, dividing it in two, held it up to say: halves of the same brain! Then somebody put on some Bektasi music and all the guests began to dance.

In the summer of 1916, Picasso drew on a page of a medium-sized sketchbook the torso of a nude woman. It is neither one of his invented figures – it hasn't enough bravura; nor is it a figure drawn from life – it hasn't enough of the idiosyncrasy of the immediate.

The face of the woman is unrecognisable, for the head is scarcely indicated. However, the torso is a kind of face. It has a familiar expression. A face of love, become hesitant or sad. The drawing is distinct in feeling from others in the sketchbook. The other drawings play rough games with Cubist or neo-classical devices, some looking back on the previous still life period, others preparing for the Harlequin themes he would take up the following year when he did the décor for the ballet *Parade*. The torso of the woman is very fragile.

Usually Picasso drew with such verve and directness that every scribble reminds you of the act of drawing and of the pleasure of that act. It is this that makes his drawings insolent. Even the weeping faces of the *Guernica* period or the skulls he drew during the German Occupation possess an insolence. They know no servitude. The act of drawing them is triumphant.

The drawing in question is an exception. Half drawn – for Picasso didn't continue on it for long – half woman, half vase, half seen as by Ingres, half seen as by a child, the apparition of the figure counts for far more than the act of drawing. It is she, not the draughtsman, who insists, insists by her very tentativeness.

My hunch is that in Picasso's imagination this drawing belonged to Eva Gouel. She had died only six months earlier of tuberculosis. They had lived together – Eva and Picasso – for four years. Into his famous Cubist still lifes he has inserted and painted her name, transforming austere canvases into love letters. JOLIE EVA. Now she was dead and he was living alone. The image lies on the paper as in a memory.

This hesitant torso has come from another floor of experience, has come in the middle of a sleepless night and still retains its key to the door.

Perhaps these three stories suggest the three distinct ways in which drawings can function. There are those that study and question the visible; those that record and communicate ideas; and those done from memory. Even in front of drawings by the old masters, the distinction between the three is important, for each type survives in a different way. Each speaks in a different tense. To each we respond with a different capacity of imagination.

In the first kind of drawing (at one time such drawings were appropriately called *studies*), the lines on the paper are traces left behind by the artist's gaze which is ceaselessly leaving, going out, interrogating

the strangeness, the enigma, of what is before his eyes – however ordinary and everyday this may be. The sum total of the lines on the paper narrates an optical emigration by which the artist, following his own gaze, settles on the person or tree or animal or mountain being drawn. And if the drawing succeeds he stays there for ever.

In his study *Abdomen and Left Leg of a Nude Man Standing in Profile*, Leonardo is still there – there in the groin of the man, drawn with red chalk on a salmon-pink prepared paper, there in the hollow behind the knee, where the femoral biceps and the semi-membranous muscle separate to allow for the insertion of the twin calf muscles. And Jacques de Gheyn (who married the heiress Eva Stalpert van der Wielen, and so could give up engraving) is still there in the astounding diaphanous wings of the dragonflies he drew with black chalk and brown ink for his friends at the University of Leyden around 1600.

If one forgets circumstantial details, technical means, kinds of paper, and so on, such drawings do not date, for the act of concentrated looking, of questioning the appearance of an object before one's eyes, has changed very little through the millennia. The ancient Egyptians stared at fish in a way comparable to the Byzantines on the Bosporus or to Matisse in the Mediterranean. What has changed, according to history and ideology, is the visual rendering of what artists dared not question: God, Power, Justice, Good, Evil. Trivia could always be visually questioned. This is why exceptional drawings of trivia carry with them their own 'here and now', putting their humanity into relief.

Between 1603 and 1609 the Flemish draughtsman and painter Roelandt Savery travelled in Central Europe. Eighty drawings of people in the street – marked with the title 'Taken From Life' – have survived. Until recently they were thought to be by the great painter Pieter Bruegel.

One of them, drawn in Prague, depicts a beggar seated on the ground. He wears a black cap; wrapped round one of his feet is a white rag, over his shoulders a black cloak. He is staring ahead, very straight; his dark sullen eyes are at the same level as a dog's would be. His hat, upturned for money, is on the ground beside his bandaged foot. No comment, no other figure, no placing. A tramp of nearly four hundred years ago.

We encounter this today. Before this scrap of paper, only six inches square, we *come across* him as we might come across him on the way to the airport or on a grass bank of the highway above Latife's shanty-town. One moment faces another and they are as close as two facing pages in today's unopened newspaper. A moment of 1607 and a moment of 1987. Time is obliterated by an eternal present. Tense: Present Indicative.

In the second category of drawings, the traffic, the *transport*, goes in the opposite direction. It is now a question of bringing to the paper what is already in the mind's eye. Delivery rather than emigration. Often such drawings were done as sketches or working drawings for paintings. They bring together, they arrange, they set a scene. Since there is no direct interrogation of the visible, they are far more dependent upon the dominant visual language of their period, and so are usually more datable in their essence – more narrowly qualifiable as Renaissance, Mannerist, eighteenth century, or whatever.

There are no confrontations, no encounters to be found in this category. Rather we look through a window onto a man's capacity to dream, to construct an alternative world in his imagination. And everything depends upon the space created within this alternative. Usually it is meagre – the direct consequence of imitation, false virtuosity. Such meagre drawings still possess an artisanal interest (through them we see how pictures were made and joined – like cabinets or clocks), but they do not speak directly to us. For this to happen, the space created within the drawing has to seem as large as the earth's or the sky's space. Then we can feel the breath of life.

Poussin could create such a space; so could Rembrandt. That the achievement is rare in European drawing may be because such space only opens up when extraordinary mastery is combined with extraordinary modesty. To create such immense space with ink marks on a sheet of paper one has to know oneself to be very small.

Such drawings are visions of what *would be if . . .* Most record visions of the past which are now closed to us, like private gardens. When there is enough space, the vision remains open and we enter. Tense: Conditional.

Finally, there are the drawings done from memory. Many are notes jotted down for later use – a way of collecting and of keeping

impressions and information. We look at them with curiosity if we are interested in the artist or the historical subject. (In the fifteenth century the wooden rakes used for raking up hay were exactly the same as those still used in the mountains where I live.)

The most important drawings in this category, however, are made (as was probably the case in the Picasso sketchbook) in order to exorcise a memory which is haunting – in order to take an image out of the mind, once and for all, and put it on paper. The unbearable image may be sweet, sad, frightening, attractive, cruel. Each has its own way of being unbearable.

The artist in whose work this mode of drawing is most obvious is Goya. He made drawing after drawing in a spirit of exorcism. Sometimes his subject was a prisoner being tortured during the Inquisition to exorcise his or her sins: a double, terrible exorcism.

I see a red wash and sanguine drawing by Goya of a woman in prison. She is chained by her ankles to the wall. Her shoes have holes in them. She lies on her side. Her skirt is pulled up above her knees. She bends her arm over her face and eyes so she need not see where she is. The drawn page is like a stain on the stone floor on which she is lying. And it is indelible.

There is no bringing together here, no setting of a scene. Nor is there any questioning of the visible. The drawing simply declares: I saw this. Historic Past Tense.

A drawing from any of the three categories, when it is sufficiently inspired, when it becomes miraculous, acquires another temporal dimension. The miracle begins with the basic fact that drawings, unlike paintings, are usually monochrome.

Paintings with their colours, their tonalities, their extensive light and shade, compete with nature. They try to seduce the visible, to *solicit* the scene painted. Drawings cannot do this. They are diagrammatic; that is their virtue. Drawings are only notes on paper. (The sheets rationed during the war! The paper napkin folded into the form of a boat and put into a raki glass where it sank.) The secret is the paper.

The paper becomes what we see through the lines, and yet remains itself. A drawing made around 1553 by Pieter Bruegel is identified in the catalogues as a *Mountain Landscape with a River, Village and*

Castle. (In reproduction its quality will be fatally lost: better to describe it.) It was drawn with brown inks and wash. The gradations of the pale wash are very slight. The paper lends itself between the lines to becoming tree, stone, grass, water, cloud. Yet it can never for an instant be confused with the substance of any of these things, for evidently and emphatically, it remains a sheet of paper with fine lines drawn upon it.

This is both so obvious and, if one reflects upon it, so strange that it is hard to grasp. There are certain paintings which animals could read. No animal could ever read a drawing.

In a few great drawings, like the Bruegel landscape, everything appears to exist in space, the complexity of everything vibrates – yet what one is looking at is only a project on paper. Reality and project become inseparable. One finds oneself on the threshold before the creation of the world. Such drawings, using the Future Tense, *foresee*, forever.

3.

The Basis of All Painting
and Sculpture Is Drawing

FOR THE ARTIST, drawing is discovery. And that is not just a slick phrase, it is quite literally true. It is the actual act of drawing that forces the artist to look at the object in front of him, to dissect it in his mind's eye and put it together again; or, if he is drawing from memory, that forces him to dredge his own mind, to discover the content of his own store of past observations. It is a platitude in the teaching of drawing that the heart of the matter lies in the specific process of looking. A line, an area of tone, is important not really because it records what you have seen, but because of what it will lead you on to see. Following up its logic in order to check its accuracy, you find confirmation or denial in the object itself or in your memory of it. Each confirmation or denial brings you closer to the object, until finally you are, as it were, inside it: the contours you have drawn no longer marking the edge of what you have seen, but the edge of what you have become. Perhaps that sounds needlessly metaphysical. Another way of putting it would be to say that each mark you make on the paper is a stepping-stone from which you proceed to the next, until you have crossed your subject as though it were a river, have put it behind you.

This is quite different from the later process of painting a 'finished' canvas or carving a statue. Here you do not pass through your subject,

but try to re-create it and house yourself in it. Each brush-mark or chisel-stroke is no longer a stepping-stone, but a stone to be fitted into a planned edifice. A drawing is an autobiographical record of one's discovery of an event – seen, remembered or imagined. A 'finished' work is an attempt to construct an event in itself. It is significant in this respect that only when the artist gained a relatively high standard of individual 'autobiographical' freedom did drawings, as we now understand them, begin to exist. In a hieratic, anonymous tradition they are unnecessary. (I should perhaps point out here that I am talking about *working* drawings – although a working drawing need not necessarily be made for a specific project. I do not mean linear designs, illustrations, caricatures, certain portraits or graphic works which may be 'finished' productions in their own right.)

A number of technical factors often enlarge this distinction between a working drawing and a 'finished' work: the longer time needed to paint a canvas or carve a block; the larger scale of the job; the problem of simultaneously managing colour, quality of pigment, tone, texture, grain, and so on – the 'shorthand' of drawing is relatively simple and direct. But nevertheless the fundamental distinction is in the working of the artist's mind. A drawing is essentially a private work, related only to the artist's own needs; a 'finished' statue or canvas is essentially a public, *presented* work – related far more directly to the demands of communication.

It follows from this that there is an equal distinction from the point of view of the spectator. In front of a painting or statue he tends to identify himself with the subject, to interpret the images for their own sake; in front of a drawing he identifies himself with the artist, using the images to gain the conscious experience of seeing as though through the artist's own eyes.

As I looked down at the clean page in my sketchbook I was more conscious of its height than its breadth. The top and bottom edges were the critical ones, for between them I had to reconstruct the way he rose up from the floor, or, thinking in the opposite direction, the way that he was held down to the floor. The energy of the pose was primarily vertical. All the small lateral movements of the arms, the twisted neck, the leg which was not supporting his weight, were related to that vertical force, as the trailing and overhanging branches of a tree

are related to the vertical shaft of the trunk. My first lines had to express that; had to make him stand like a skittle, but at the same time had to imply that, unlike a skittle, he was capable of movement, capable of readjusting his balance if the floor tilted, capable for a few seconds of leaping up into the air against the vertical force of gravity. This capability of movement, this irregular and temporary rather than uniform and permanent tension of his body, would have to be expressed in relation to the side edges of the paper, to the variations on either side of the straight line between the pit of his neck and the heel of his weight-bearing leg.

I looked for the variations. His left leg supported his weight and therefore the left, far side of his body was tense, either straight or angular; the near, right side was comparatively relaxed and flowing. Arbitrary lateral lines taken across his body ran from curves to sharp points – as streams flow from hills to sharp, compressed gullies in the cliff-face. But of course it was not as simple as that. On his near, relaxed side his fist was clenched and the hardness of his knuckles recalled the hard line of his ribs on the other side – like a cairn on the hills recalling the cliffs.

I now began to see the white surface of the paper, on which I was going to draw, in a different way. From being a clean flat page it became an empty space. Its whiteness became an area of limitless, opaque light, possible to move through but not to see through. I knew that when I drew a line on it – or *through* it – I should have to control the line: not like the driver of a car, on one plane, but like a pilot in the air, movement in all three dimensions being possible.

Yet, when I made a mark, somewhere beneath the near ribs, the nature of the page changed again. The area of opaque light suddenly ceased to be limitless. The whole page was changed by what I had drawn just as the water in a glass tank is changed immediately you put a fish in it. It is then only the fish that you look at. The water merely becomes the condition of its life and the area in which it can swim.

Then, when I crossed the body to mark the outline of the far shoulder, yet another change occurred. It was not simply like putting another fish into the tank. The second line altered the nature of the first. Whereas before the first line had been aimless, now its meaning was fixed and made certain by the second line. Together they held down the edges of

the area between them, and the area, straining under the force which had once given the whole page the potentiality of depth, heaved itself up into a suggestion of solid form. The drawing had begun.

The third dimension, the solidity of the chair, the body, the tree, is, at least as far as our senses are concerned, the very proof of our existence. It constitutes the difference between the word and the world. As I looked at the model I marvelled at the simple fact that he *was* solid, that he occupied space, that he was more than the sum total of ten thousand visions of him from ten thousand different viewpoints. In my drawing, which was inevitably a vision from just one point of view, I hoped eventually to imply this limitless number of other facets. But now it was simply a question of building and refining forms until their tensions began to be like those I could see in the model. It would of course be easy by some mistaken over-emphasis to burst the whole thing like a balloon; or it might collapse like too thin clay on a potter's wheel; or it might become irrevocably misshapen and lose its centre of gravity. Nevertheless, the thing was there. The infinite, opaque possibilities of the blank page had been made particular and lucid. My task now was to co-ordinate and measure: not to measure by inches as one might measure an ounce of sultanas by counting them, but to measure by rhythm, mass and displacement; to gauge distances and angles as a bird flying through a trellis of branches; to visualise the ground plan like an architect; to feel the pressure of my lines and scribbles towards the uttermost surface of the paper, as a sailor feels the slackness or tautness of his sail in order to tack close or far from the surface of the wind.

I judged the height of the ear in relation to the eyes, the angles of the crooked triangle of the two nipples and the navel, the lateral lines of the shoulders and hips – sloping towards each other so that they would eventually meet, the relative position of the knuckles of the far hand directly above the toes of the far foot. I looked, however, not only for these linear proportions, the angles and lengths of these imaginary pieces of string stretched from one point to another, but also for the relationships of planes, of receding and advancing surfaces.

Just as looking over the haphazard roofs of an unplanned city you find identical angles of recession in the gables and dormer-windows of quite different houses – so that if you extended any particular plane

through all the intermediary ones, it would eventually coincide perfectly with another – in exactly the same way you find extensions of identical planes in different parts of the body. The plane, falling away from the summit of the stomach to the groin, coincided with that which led backwards from the near knee to the sharp, outside edge of the calf. One of the gentle, inside planes, high up the thigh of the same leg, coincided with a small plane leading away and around the outline of the far pectoral muscle.

And so, as some sort of unity was shaped and the lines accumulated on the paper, I again became aware of the real tensions of the pose. But this time more subtly. It was no longer a question of just realising the main, vertical stance. I had become involved more intimately with the figure. Even the smaller facts had acquired an urgency and I had to resist the temptation to make every line over-emphatic. I entered into the receding spaces and yielded to the oncoming forms. Also, I was correcting: drawing over and across the earlier lines to re-establish proportion: or to find a way of expressing less obvious discoveries. I saw that the line down the centre of the torso, from the pit of the neck, between the nipples, over the navel and between the legs, was like the keel of a boat, that the ribs formed a hull and that the near, relaxed leg dragged on its forward movement like a trailing oar. I saw that the arms hanging either side were like the shafts of a cart, and that the outside curve of the weight-bearing thigh was like the ironed rim of a wheel. I saw that the collar-bones were like the arms of a figure on a crucifix. Yet such images, although I have chosen them carefully, distort what I am trying to describe. I saw and recognised quite ordinary anatomical facts; but I also felt them physically – as if, in a sense, *my* nervous system inhabited *his* body.

A few of the things I recognised I can describe more directly. I noticed how at the foot of the hard, clenched, weight-bearing leg there was clear space beneath the arch of the instep. I noticed how subtly the straight under-wall of the stomach elided into the attenuated, joining planes of thigh and hip. I noticed the contrast between the hardness of the elbow and the vulnerable tenderness of the inside of the arm at the same level.

Then, quite soon, the drawing reached its point of crisis. Which is to say that what I had drawn began to interest me as much as what I

could still discover. There is a stage in every drawing when this happens. And I call it a point of crisis because at that moment the success or failure of the drawing has really been decided. One now begins to draw according to the demands, the needs, of the drawing. If the drawing is already in some small way true, then these demands will probably correspond to what one might still discover by actual searching. If the drawing is basically false, they will accentuate its wrongness.

I looked at my drawing, trying to see what had been distorted; which lines or scribbles of tones had lost their original and necessary emphasis, as others had surrounded them; which spontaneous gestures had evaded a problem, and which had been instinctively right. Yet even this process was only partly conscious. In some places I could clearly see that a passage was clumsy and needed checking; in others, I allowed my pencil to hover around – rather like the stick of a water-diviner. One form would pull, forcing the pencil to make a scribble of tone which could re-emphasise its recession; another would jab the pencil into re-stressing a line which could bring it further forward.

Now when I looked at the model to check a form, I looked in a different way. I looked, as it were, with more connivance: to find only what I wanted to find.

Then the end. Simultaneously ambition and disillusion. Even as in my mind's eye I saw my drawing and the actual man coincide – so that, for a moment, he was no longer a man posing but an inhabitant of my half-created world, a unique expression of my experience; even as I saw this in my mind's eye, I saw in fact how inadequate, fragmentary, clumsy my small drawing was.

I turned over the page and began another drawing, starting from where the last one had left off. A man standing, his weight rather more on one leg than the other . . .

4.

Frederick Antal –
A Personal Tribute

ANTAL, THE LOGICAL, precise, profound art historian, has deservedly earned his international reputation. But in any assessment of his work the importance of his Marxism tends to be underestimated. In a curious way this is probably done out of respect for him: as though to say 'He was brilliant *despite* that – so let's charitably forget it.' Yet, in fact, to do this is to deny all that Antal was. Admittedly a man's personality is fashioned by his temperament as well as by his beliefs. And certainly Antal had his temperament. Nevertheless, all the features that distinguished him so clearly, both as a man and as a thinker, completely coincided with, even if they were not all originally created by, his Marxism.

Art history for him was not just an 'interesting' field to be excavated: it was a revolutionary activity. Facts were weapons unearthed from the past in order to be used in the future. And his whole character reflected this attitude. Meeting him for the first time one would not have guessed that he was an historian. He had none of the comfortable insulation against life that academic study usually ensures.

In appearance he was very tall, with long, dark, swept-back hair. His face was gaunt and he had very bushy protruding eyebrows which, always clenched, emphasised by contrast the depth and calm of his

eyes that were simultaneously velvety, gentle and very hard. Only the movements of his long, thin hands indicated his extreme sensitivity. His expression was severe – not the petulant severity of an embittered schoolmaster, but the patient severity of a man who has long been vigilant alone. When he occasionally laughed or made some gentle personal remark, his expression changed and became as uncomplicated as that of a schoolboy.

One would probably have said, despite the fact that his presence straightaway shamed one out of any romanticism, that he was either a poet or a political leader. When I used to go and see him and tell him of my week's activities, I felt like a messenger reporting to a general. Not because I ever had anything very important or revealing to tell him, but because the way he would listen reminded one that to the real tactician even the smallest facts may be significant.

As for the poet in him – this was more complicated. It had nothing to do, for instance, with his attitude to language. On the contrary, he had little feeling for words and considered them absolutely functionally, absolutely unsensuously; they were simply nails to be hit on the head in order to fix an idea or establish a fact in its proper place. It was rather that his sense of history, connecting the past with the future, was similar to the epic poet's sense of destiny. And just as the poet seeks to *connect* intuitively by images, Antal sought to connect rationally by research. Above all his compulsion to work was similar to a poet's. He worked to release a vision.

Another thing I would like to emphasise is Antal's *feeling* for paintings and sculpture. He never simplified the mystery out of art – and by mystery I mean the power of a work of art to affect the heart. I have seen him profoundly moved in front of works he admired. Nor was his judgment of a work necessarily dependent upon his knowledge of all the related facts. A few weeks before he died, we went together to an exhibition of a contemporary Asian painter whom neither of us knew anything about. As we walked round he demanded now and again the date of a particular painting. Most of them were fifteen or twenty years old. After about half an hour he asked me what I thought. I was rather enthusiastic. He agreed that the paintings were good, but told me to think about what their style could lead to, what the same artist's later pictures would be like. Then, in great detail, he described what he

foresaw. When we went out we passed through another gallery. There, unbeknown to either of us, were the same artist's later paintings. They were exactly as Antal had described them.

Finally I want to mention his optimism. He always said that it was not age or generation which counted, but one's outlook. And it was the optimism of Antal's outlook that kept him young. As an exile, at odds in his fundamental beliefs with nearly all his Western colleagues, and – a lack he felt very keenly – denied in this country any outlet for his great talents as a polemicist, he had little personal reason for being optimistic. Nor was his optimism of the short-term sentimental sort. Indeed he saw very clearly the full extent of the present corruption of Western culture and realised that even when true socialism had been achieved, it would take a long time for any tradition of real art to be re-established. What I call his optimism consisted of his conviction that all who fought this corruption and worked for socialism – in however small or unrecognised a way – were doing something of certain value. In an age of frantic self-justification erected over a sense of futility and despair, he remained intellectually calm: confident in the judgment of history which – as I have tried to show – meant for him the judgment of the future.

5.

An Address to Danish
Worker Actors on the Art
of Observation, by Bertolt
Brecht, Translated by Anya
Rostock and John Berger

You have come here to act plays
But now you are to be asked:
For what purpose?
You have come here to reveal
Yourselves in all that you can do.
You think this worthy of being watched.
And you hope the people will applaud
As you transport them
Out of the narrowness of their world
Into the largeness of yours,
Sharing with you the dizzy peaks
And the tumults of passion.
But now you are to be asked:
For what purpose is this?

On their low benches
Your spectators begin to argue.

Some hold and maintain
You must do more than show yourselves.
You must show the world.
Where is the use, they ask,
Of being shown time and time again
How this one can be sad
How she is heartless
How that one would make a wicked king?
Where is the use in this endless
Exhibiting of grimaces,
These antics of a handful
In the hands of their fate?

You show us only people dragged along,
Victims of foreign forces and themselves.
An invisible master
Throws them down
Their joys like crumbs to dogs.
And so too the noose is fitted round their necks –
The tribulation that comes from above.
And we on our low benches
Held by your twitches and grimacing faces,
We gape with fixed eyes
And feel at one remove
Joys that are given like alms,
Fears beyond control.

No. We who are discontented
Have had enough on our low benches.
We are no longer satisfied.
Have you not heard it spread abroad
That the net is knotted
And is cast
By men?
Even now
In the cities of a hundred floors,
Over the seas on which the ships are manned,

To the furthest hamlet –
Everywhere now the report is: man's fate is man.

You actors of our time,
The time of change
And the time of the great taking over
Of all nature to master it
Not forgetting human nature,
This is now our reason
For insisting that you alter.
Give us the world of men as it is,
Made by men and changeable.

Thus the gist of the talk on the low benches.
Not all of course agree.
Most sit, their shoulders hunched,
With brows furrowed
Like stony fields ploughed
Repeatedly in vain.
Worn away by increasing daily struggles
They avidly await the very thing their companions
Hate.

A little kneading for the slack spirit.
A little tightening for the tired nerve.
The easy adventure of magically
Being led by the hand
Out from the world given them,
Out from the one they cannot master.
Whom then, actors, should you obey?
I'd say: the discontented.

Yet how to begin? How to show
The living together of men
That it may be understood
And become a world that can be mastered?
How to reveal not only yourselves and others

Floundering in the net
But also make clear how the net of fate
Is knotted and cast,
Cast and knotted by men?
Above all other arts
You, the actor, must conquer
The art of observation.

Of no account at all
How you look.
But what you have seen
And what you reveal does count.
It is worth knowing what you know.
They will watch you
To see how well you have watched.
But one who observes only himself
Gains no knowledge of men.
From himself he hides too much of himself.
And no man is wiser than he has become.

Therefore your training must begin among
The lives of other people. Make your first school
The place you work in, your home,
The district to which you belong,
The shop, the street, the train.
Observe each one you set eyes upon.
Observe strangers as if they were familiar
And those whom you know as if they were strangers.

Look. A man pays out his taxes. He differs from
Other men paying their taxes.
Even though it is true
No man pays them gladly.
In these circumstances
He may even differ from his normal self.
And is the man who collects the taxes different
In every way from the man who must pay?

The collector must also contribute his due
And he has much else in common
With the one he oppresses.
Listen.
This woman has not always spoken with her present harshness;

She does not speak so harshly to all.
Nor does that charmer charm every one.
Is the bullying customer
Tyrant all through?
Is he not also full of fear?
The mother without shoes for her children
Looks defeated,
But with the courage still left her
Whole empires were conquered:
She is bearing – you saw? – another child.
And have you seen
The eyes of a sick man told
He can never be well again
Yet could be well
Were he not compelled to work?
Observe how he spends such time as remains
Turning the pages of a book telling
How to make the earth a habitable planet.
Remember too the press photos and the newsreels.
Study your rulers
Walking and talking and holding in their pale
Cruel hands
The threads of your fate.

Make pictures
Unfolding and growing like movements in history.
For later that is how you must show them on the stage.
All this watch closely. Then in your mind's eye
From all the struggles waged
The struggle for work,
Bitter and sweet dialogues between men and women,

Talk about books,
Resignation and rebellion,
Trials and failures,
All these you must later show as
Historical processes.
(Even of us here and now
You might make such a picture:
The playwright, having fled his country,
Instructs you in the art of observation.)

To observe
You must learn to compare.
To be able to compare
You must have observed already.
From observation comes knowledge.
But knowledge is needed to observe.
He who does not know
What to make of his observation
Will observe badly.
The fruit grower will look at the apple tree
With a keener eye than the strolling walker.
But only he who knows that the fate of man is man
Can see his fellow men keenly with accuracy.
The art of observing men
Is only part of the skill of leading them.
And your job as actors
Should make you prospectors and teachers
Of this larger skill.
By knowing and demonstrating the nature of men
You will teach others to lead their own lives.
You will teach them the great art of living together.

Yet now I hear you asking:
How can we –
Kept down, kept moving, kept ignorant
Kept in uncertainty
Oppressed and dependent –

How can we
Step out like prospectors and pioneers
To conquer a strange country for gain?
Always we have been subject to those
More fortunate than us.
How should we
Who have been till now
Only the trees that bear the fruit
Become overnight
Fruit growers?
Yet, as I see it,
That is the art you must now acquire,
You, my friends, who on the same day are
Actors and workers.

It cannot be impossible
To learn that which is useful.
You are the very ones,
You in your daily occupations,
In whom the art of observing is naturally born.
For you it is of use
To know what the foreman can and cannot do,
To know also the ways of your mates exactly
And their thoughts.
How else save with a knowledge of men
Can you wage the fight of your class?
I see all the finest among you
Impatient for knowledge, making
Observation more keen
Thus adding again to itself.
Already the best of you learn
Those laws which govern
The living together of men,
Already your class makes ready
To overcome all that hindering you
Stands in the way of mankind.
Here is where you

Acting and working,
Learning and teaching,
Can intervene from your stage
In the struggles of our time.

You with the intentness of your studies
And the elation of your knowledge
Can make the experience of struggle
The property of all
And transform justice
Into a passion.

6.

Revolutionary Undoing: On Max Raphael's The Demands of Art

SOME FIGHT BECAUSE they hate what confronts them; others because they have taken the measure of their lives and wish to give meaning to their existence. The latter are likely to struggle more persistently. Max Raphael was a very pure example of the second type.

He was born near the Polish–German border in 1889. He studied philosophy, political economy and the history of art in Berlin and Munich. His first work was published in 1913. He died in New York in 1952. In the intervening forty years he thought and wrote incessantly. Only a fraction of his work has been published, and most of that is out of print and unobtainable. He left thousands of pages of manuscript which his widow and friends are ordering and hoping to publish. Their subject-matter ranges from palaeontology to classical architecture, from Gothic sculpture to Flaubert, from modern city planning to epistemology.

For five years I tried to interest European publishers in his work. In vain. A fact which I mention only because in a few decades it will be hard to remember how unknown and unrecognised Max Raphael still was in 1969.

His life was austere. He held no official academic post. He was forced several times to emigrate. He earned very little money. He

wrote and noted without cease. As he travelled, small groups of friends and unofficial students collected around him. By the cultural hierarchies he was dismissed as an unintelligible but dangerous Marxist: by the party communists as a Trotskyist. Unlike Spinoza he had no artisanal trade.

To appreciate the possible role of the book under review,[1] we must be clear about the present situation of the arts. (Nobody who is not prepared to grapple with fundamentals should approach the book.) It is a situation of extreme crisis. The validity of art itself is in question. There is not a significant artist in the world who is not asking himself whether his art is justified – not on account of the quality of his talent, but on account of the relevance of art to the demands of the time in which he is living.

Raphael quotes a remark of Cézanne's in the context of a quite different analysis:

> I paint my still lifes, these *natures mortes*, for my coachman who does not want them, I paint them so that children on the knees of their grandfathers may look at them while they eat their soup and chatter. I do not paint them for the pride of the Emperor of Germany or the vanity of the oil merchants of Chicago. I may get ten thousand francs for one of these dirty things, but I'd rather have the wall of a church, a hospital, or a municipal building.

Since 1848 every artist unready to be a mere paid entertainer has tried to resist the bourgeoisation of his finished work, the transformation of the spiritual value of his work into property value. This regardless of his political opinions as such. Cézanne's attempt, like that of all his contemporaries, was in vain. The resistance of later artists became more active and more violent – in that the resistance was built into their works. What Constructivism, Dadaism, Surrealism, and so on, all shared was their opposition to art-as-property and art-as-a-cultural-alibi-for-existing-society. We know the extremes to which they went:

1 Max Raphael, *The Demands of Art: With an Appendix 'Toward an Empirical Theory of Art'*, translated [from the German] by Norbert Guterman (London: Routledge & Kegan Paul, 1968).

the sacrifices they were prepared to make as creators; and we see that their resistance was as ineffective as Cézanne's.

In the last decade the tactics of resistance have changed. Less frontal confrontation. Instead, infiltration. Irony and philosophic scepticism. The consequences in Tachism, Pop Art, Minimal Art, Neo-Dada, and so on. But such tactics have been no more successful than earlier ones. Art is still transformed into the property of the property-owning class. In the case of the visual arts the property involved is physical; in the case of the other arts it is moral property.

Art historians with a social or Marxist formation have interpreted the art of the past in terms of class ideology. They have shown that a class, or groups in a class, tended to support and patronise art which to some degree reflected or furthered their own class values and views. It now appears that in the later stages of capitalism this has ceased to be generally true. Art is treated as a commodity whose meaning lies *only* in its rarity value and in its functional value as a stimulant of sensation. It ceases to have implications beyond itself. Works of art become objects whose essential character is like that of diamonds or sun-tan lamps. The determining factor of this development – internationalism of monopoly, powers of mass-media communication, level of alienation in consumer societies – need not concern us here. But the consequence does. *Art can no longer oppose what is.* The faculty of proposing an alternative reality has been reduced to the faculty of designing – more or less well – an object.

Hence the imaginative doubt in all artists worthy of their category. Hence the fact that the militant young begin to use 'art' as a cover for more direct action.

One might argue that artists should continue, regardless of society's immediate treatment of their work: that they should address themselves to the future, as all imaginative artists after 1848 have had to do. But this is to ignore the world-historical moment at which we have arrived. Imperialism, European hegemony, the moralities of capitalist-Christianity and state-communism, the Cartesian dualism of white reasoning, the practice of constructing 'humanist' cultures on a basis of monstrous exploitation – this entire interlocking system is now being challenged: a world struggle is being mounted against it. Those

who envisage a different future are obliged to define their position towards this struggle, obliged to choose. Such a choice tends to lead them either to impotent despair or to the conclusion that world liberation is the precondition for any new valid cultural achievement. (I simplify and somewhat exaggerate the positions for the sake of brevity.) Either way their doubts about the value of art are increased. An artist who now addresses the future does not necessarily have his faith in his vision confirmed.

In this present crisis, is it any longer possible to speak of the revolutionary meaning of art? This is the fundamental question. It is the question that Max Raphael begins to answer in *The Demands of Art*.

The book is based on some lectures that Raphael gave in the early 1930s to a modest adult education class in Switzerland under the title 'How Should One Approach a Work of Art?'. He chose five works and devoted a chapter of extremely thorough and varied analysis to each. The works are: Cézanne's *Mont Sainte-Victoire* of 1904–06 (the one in the Philadelphia Museum), Degas's etching of *Madame X Leaving Her Bath*, Giotto's *Dead Christ* (Padua) compared with his later *Death of Saint Francis* (Florence), a drawing by Rembrandt of *Joseph Interpreting Pharaoh's Dreams*, and Picasso's *Guernica*. (The chapter on *Guernica* was of course written later.) These are followed by a general chapter on 'The Struggle to Understand Art', and by an appendix of an unfinished but extremely important essay entitled 'Towards an Empirical Theory of Art', written in 1941. The editing, production and translating of the present volume – under the direction of two of Raphael's friends – are a model of an efficient labour of love.

I shall not discuss Raphael's analysis of the five individual works. They are brilliant, long, highly particularised and dense. The most I can do is to attempt a crude outline of his general theory.

A question which Marx posed but could not answer: If art in the last analysis is a superstructure of the economic base, why does its power to move us endure long after the base has been transformed? Why, asked Marx, do we still look towards Greek art as an ideal? He began to answer by speaking about the 'charm' of 'young children' (the young Greek civilisation), and then broke off the manuscript and was far too occupied ever to return to the question.

'A transitional epoch', writes Raphael,

always implies uncertainty: Marx's struggle to understand his own epoch testifies to this. In such a period two attitudes are possible. One is to take advantage of the emergent forces of the new order with a view to undermining it to affirm it in order to drive it beyond itself: this is the active, militant, revolutionary attitude. The other clings to the past, is retrospective and romantic, bewails or acknowledges the decline, asserts that the will to live is gone – in short, it is the passive attitude. Where economic, social, and political questions were at stake Marx took the first attitude; in questions of art he took neither.

He merely reflected his epoch.

Just as Marx's taste in art – the classical ideal excluding the extraordinary achievements of palaeolithic, Mexican, African art – reflected the ignorance and prejudice of art appreciation in his period, so his failure to create (though he saw the need to do so) a theory of art larger than that of the superstructure theory was the consequence of the continual, overwhelming primacy of economic power in the society around him.

In view of this lacuna in Marxist theory, Raphael sets out to 'develop a theory of art that I call empirical because it is based on a study of works of art from all periods and nations. I am convinced that mathematics, which has travelled a long way since Euclid, will someday provide us with the means of formulating the results of such a study in mathematical terms.' And he reminds the sceptical reader that before infinitesimal calculus was discovered even nature could not be studied mathematically.

'Art is an interplay, an equation of three factors – the artist, the world and the means of figuration.' Raphael's understanding of the third factor, the means or process of figuration, is crucial. For it is this process which permits him to consider the finished work of art as possessing a specific reality of its own.

Even though there is no such thing as a single, uniquely beautiful proportion of the human body or a single scientifically correct method of representing space, or one method only of artistic figuration, whatever form art may assume in the course of history, it is always a synthesis between nature (or history) and the mind, and as

such it acquires a certain autonomy vis-à-vis both these elements. This independence seems to be created by man and hence to possess a psychic reality; but in point of fact the process of creation can become an existent only because it is embodied in some concrete material.

The artist chooses his material – stone, glass, pigment, or a mixture of several. He then chooses a way of working it – smoothly, roughly, in order to preserve its own character, in order to destroy or transcend it. These choices are to a large measure historically conditioned. By working his material so that it represents ideas or an object, or both, the artist transforms raw material into 'artistic' material. What is represented is materialised in the worked, raw material; whereas the worked raw material acquires an immaterial character through its representations and the *unnatural* unity which connects and binds these representations together. 'Artistic' material, so defined, a substance half physical and half spiritual, is an ingredient of the material of figuration.

A further ingredient derives from the means of representation. These are colour, line and light-and-shade. Perceived in nature, these qualities are merely the stuff of sensation – undifferentiated from one another and arbitrarily mixed. The artist, in order to replace contingency by necessity, first separates the qualities and then combines them around a central idea or feeling which determines all their relations.

The two processes which produce the material of figuration (the process of transforming raw material into artistic material and the process of transforming the matter of sensation into means of representation) are continually interrelated. Together they constitute what might be called the matter of art.

Figuration begins with the separate long-drawn-out births of idea and motif, and is complete when the two are born and indistinguishable from one another.

The characteristics of the individual idea are:

1. It is simultaneously an idea and a feeling.
2. It contains the contrasts between the particular and the general,

the individual and the universal, the original and the banal.

3. It is a progression towards ever deeper meanings.
4. It is the nodal point from which secondary ideas and feelings develop.

'The motif is the sum total of line, colour and light by means of which the conception is realised.' The motif begins to be born apart from but at the same time as the idea because 'only in the act of creation does the content become fully conscious of itself'.

What is the relation between the pictorial (individual) idea and nature?

The pictorial idea separates usable from unusable elements of natural appearances and, conversely, study of natural appearances chooses from among all possible manifestations of the pictorial idea the one that is most adequate. The difficulty of the method comes down to 'proving what one believes' – 'proof' here consisting in this, that the opposed methodological starting points (experience and theory) are unified, brought together in a reality of a special kind, different from either, and that this reality owes its pictorial life to a motif adequate to the conception and developed compositionally.

What are the methods of figuration?
1. The structuring of space.
2. The rendering of forms within that space *effective*.

The structuring of space has nothing to do with perspective: its tasks are to dislocate space so that it ceases to be static (the simplest example is that of the forward-coming relaxed leg in standing Greek figures) and to divide space into quanta so that we become conscious of its divisibility, and thus cease to be the creatures of *its* continuity (for example, the receding planes parallel to the picture surface in late Cézannes). 'To create pictorial space is to penetrate not only into the depths of the picture but also into the depths of our intellectual system of co-ordinates (which matches that of the world). Depth of space is depth of essence or else it is nothing but appearance and illusion.'

The distinction between actual form and effective form is as follows: Actual form is descriptive; effective form is suggestive, i.e. through it the artist, instead of trying to convey the contents and feelings to the viewer by fully describing them, provides him only with as many clues as he needs to produce these contents and feelings within himself. To achieve this the artist must act not upon individual sense organs but upon the whole man, i.e. he must make the viewer live in the work's own mode of reality.

What does figuration, with its special material (see above), achieve?

Intensity of figuration is not display of the artist's strength; not vitality, which animates the outer world with the personal energies of the creative artist; not logical or emotional consistency, with which a limited problem is thought through or felt through to its ultimate consequences. What it does denote is the degree to which the very essence of art has been realised: the undoing of the world of things, the construction of the world of values, and hence the constitution of a new world. The originality of this constitution provides us with a general criterion by which we can measure intensity of figuration. Originality of constitution is not the urge to be different from others, to produce something entirely new; it is (in the etymological sense) the grasping of the origin, the roots of both ourselves and things.

One must distinguish here between Raphael's 'world of values' and the idealist view of art as a depository of transcendental values. For Raphael the values lie *in the activity* revealed by the work. The function of the work of art is to lead us from the work to the process of creation which it contains. This process is determined by the material of figuration, and it is within this material, which Raphael discloses and analyses with genius, that mathematics may one day be able to discover precise principles. The process is directed towards creating within the work a synthesis of the subjective and objective, of the conditional and the absolute within a totality governed by its own laws of necessity. Thus the world of things is replaced within the work by a hierarchy of values created by the process it contains.

I can give no indication here of the detailed, specific and

unabstract way in which Raphael applies his understanding to the five works he studies. I can only state that his eye and sensuous awareness were as developed as his mind. Reading him, one has the impression, however difficult the thought, of a man of unusual and stable balance.

Through the text of this book one can feel the profile of an austere thinker who belonged to the twentieth century because he was a dialectical materialist inheriting the main tradition of European philosophy, but who at the same time was a man whose vital constitution made it impossible for him to ignore the unknown, the as yet tentative, the explosive human potential which will always render man indefinable within any categorical system.

> Since we cannot know ourselves directly, but only through our actions, it remains more than doubtful whether our idea of ourselves accords with our real motives. But we must strive unremittingly to achieve this congruence. For only self-knowledge can lead to self-determination, and false self-determination would ruin our lives and be the most immoral action we could commit.

To return now to our original question: What is the revolutionary meaning of art? Raphael shows that the revolutionary meaning of a work of art has nothing to do with its subject matter in itself, or with the functional use to which the work is put, but is a meaning continually awaiting discovery and release:

> However strong a given historical tendency may be, man can and has the duty to resist it when it runs counter to his creative powers. There is no fate which decrees that we must be victims of technology or that art must be shelved as an anachronism; the 'fate' is merely misuse of technology by the ruling class to suppress the people's power to make its own history. To a certain extent it is up to every individual, by his participation in social and political life, to decide whether art shall or shall not become obsolete. The understanding of art helps raise this decision to its highest level. As a vessel formed by the creative forces which it preserves, the work of art keeps alive and enhances every urge to come to terms with the world.

We have said that art leads us from the work to the process of creation. This reversion, outside the theory of art, will eventually generate universal doubt about the world as given, the natural as well as the social. Instead of accepting things as they are, of taking them for granted, we learn, thanks to art, to measure them by the standard of perfection. The greater the unavoidable gulf between the ideal and the real, the more inescapable is the question: Why is the existing world the way it is? How has the world come to be what it is? *De omnibus rebus dubitandum est! Quid certum?* 'We must doubt all things! What is certain?' (Descartes). It is the nature of the creative mind to dissolve seemingly solid things and to transform the world as it is into a world in process of becoming and creating. This is how we are liberated from the multiplicity of things and come to realise what it is that all conditional things ultimately possess in common. Thus, instead of being creatures isolated among other isolated creatures we become part of the power that creates all things.

Raphael did not, could not, make our choices for us. Everyone must resolve for himself the conflicting demands of his historical situation. But even to those who conclude that the practice of art must be temporarily abandoned, Raphael will show as no other writer has ever done the revolutionary meaning of the works inherited from the past – and of the works that will be eventually created in the future. And this he shows without rhetoric, without exhortation, modestly and with reason. His was the greatest mind yet applied to the subject.

7.

Walter Benjamin: Antiquarian and Revolutionary

WALTER BENJAMIN WAS born of a bourgeois Jewish family in Berlin in 1892. He studied philosophy and became a kind of literary critic – a kind such as had never quite existed before. Every page, every object which attracted his attention, contained, he believed, a coded testament addressed to the present: coded so that its message should not become a straight highway across the intervening period blocked with the traffic of direct causality, the military convoys of progress and the gigantic pantechnicons of inherited institutionalised ideas.

He was at one and the same time a romantic antiquarian and an aberrant Marxist revolutionary. The structuring of his thought was theological and Talmudic; his aspirations were materialist and dialectical. The resulting tension is typically revealed in such a sentence as: 'The concept of life is given its due only if everything that has a history of its own, and is not merely the setting for history, is credited with life.'

The two friends who probably influenced him most were Gerhard Scholem, a Zionist professor of Jewish mysticism in Jerusalem, and Bertolt Brecht. His life-style was that of a financially independent nineteenth-century 'man of letters', yet he was never free of severe financial difficulties. As a writer he was obsessed with giving the objective

existence of his subject its full weight (his dream was to compose a book entirely of quotations); yet he was incapable of writing a sentence which does not demand that one accepts his own highly idiosyncratic procedure of thought. For example: 'What seems paradoxical about everything that is justly called beautiful is the fact that it appears.'

The contradictions of Walter Benjamin – and I have listed only some of them above – continually interrupted his work and career. He never wrote the full-length book he intended on Paris at the time of the Second Empire, seen architecturally, sociologically, culturally, psychologically, as the quintessential locus of mid-nineteenth-century capitalism. Most of what he wrote was fragmentary and aphoristic. During his lifetime his work reached a very small public and every 'school' of thought – such as might have encouraged and promoted him – treated him as an unreliable eclectic. He was a man whose originality precluded his reaching whatever was defined by his contemporaries as achievement. He was treated, except by a few personal friends, as a failure. Photographs show the face of a man rendered slow and heavy by the burden of his own existence, a burden made almost overwhelming by the rapid, instantaneous brilliance of his scarcely controllable insights.

In 1940 he killed himself for fear of being captured by the Nazis whilst trying to cross the French frontier into Spain. It is unlikely that he would have been captured. But from a reading of his works it appears likely that suicide may have seemed a natural end for him. He was very conscious of the degree to which a life is given form by its death; and he may have decided to choose that form for himself, bequeathing to life his contradictions still intact.

Fifteen years after Benjamin's death a two-volume edition of his writings was published in Germany, and he acquired a posthumous public reputation. In the last five years this reputation has begun to become international, and now there are frequent references to him in articles, conversation, criticism and political discussions.

Why is Benjamin more than a literary critic? And why has his work had to wait nearly half a century to begin to find its proper audience? In trying to answer these two questions, we will perhaps recognise more clearly the need in us which Benjamin now answers and which, never at home in his own time, he foresaw.

The antiquarian and the revolutionary can have two things in common: their rejection of the present as given and their awareness that history has allotted them a task. For them both history is vocational. Benjamin's attitude as a critic to the books or poems or films he criticised was that of a thinker who needed a fixed object before him in historic time, in order thereby to measure time (which he was convinced was not homogeneous) and to grasp the import of the specific passage of time which separated him and the work, to redeem, as he would say, that time from meaninglessness:

> Only that historian will have the gift of fanning the spark of hope in the past who is firmly convinced that *even the dead* will not be safe from the enemy (the ruling class) if he wins. And this enemy has not ceased to be victorious.

Benjamin's hypersensitivity to the dimension of time was not, however, limited to the scale of historical generalisation or prophecy. He was equally sensitive to the time-scale of a life –

> A *la Recherche du temps perdu* is the constant attempt to charge an entire lifetime with the utmost awareness. Proust's method is actualization, not reflexion. He is filled with the insight that none of us has time to live the true dramas of the life that we are destined for. This is what ages us – this and nothing else. The wrinkles and creases on our faces are the registration of the great passions, vices, insights that called on us; but we, the masters, were not home . . .

– or to the effect of a second. He is writing about the transformation of consciousness brought about by the film:

> Our taverns and our metropolitan streets, our offices and furnished rooms, our railroad stations and our factories appeared to have us locked up hopelessly. Then came the film and burst this prison-world asunder by the dynamite of the tenth of a second, so that now, in the midst of its far-flung ruins and debris, we calmly and adventurously go travelling. With the close-up, space expands; with slow motion, movement is extended.

I do not wish to give the impression that Benjamin used works of art or literature as convenient illustrations of already formulated arguments. The principle that works of art are not for use but only for judgment, that the critic is an impartial go-between between the utilitarian and the ineffable, this principle, with all its subtler and still current variations, represents no more than a claim by the privileged that their love of passive pleasure must be considered disinterested! Works of art await use. But their real usefulness lies in what they actually are – which may be quite distinct from what they once were – rather than in what it may be convenient to believe they are. In this sense Benjamin used works of art very realistically. The passage of time which so intrigued him did not end at the exterior surface of the work; it entered into it and there led him into its 'after-life'. In this after-life, which begins when the work has reached 'the age of its fame', the separatedness and isolated identity of the individual work is transcended just as was meant to happen to the soul in the traditional Christian heaven. The work enters the totality of what the present consciously inherits from the past, and in entering that totality it changes it. The after-life of Baudelaire's poetry is not only coexistent with Jeanne Duval, Edgar Allan Poe and Constantin Guys but also, for example, with Haussmann's boulevards, the first department stores, Engels's descriptions of the urban proletariat, and the birth of the modern drawing-room in the 1830s which Benjamin described as follows:

> For the private citizen, for the first time the living-space became distinguished from the place of work. The former constituted itself as the interior. The counting-house was its complement. The private citizen who in the counting-house took reality into account required of the interior that it should maintain him in his illusions. This necessity was all the more pressing since he had no intention of adding social preoccupations to his business ones. In the creation of his private environment he suppressed them both. From this sprang the phantasmagorias of the interior. This represented the universe for the private citizen. In it, he assembled the distant in space and in time. His drawing-room was a box in the world theatre.

Perhaps it is now a little clearer why Benjamin was more than a literary critic. But one more point needs to be made. His attitude to works of

art was never a mechanically social-historical one. He never tried to seek simple causal relations between the social forces of a period and a given work. He did not want to explain the appearance of the work; he wanted to discover the place that its existence needed to occupy in our knowledge. He did not wish to encourage a love of literature; he wanted the art of the past to realise itself in the choices men make today in deciding their own historical role.

Why is it only now that Benjamin begins to be appreciated as a thinker, and why is his influence likely to increase still further in the 1970s? The awakened interest in Benjamin coincides with Marxism's current re-examination of itself; this re-examination is occurring all over the world, even where it is treated as a crime against the state.

Many developments have led to the need for re-examinations: the extent and degree of the pauperisation and violence which imperialism and neo-colonialism inflict upon an ever-increasing majority in the world; the virtual depoliticisation of the people of the Soviet Union: the re-emergence of the question of revolutionary *democracy* as primary; the achievements of China's *peasant* revolution; the fact that the proletariats of consumer societies are now less likely to arrive at revolutionary consciousness through the pursuit of their directly economic self-interests than through a wider and more generalised sense of pointless deprivation and frustration; the realisation that socialism, let alone communism, cannot be fully achieved in one country so long as capitalism exists as a global system, and so on.

What the re-examinations will entail, in terms of both theory and political practice, cannot be foreseen in advance or from outside the specific territories involved. But we can begin to define the interregnum – the period of re-examination – in relation to what actually preceded it, whilst leaving sensibly aside the claims and counter-claims concerning what Marx himself really meant.

The interregnum is anti-deterministic, both as regards the present being determined by the past and the future by the present. It is sceptical of so-called historical laws, as it is also sceptical of any supra-historical value, implied by the notion of overall Progress or Civilisation. It is aware that excessive personal political power always depends for its survival upon appeals to an impersonal destiny: that

every true revolutionary act must derive from a personal hope of being able to contest in that act the world as it is. The interregnum exists in an invisible world, where time is short, and where the immorality of the conviction that ends justify means lies in the arrogance of the assumption that time is always on one's own side and that, therefore, the present moment – the time of the Now, as Benjamin called it – can be compromised or forgotten or denied.

Benjamin was not a systematic thinker. He achieved no new synthesis. But at a time when most of his contemporaries still accepted logics that hid the facts, he foresaw our interregnum. And it is in this context that thoughts like the following from his *Theses on the Philosophy of History* apply to our present preoccupations:

> The true picture of the past flits by. The past can be seized only as an image which flashes up at the instant when it can be recognized and is never seen again. 'The truth will not run away from us': in the historical outlook of historicism these words of Gottfried Keller mark the exact point where historical materialism cuts through historicism. For every image of the past that is not recognized by the present as one of its own concerns threatens to disappear irretrievably.
>
> A historical materialist cannot do without the notion of a present which is not a transition, but in which time stands still and has come to a stop. For this notion defines the present in which he himself is writing history.
>
> Whoever has emerged victorious participates to this day in the triumphal procession in which the present rulers step over those who are lying prostrate. According to traditional practice, the spoils are carried along in the procession. They are called cultural treasures, and a historical materialist views them with cautious detachment. For without exception the cultural treasures he surveys have an origin which he cannot contemplate without horror. They owe their existence not only to the efforts of the great minds and talents who have created them, but also to the anonymous toil of their contemporaries. There is no document of civilisation which is not at the same time a document of barbarism.

8.

The Storyteller

NOW THAT HE has gone down, I can hear his voice in the silence. It carries from one side of the valley to the other. He produces it effortlessly, and, like a yodel, it travels like a lasso. It turns to come back after it has attached the hearer to the shouter. It places the shouter at the centre. His cows respond to it as well as his dog. One evening two cows were missing after we had chained them all in the stable. He went and called. The second time he called, the two cows answered from deep in the forest, and a few minutes later they were at the stable door, just as night fell.

The day before he went down, he brought the whole herd back from the valley at about two in the afternoon – shouting at the cows, and at me to open the stable doors. Muguet was about to calve – the two forefeet were already out. The only way to bring her back was to bring the whole herd back. His hands were trembling as he tied the rope round the forefeet. Two minutes pulling and the calf was out. He gave it to Muguet to lick. She mooed, making a sound a cow never makes on other occasions – not even when in pain. A high, penetrating, mad sound. A sound stronger than complaint, and more urgent than greeting. A little like an elephant trumpeting. He fetched the straw to bed the calf on. For him these moments are moments of triumph: moments of true gain: moments which unite the foxy,

ambitious, hard, indefatigable, seventy-year-old cattle-raiser with the universe which surrounds him.

After working each morning we used to drink coffee together and he would talk about the village. He remembered the date and the day of the week of every disaster. He remembered the month of every marriage of which he had a story to tell. He could trace the family relations of his protagonists to their second cousins by marriage. From time to time I caught an expression in his eyes, a certain look of complicity. About what? About something we share despite the obvious differences. Something that joins us together but is never directly referred to. Certainly not the little work I do for him. For a long time I puzzled over this. And suddenly I realised what it was. It was his recognition of our equal intelligence; we are both historians of our time. We both see how events fit together.

In that knowledge there is – for us – both pride and sadness. Which is why the expression I caught in his eyes was both bright and consoling. It was the look of one storyteller to another. I am writing on pages like these which he will not read. He sits in the corner of his kitchen, his dog fed, and sometimes he talks before he goes to bed. He goes to bed early after drinking his last cup of coffee for the day. I am seldom there, and unless he were personally telling me the stories I wouldn't understand them because he speaks in patois. The complicity remains, however.

I have never thought of writing as a profession. It is a solitary independent activity in which practice can never bestow seniority. Fortunately anyone can take up the activity. Whatever the motives, political or personal, which have led me to undertake to write something, the writing becomes, as soon as I begin, a struggle to give meaning to experience. Every profession has limits to its competence, but also its own territory. Writing, as I know it, has no territory of its own. The act of writing is nothing except the act of approaching the experience written about; just as, hopefully, the act of reading the written text is a comparable act of approach.

To approach experience, however, is not like approaching a house. Experience is indivisible and continuous, at least within a single lifetime and perhaps over many lifetimes. I never have the impression that my experience is entirely my own, and it often seems to me that it

preceded me. In any case experience folds upon itself, refers backwards and forwards to itself through the referents of hope and fear; and, by the use of metaphor which is at the origin of language, it is continually comparing like with unlike, what is small with what is large, what is near with what is distant. And so the act of approaching a given moment of experience involves both scrutiny (closeness) and the capacity to connect (distance). The movement of writing resembles that of a shuttlecock: repeatedly it approaches and withdraws, closes in and takes its distance. Unlike a shuttlecock, however, it is not fixed to a static frame. As the movement of writing repeats itself, its nearness to, its intimacy with the experience increases. Finally, if one is fortunate, meaning is the fruit of this intimacy.

For the old man, who talks, the meaning of his stories is more certain but no less mysterious. Indeed the mystery is more openly acknowledged. I will try to explain what I mean by that.

All villages tell stories. Stories of the past, even of the distant past. As I was walking in the mountains with another friend of seventy by the foot of a high cliff, he told me how a young girl had fallen to her death there, whilst hay-making on the alpage above. Was that before the war? I asked. In about 1800 (no misprint), he said. And stories of the very same day. Most of what happens during a day is recounted by somebody before the day ends. The stories are factual, based on observations or on an account given by somebody else. A combination of the sharpest observation of the daily recounting of the day's events and encounters, and of life-long mutual familiarities is what constitutes so-called village *gossip*. Sometimes there is a moral judgment implicit in the story, but this judgment – whether just or unjust – remains a detail: the story *as a whole* is told with some tolerance because it involves those with whom the storyteller and listener are going to go on living.

Very few stories are narrated either to idealise or condemn; rather they testify to the always slightly surprising range of the possible. Although concerned with everyday events, they are mystery stories. How is it that C, who is so punctilious in his work, overturned his haycart? How is it that L is able to fleece her lover J of everything, and how is it that J, who normally gives nothing away to anybody, allows himself to be fleeced?

The story invites comment. Indeed it creates it, for even total silence is taken as a comment. The comments may be spiteful or bigoted, but, if so, they themselves will become a story and thus, in turn, become subject to comment. How is it that F never lets a single chance go by of damning her brother? More usually the comments, which add to the story, are intended and taken as the commentator's personal response – in the light of that story – to the riddle of existence. Each story allows everyone to define himself.

The function of these stories, which are, in fact, close, oral, daily history, is to allow the whole village to define itself. The life of a village, as distinct from its physical and geographical attributes, is the sum of all the social and personal relationships existing within it, plus the social and economic relations – usually oppressive – which link the village to the rest of the world. But one could say something similar about the life of some large town. Even of some cities. What distinguishes the life of a village is that it is also *a living portrait of itself*: a communal portrait, in that everybody is portrayed and everybody portrays; and this is only possible if everybody knows everybody. As with the carvings on the capitals in a Romanesque church, there is an identity of spirit between what is shown and how it is shown – as if the portrayed were also the carvers. A village's portrait of itself is constructed, not out of stone, but out of words, spoken and remembered: out of opinions, stories, eyewitness reports, legends, comments and hearsay. And it is a continuous portrait; work on it never stops.

Until very recently the only material available to a village and its peasants for defining themselves was their own spoken words. The village's portrait of itself was – apart from the physical achievements of their work – the only reflection of the meaning of their existence. Nothing and nobody else acknowledged such a meaning. Without such a portrait – and the 'gossip' which is its raw material – the village would have been forced to doubt its own existence. Every story and every comment on the story which is a proof that the story has been *witnessed* contributes to the portrait, and confirms the existence of the village.

This continuous portrait, unlike most, is highly realistic, informal and unposed. Like everybody else, and perhaps more so, given the insecurity of their lives, peasants have a need for formality, and this

formality is expressed in ceremony and ritual; but as makers of their own communal portrait they are informal because this informality corresponds closer to the truth: the truth which ceremony and ritual can only partially control. All weddings are similar but every marriage is different. Death comes to everyone but one mourns alone. That is the truth.

In a village, the difference between what is known about a person and what is unknown is slight. There may be a number of well-guarded secrets but, in general, deceit is rare because impossible. Thus there is little inquisitiveness, in the prying sense of the term, for there is no great need for it. Inquisitiveness is the trait of the city *concierge* who can gain a little power or recognition by telling X what he doesn't know about Y. In the village X already knows it. And thus too there is little performing: peasants do not *play roles* as urban characters do.

This is not because they are 'simple' or more honest or without guile, it is simply because the space between what is unknown about a person and what is generally known – and this is the space for all performance – is too small. When peasants play, they play practical jokes. As when four men, one Sunday morning when the village was at mass, fetched all the wheelbarrows used for cleaning out the stables and lined them up outside the church porch so that as each man came out he was obliged to find his barrow and wheel it, he in his Sunday clothes, through the village street! This is why the village's continual portrait of itself is mordant, frank, sometimes exaggerated but seldom idealised or hypocritical. And the significance of this is that hypocrisy and idealisation close questions, whereas realism leaves them open.

There are two forms of realism. Professional and traditional. Professional realism, as a method chosen by an artist or a writer like myself, is always consciously political; it aims to shatter an opaque part of the ruling ideology, whereby, normally, some aspect of reality is consistently distorted or denied. Traditional realism, always popular in its origins, is in a sense more scientific than political. Assuming a fund of empirical knowledge and experience, it poses the riddle of the unknown. How is it that . . . ? Unlike science it can live without the answer. But its experience is too great to allow it to ignore the question.

Contrary to what is usually said, peasants are interested in the world beyond the village. Yet it is rare for a peasant to remain a peasant and be

able to move. He has no choice of locality. His place was a given at the very moment of his conception. And so if he considers his village the centre of the world, it is not so much a question of parochialism as a phenomenological truth. His world has a centre (mine does not). He believes that what happens in the village is typical of human experience. This belief is only naive if one interprets it in technological or organisational terms. He interprets it in terms of the species *man*. What fascinates him is the typology of human characters in all their variations, and the common destiny of birth and death, shared by all. Thus the foreground of the village's living portrait of itself is extremely specific, whilst the background consists of the most open, general, and never entirely answerable questions. Therein is the acknowledged mystery.

The old man knows that I know this as sharply as he does.

9.

Ernst Fischer: A
Philosopher and Death

IT WAS THE last day of his life. Of course, we did not know it then – not until almost ten o'clock in the evening. Three of us spent the day with him: his wife Lou, Anya and myself.

Ernst Fischer was in the habit of spending the summer in a small village in Styria. He and Lou stayed in the house of three sisters who were old friends and who had been Austrian communists with Ernst and his two brothers in the 1930s. The youngest of the three sisters, who now runs the house, was imprisoned by the Nazis for hiding and aiding political refugees. The man with whom she was then in love was beheaded for a similar political offence.

It often rains in Styria; and if you are in this house, you sometimes have the impression that it is still raining after it has stopped, on account of the sound of water in the garden. Yet the garden is not damp, and many colours of many flowers break up its greenness. The garden is a kind of sanctuary. But to grasp its full meaning one must, as I said, remember that in its outhouses men and women were hiding for their lives thirty years ago, and were protected by the three sisters who now arrange vases of flowers and let rooms to a few old friends in the summer in order to make ends meet.

When I arrived in the morning, Ernst was walking in the garden. He was thin and upright. And he trod very lightly, as though his weight, such as it was, was never fully planted on the ground. He wore a wide-brimmed white-and-grey hat, which Lou had recently bought for him. He wore the hat like he wore all his clothes, lightly, elegantly, but without concern. He was fastidious – not about details of dress, but about the nature of appearances.

He took present pleasures at their full face-value, and his capacity to do this was in no way diminished by political disappointment or by the bad news which since 1968 had persistently arrived from so many places. He was a man without a trace, without a line on his face, of bitterness. Some, I suppose, might therefore call him an innocent. They would be wrong. He was a man who refused to jettison or diminish his very high quotient of belief. Recently, he *believed* in scepticism.

It is the surety and strength of his convictions which now make it seem that he died so suddenly. His health was frail since childhood. He was often ill. Recently, his eyesight began to fail, and he could read only with a powerful magnifying glass – more often Lou read to him. Yet, despite this, it was quite impossible for anyone who knew him to suppose that he was dying slowly, that every year he belonged a little less vehemently to life. He was fully alive because he was fully convinced.

What was he convinced of? His books, his political interventions, his speeches, are there on record to answer the question. Or do they not answer it fully enough? He was convinced that capitalism would eventually destroy man – or be overthrown. He had no illusions about the ruthlessness of the ruling class everywhere. He recognised that we lacked a model for socialism. He was impressed by, and highly interested in, what is happening in China; but he did not believe in a Chinese model. What is so hard, he said, is that we are forced back to offering visions.

We walked towards the end of the garden, where there is a small lawn surrounded by bushes and a willow tree. He used to lie there talking with animated gestures, fingers plucking, hands turning out and drawing in – as though, literally, winding the wool from off his listeners' eyes. As he talked, his shoulders bent forward to follow his hands; as he listened, his head inclined forward to follow the speaker's words. Now the same lawn, with the deck-chairs piled in the outhouse, appears oppressively, flagrantly empty.

It had already begun to rain, and so we went to sit in his room for a while before going out to lunch. We used to sit, the four of us, round a small round table, talking. Sometimes I faced the window and looked out at the trees and the forests on the hills. That morning, I pointed out that, when the frame with the mosquito net was fitted over the window, everything looked more or less two-dimensional and so composed itself. We give too much weight to space, I went on – there's perhaps more of nature in a Persian carpet than in most landscape paintings. We'll take the hills down, push the trees aside and hang up carpets for you, said Ernst.

We were going to have lunch in a *pension* up in the hills. The idea was to look and see whether it would be suitable for Ernst to work there during September or October. Earlier in the year Lou had written to dozens of small hotels and boarding houses, and this was the only one which was cheap and sounded promising. They wanted to take advantage of my having a car to go and have a look.

Two days after his death, there was a long article about him in *Le Monde*. 'Little by little', it said, 'Ernst Fischer had established himself as one of the most original and rewarding thinkers of "heretical" Marxism . . .' He had influenced an entire generation of the left in Austria. During the last four years he was continually denounced in Eastern Europe for the significant influence he had had on the thinking of the Czechs who had created the Prague Spring. His books were translated into most languages.

But the conditions of his life during the last five years were cramped and harsh. The Fischers had little money, were always subject to financial worries, and lived in a small, noisy workers' flat in Vienna. Why not? I hear his opponents ask. Was he better than the workers? No, but he needed professional working conditions. In any case, he himself did not complain. But with the unceasing noise of families and radios in the flats above and on each side, he found it impossible to work as concentratedly in Vienna as he wished to do and was capable of doing. Hence the annual search for quiet, cheap places in the country – where three months might represent so many chapters completed. The three sisters' house was not available after August.

We drove up a steep dust road through the forest and we found the *pension*. The young woman and her husband were expecting us, and

they showed us to a long table where some other guests were already eating. The room was a large one, with a bare wooden floor and big windows, from which you looked over the shoulders of some nearby steep fields, across the forest, to the plain below. It was not unlike a canteen in a youth hostel, except that there were cushions on the benches and flowers on the tables. The two bedrooms were identical, side by side, with the lavatory on the same landing opposite them. Each room was narrow, with a bed against the wall, a washbasin, an austere cupboard, and at the end of it the window with a view of miles and miles of landscape. You can put a table in front of the window and work here. Yes, yes, he said. You'll finish the book. Perhaps not all of it, but I could get much done. You must take it, I said.

We went for a walk together, the walk into the forest he would take each morning. I asked him why in the first volume of his memoirs he wrote in several distinctly different styles.

Each style belongs to a different person.

To a different aspect of yourself?

No, rather, it belongs to a different self.

Do these different selves coexist, or, when one is predominant, are the others absent?

They are present together at the same time. None can disappear. The two strongest are my violent, hot, extremist, romantic self and the other my distant, sceptical self.

Do they discourse together in your head?

No.

(He had a special way of saying no. As if he had long ago considered the question at length, and after much patient investigation had then arrived at the answer.)

They watch each other, he continued. The sculptor, Hrdlicka, has done a head of me in marble. It makes me look much younger than I am. But you can see these two predominant selves in me – each corresponding to a side of my face. One is perhaps a little like Danton, the other a little like Voltaire.

As we walked along the forest path, I changed sides so as to examine his face, first from the right and then from the left. Each eye was different, and was confirmed in its difference by the corner of the mouth on its side of his face. The right side was tender and wild. He

69

had mentioned Danton. But I thought rather of an animal: perhaps a kind of goat, light on its feet; a chamois, maybe. The left side was sceptical but harsher: it made judgments but kept them to itself; it appealed to reason with an unswerving certainty. The left side would have been inflexible had it not been compelled to live with the right. I changed sides again to check my observations.

And have their relative strengths always been the same? I asked.

The sceptical self has become stronger, he said. But there are other selves, too. He smiled at me, and took my arm, and added as though to reassure me: its hegemony is not complete.

He said this a little breathlessly and in a slightly deeper voice than usual; in the voice in which he spoke when moved – for example, when embracing a person he loved.

His walk was very characteristic. His hips moved stiffly, but otherwise he walked like a young man, quickly, lightly, to the rhythm of his own reflections. The present book, he said, is written in a consistent style – detached, reasoning, cool.

Because it comes later?

No, because it is not really about myself. It is about a historical period. The first volume is also about myself, and I could not have told the truth if I had written it all in the same voice. There was no self which was above the struggle of the others and could have told the story evenly. The categories we make between different aspects of experience – so that, for instance, some people say I should not have spoken about love *and* about the Comintern in the same book – these categories are mostly there for the convenience of liars.

Does one self hide its decisions from the others?

Maybe he didn't hear the question. Maybe he wanted to say what he said, whatever the question.

My first decision, he said, was not to die. I decided when I was a child, in a sickbed, with death at hand, that I wanted to live.

On the way back through Graz, I stopped at a bookshop to find Ernst a copy of some poems by the Serbian poet, Miodrag Pavlović. Ernst had said some time during the afternoon that he no longer wrote poems and no longer saw the purpose of poetry. It may be, he added, that my idea of poetry is outdated. I wanted him to read Pavlović's poems. I gave him the book in the car. I already have it, he

said. But he put his hand on my shoulder. For the last time without suffering.

We were going to have supper in the café in the village. On the stairs outside his room, Ernst, who was behind me, suddenly but softly cried out. I turned round immediately. He had both his hands pressed to the small of his back. Sit down, I said, lie down. He took no notice. He was looking past me into the distance. His attention was there, not here. At the time I thought this was because the pain was bad. But it seemed to pass quite quickly. He descended the stairs – no more slowly than usual. The three sisters were waiting at the front door, to wish us goodnight. We stopped a moment to talk. Ernst explained his rheumatism had jabbed him in the back.

There was a curious distance about him. Either he consciously suspected what had happened, or else the chamois in him, the animal that was so strong in him, had already left to look for a secluded place in which to die. I question whether I am now using hindsight. I am not. He was already distant.

We walked, chatting, through the garden past the sounds of water. In the public bar of the café, we sat at our usual table. Some peasants were having their evening drink. They went out. The landlord, a man only interested in stalking and shooting deer, who is mean in his café, switched off two of the lights and went out to fetch our soup. Lou was furious and shouted after him. He didn't hear. She got up, went behind the bar and switched on the two lights again. I would have done the same, I said. Ernst smiled at Lou and then at Anya and me. If you and Lou lived together, he said, it would be explosive.

When the next course came, Ernst was unable to eat it. The landlord came up to inquire whether it was not good. It is excellently prepared, said Ernst, holding up the untouched plate of food in front of him, and excellently cooked, but I am afraid that I cannot eat it. He looked pale, and he said he had pains in the lower part of his stomach.

Let us go back, I said. Again he appeared – in response to the suggestion – to look into the distance. Not yet, he said, in a little while.

We finished eating. He was unsteady on his feet, but he insisted on standing alone. On the way to the door, he placed his hand on my shoulder – as he had in the car. But it expressed something very different. And the touch of his hand was now even lighter.

After we had driven a few hundred metres, he said: I think I may be going to faint. I stopped and put my arm round him. His head fell on my shoulder. He was breathing in short gasps. With his left, sceptical eye he looked hard up into my face. A sceptical, questioning, unswerving look. Then his look became unseeing.

Anya flagged down a passing car, and went back to the village to fetch help. She came back in another car. When she opened the door of our car, Ernst tried to move his feet out. It was his last instinctive movement – to be ordered, willed, neat.

When we reached the house, the news had preceded us; and the gates were already open, so that we could drive up to the front door.

The young man who had brought Anya back from the village carried Ernst indoors and upstairs over his shoulders. I walked behind to stop his head banging against the door-jambs. We laid him down on his bed. We did helpless things to occupy ourselves whilst waiting for the doctor. But even waiting for the doctor was a pretext. There was nothing to do. We massaged his feet, we fetched a hot-water bottle, we felt his pulse. I stroked his cold head. His brown hands on the white sheet, curled up but not grasping, looked quite separate from the rest of his body. They appeared cut off by his cuffs. Like the forefeet cut off from an animal found dead in the forest.

The doctor arrived. A man of fifty. Tired, pale-faced, sweating. He wore a peasant's suit without a tie. He was like a veterinary surgeon. Hold his arm, he said, whilst I give this injection. He inserted the needle finely in the vein, so that the liquid should flow along it like the water along the barrel pipe in the garden. At this moment we were alone in the room together. The doctor shook his head. How old is he? Seventy-three. He looks older, he said.

He looked younger when he was alive, I said.

Has he had a blocked blood vessel before?

Yes.

He has no chance this time, he said.

Lou, Anya, the three sisters and I stood around his bed. He had gone.

Besides painting scenes from everyday life on the walls of their tombs, the Etruscans carved on the lid of their sarcophagi full-length figures representing the dead. Usually these figures are half-reclining,

raised on one elbow, feet and legs relaxed as though on a couch, but head and neck alert as they gaze into the distance. Many thousands of such carvings were executed quickly, and more or less according to a formula. But however stereotyped the rest of the figure, their alertness as they look into the distance is striking. Given the context, the distance is surely a temporal rather than spatial one: the distance is the future the dead projected when alive. They look into that distance as though they could stretch out a hand and touch it.

I can make no sarcophagus carving. But there are pages written by Ernst Fischer where it seems to me that the writer wrote adopting an equivalent stance, achieving a similar quality of expectation.

10.

Gabriel García Márquez: The Secretary of Death Reads It Back

THE DAY BEFORE yesterday a close friend of mine killed himself by blowing his brains out. Today in my head his death assembles a thousand memories of his life, which I now see, not perhaps more clearly, but more truthfully than before. Life, being lived, always tends to simplify; hence one of the reasons why a certain kind of story is told to contest the opportunism of these simplifications. In one sense a story does not go anywhere, it just *is* – as my departed friend now is in my imagination.

These simple thoughts are relevant to Márquez's new book whether one considers its story or its form of storytelling. I want principally to consider the latter because Márquez is an exemplary storyteller in a tradition which to us in our NATO culture has become rare. By understanding better Márquez's storytelling, we can perhaps learn more about most people in the world and even about our own future, when our culture falls apart.

Like his others, this story is set somewhere round about Colombia, the country where Márquez was born. It is short, a mere 120 pages. Like his last book, *The Autumn of the Patriarch*, this one is about a death, a violent one.

The narrative, told with the hindsight of today, describes what happened between 5.30 and 6.30 one morning, in February a quarter

of a century ago, when Santiago Nasar, of Arab descent, is knifed to death whilst hungover after the previous night's wedding revels, and after the bride had been discovered by the sad groom not to have been a virgin; knifed to death against one of the two doors of his own house which inadvertently his mother, usually so clairvoyant about her son's dreams, had ordered to be bolted, thus cutting off his only means of escape from the two brothers Vicario with their pig-slaughtering knives, who had been forced by honour (notwithstanding all their attempts to let their victim be forewarned and thus to escape) to kill the man whom in a moment of truthfulness or aberration – who knows? – their sister Angela, the bride, had just named that night as the one who had deflowered her.

The story is more austere than any of his others. It is written as though by an investigator who is anxious to find out the simplest truth. But because it is not a Protestant Western book, the model for the investigator is not that of a detective but rather that of a hieroglyphist. The lines of inquiry are centred, like the petals of a daisy, round their capitulum, which is the moment of the assassination against the door. Everything is centred on that instant when Santiago Nasar, twenty-one years old, ranch-owner, falconer, cries out for his mother for the last terrible time.

And with all his short, slender petals of inquiry, what is it that Márquez hopes to find out? Never psychological motivation. Never legal guilt or innocence. Never a process of cause and effect. Never the pathology of drunkenness or sexuality. Never a story of success or failure. He simply wants to establish what *may* have happened that early morning in the public square when the town was already awake and out in the streets: because if he establishes this and if he allows us, his listeners, to grasp what may have happened, it is possible that the destiny of all those involved – Nasar, his fiancée, his mother, the two brothers reluctantly avenging the honour of their sister, the bride and bridegroom – will be mounted (like a stone in a ring) in all its mystery. Detective stories set out to solve mysteries. *Chronicle of a Death Foretold* sets out to preserve one.

> For years we couldn't talk about anything else. Our daily conduct, dominated then by so many linear habits, had suddenly begun to

spin around a single common anxiety. The cocks of dawn would catch us trying to give order to the chain of many chance events that had made absurdity possible, and it was obvious that we weren't doing it from an urge to clear up mysteries but because none of us could go on living without an exact knowledge of the place and the mission assigned to us by fate.

Of my contemporaries, Márquez is the one I admire the most. Perhaps this is not disinterested. In some countries critics have compared my own recent fiction with his, and it is true that I see him not as a critic but as a colleague in an art of storytelling.

But which art? Márquez sets out to preserve a mystery. Does this mean that he is an obscurantist, profiting from, or enjoying, mystification for its own sake? Such an accusation would be absurd; he is also a highly professional journalist committed to exposing ideological myths and to the struggle for the democratic right to know. He speaks of 'the mission assigned to us by fate'. Yet undoubtedly his sense of history is Marxist. What is the form and tradition of storytelling which reconciles what we have been taught to think of as such irreconcilable contradictions?

A moment's reflection shows that any story drawn from life begins, for the storyteller, with its end. The story of Dick Whittington becomes that story when he has at last become mayor of London. The story of Romeo and Juliet first begins as a story after they are dead. Most, if not all, stories begin with the death of the principal protagonist. It is in this sense that one can say that storytellers are Death's secretaries. It is Death who hands them the file. The file is full of sheets of uniformly black paper, but they have eyes for reading them, and from this file they construct a story for the living. Here the question of invention, so much insisted upon by certain schools of modern critics and professors, becomes patently absurd. All that the storyteller needs or has is the capacity to read what is written in black.

I think of Rembrandt's painting in The Hague of the blind Homer; it is the supreme image of such a secretary. And I like to think of a photograph of Gabriel García, with his bon vivant's face and scurrilous energy, beside it. There is nothing pretentious in this comparison: we, Death's secretaries, all carry the same sense of duty, the same

oblique shame (we have survived, the best have departed) and the same obscure pride which belongs to us personally no more than do the stories we tell. Yes, I like to think of that photo beside that painting.

It is significant that this book is called a chronicle. The tradition of storytelling of which I am speaking has little to do with that of the *novel*. The chronicle is public and the novel is private. The chronicle, like the epic poem, retells more memorably what is already generally known; the novel, by contrast, reveals what is secret in a family of private lives. The novelist surreptitiously beckons the reader into the private home and there, their fingers to their lips, they watch together. The chronicler tells his story in the market-place and competes with the clamour of all the other vendors: his occasional triumph is to create a silence around his words.

Thus novelist and storyteller are distinct, and it is obvious that they belong to different historical periods, confronting or collaborating with different ruling classes. Yet there is an internal distinction, too, which concerns the tense of the narrative. Novels begin with the drama of hope: their protagonists' hopes for their lives. The novel as a form does not lend itself to the telling of the lives of the absolutely underprivileged. (Dickens *rescues* the most destitute of his characters so that they can become characters in a novel.) And so the tenses of the novel or, rather, the tenses of the reader's heart as he reads a novel, are those of the future or the conditional. Novels are about Becoming.

The tense of the chronicle, the narrative of the storyteller, is the historic present. The story refers insistently to what is over, but it refers to it in such a way that, although it is over, it can be retained. This retaining is not so much a question of recollection as of coexistence, the past with the present. Epic chronicles are about Being. The capitulum of Santiago Nasar's assassination, that moment at 6.30 a.m. twenty-five years ago, is still present.

Perhaps this makes the story sound portentous. Those who know Márquez's writings will find this hard to believe, and they are right. Indeed, of all his books, this one is the most everyday, the most ordinary. All the characters are small-town petit-bourgeois. Their daily preoccupations are short-sighted and trivial. There is not a single noble appeal in the book. When he goes to meet his death, Santiago

Nasar (who in my opinion did not seduce Angela and was to die absurdly for an act that he never committed) is still calculating with a kind of idle curiosity – in a few seconds' time this idleness will acquire the quality of a paradise – is still calculating exactly how much the previous night's wedding celebrations have cost the bridegroom.

Nevertheless everyone in the story (in life was it different?) has another dimension, a dignity which has nothing to do with power, but with the way they live their fate. This implies neither passivity nor the abnegation of choice. The notion of fate confuses the Western novelist only because he conceives of it as existing in the same time as free will. It exists in a different time where, quite literally, all has been said and done.

To put it now very simply: this is a story about people and told to people who still believe that life is a story. Nobody chooses their story. Yet, by definition, a story whether lived or heard has a meaning. To ask whether this meaning is objective or subjective is already to move outside the circle of listeners. To ask what the meaning is is to ask for the unsayable. Nevertheless the faith in meaning promises one thing: meaning has to be shareable. Such stories begin with mortality, but they never end with solitude. When Santiago Nasar cries for the last time for his mother, he is suffering a terrible loneliness. For more than twenty years Angela will live alone with her secret and her memories. Finally her wronged and unhappy husband, who has received from her thousands of letters, not one of which he opened, comes back to live with her – such was their loneliness during those years. There is bitter loneliness but there is no solitude, for all are engaged in an unending common struggle to glimpse through and beyond the absurd. Everyone is reading, but not a book. As I am reading the life of my friend who killed himself, I think, when he was happiest.

11.

Roland Barthes: Inside the Mask

IN FRANCE THERE is a paperback series of illustrated books about writ-
ers – ranging from Aristophanes to Pasternak.[1] Each volume is both a
biography and a selection of quotations. Costing just over £1, these
books are addressed to a wide public and their purpose – aided by the
illustrations – is to offer this public the chance of making the writer's
acquaintance. The notion of the family scrapbook probably played a
part in the conception of the series.

Barthes opens his book like this:

> To begin with, some images: they are the author's treat to himself,
> for finishing his book. His pleasure is a matter of fascination (and
> thereby quite selfish). I have kept only the images which enthral
> me, *without my knowing why* (such ignorance is the very nature of
> fascination, and what I shall say about each image will never be
> anything but . . . imaginary).

It is necessary to explain the difference of context – and Barthes with
all his concern for *context* would be the first to do so – because, when

1 This chapter is a review of Roland Barthes, *Roland Barthes*, translated by
Richard Howard (London: Macmillan, 1977).

the same book is published, at almost eight times the price, as a single title, it becomes a different object. And the difference is likely to make the exercise of writing the book appear narrower and far more egocentric than it was. Macmillan have given the book an aristocratic imprint.

The book, however, is original, and its originality endures even after having suffered such a transformation. Its originality is not due, as the blurb claims, to Barthes's speaking 'so freely about himself'. It is original because it amounts to an original interrogation: a book in which language is allowed to question an intellectual life history and the individual which that history describes. It is, if you wish, a confession of Barthes's language. And he believes that a person's language (the way that it is uniquely deployed around the centre of his consciousness) is, among other things, a projection of that person's body:

> Different from secondary sexuality, the sexiness of a body (which is not its beauty) inheres in the fact that it is possible to discern (to fantasise) in it the erotic practice to which one subjects it in thought (I conceive of this particular practice, specifically, and of no other). Similarly, distinguished within the text, one might say that there are *sexy sentences*: disturbing by their very isolation, as if they possessed the promise which is made to us, the readers, by a linguistic practice, as if we were to seek them out by virtue of a pleasure *which knows what it wants*.

The book consists of a section of questioned photographs relating to Barthes's childhood. (He was born in 1915 and spent the first eight years of his life in Bayonne.) This is followed by 140 pages of brief and separate self-reflective fragments, each headed by a title. They can, I think, be read in any order. They do not repeat themselves but they fold together, and this folding constitutes their unity. When folded their linguistic practice can be traced back to the boy in Bayonne, when unfolded they disconcertingly address the languages (political, psychological, rhetorical, sexual, scientific) which have helped to form some of us in Europe. For example:

> *Recurrence as farce*: Intensely struck, that first time, and struck forever by that notion of Marx's that in History tragedy sometimes

recurs, *but as a farce*. Farce is an ambiguous form, since it permits us to read within it the figure of what it mockingly repeats: as with *Accountancy*: a positive value in the period when the bourgeoisie was a progressive force, a pejorative feature when that bourgeoisie had become triumphant, settled, exploitative; and as with the 'concrete' (the alibi of so many mediocre scholars and dull politicians), which is merely the farce of one of the highest values: the exemption of meaning.

In a review of this length it is impossible to define the terms by which he interrogates himself. The most that one can say is that Barthes is concerned with language's blind-spots, with the spaces to which words, as conventionally used, cannot apply. To explore this concern, he has to 'borrow' words, and this sometimes leads to obscurity. And sometimes the effort involved seems disproportionate to the area of the space suggested. When this occurs one is reminded of how privileged Barthes is (European, member of the Parisian intellectual elite, at ease). Yet he is the first to recognise this, and he uses his privilege to achieve a habit of questioning which is at the same time leisured and disciplined. (Perhaps the hope which inspires Barthes is not so far from Gide's.) Nobody can unmask Barthes because, before the paragraph is finished, he himself has taken off the mask to demonstrate what it looks like from the inside.

The Adjective

He is troubled by any *image* of himself, suffers when he is named. He finds the perfection of a human relationship in this vacancy of the image: to abolish – in oneself, between oneself and others – *adjectives*: a relationship which adjectivises is on the side of the image, on the side of domination, of death.

If it were not for its outrageous price, I would widely recommend this book. It is a valuable experience making Barthes's acquaintance. I imagine that he is an excellent teacher and a very good friend. His points of departure are often small, and even precious. His writing – in its pride and in its reticence – is highly aesthetic. His conclusions are sometimes utopian. The most utopian of his beliefs is that somehow

language might redeem the soul. Yet he deserves trust. And that is very rare. He is no opportunist. He never repeats what others have said. And he is continually drawn in his search for truth to what has not previously been revealed – the inside of the mask, the reverse side of all words.

12.

Forthflowing on a Joycean Tide

I FIRST SAILED into James Joyce's *Ulysses* when I was fourteen years old. I use the words *sailed into* instead of read because, as its title reminds us, the book is like an ocean; you do not read it, you navigate it. Like many people whose childhoods are lonely, by the age of fourteen my imagination was already grown up, ready to put to sea; what it lacked was experience. I had already read A *Portrait of the Artist as a Young Man*, and its title was the honorary title I gave to myself in my daydreams. A kind of alibi or seaman's card – to show, when challenged, to the middle-aged, or one of their agents.

It was the winter of 1940–41. Joyce was in fact dying of a duodenal ulcer in Zurich. But I did not know that then. I did not think of him as mortal. 1 knew what he looked like and even that he suffered from bad eyesight. I did not picture him as a god, but I felt him through his words, through his endless perambulations, as ever present. And so not prone to die.

The book had been given to me by a friend who was a subversive schoolmaster. Arthur Stowe his name. Stowbird I called him. I owe him everything. It was he who extended his arm and offered me a hand to grasp so that I could climb out of the basement in which I had been brought up, a basement of conventions, taboos, rules, *idées reçues*, prohibitions, fears, where nobody dared to question anything

and where everybody used their courage – for courage they had – to submit to no matter what, without complaining. It was the French edition in English published by Shakespeare and Company. Stowbird had bought it in Paris on his last trip before the war broke out. He used to wear a long raincoat and a black beret acquired at the same moment.

When he gave the book to me, I believed it was illegal in Britain to own a copy. In fact this was no longer the case. Yet the 'illegality' of the book was for me, the fourteen-year-old, a telling literary quality. And there, perhaps, I was not mistaken. I was convinced that legality was an arbitrary pretence. Necessary for the social contract, indispensable for society's survival, but turning its back on most lived experience. I knew this by instinct, and when I read the book for the first time, I came to appreciate with mounting excitement that its supposed illegality was more than matched by the illegitimacy of the lives and souls in its epic.

Whilst I read the book, the Battle of Britain was being fought above the south coast of England, and London. The country was expecting invasion. No future was certain. Between my legs I was becoming a man, but it was quite possible that I would not live long enough to discover what life was about. And of course I didn't know. And of course I didn't believe what I was told, either in history classes, on the radio, or in the basement.

All their accounts were too small to add up to the immensity of what I did not know. Not, however, *Ulysses*. This book had that immensity. It didn't pretend to it; it was impregnated by it, it flowed through it. To compare the book with an ocean again makes sense, for isn't it, too, the most *liquid* book ever written?

Now I was about to write: there were many parts, during this first reading, which I didn't understand. Yet this would be false. There were no parts that I understood. And there was no part that did not make the same promise to me: the promise that deep down, beneath the words, beneath the pretences, beneath the claims and the everlasting moralistic judgment, beneath the opinions and lessons and boasts and cant of everyday life, the lives of adult women and men were made up of such stuff as this book was made of: offal with flecks in it of the divine. The first and last recipe!

Even at my young age, I recognised Joyce's prodigious erudition. He was, in one sense, Learning incarnate. But Learning without

solemnity that threw away its cap and gown to become joker and juggler. Perhaps even more significant for me at that time was the company his learning kept: the company of the unimportant, those for ever off stage – the company of publicans and sinners, as the Bible puts it, low company. *Ulysses* is full of the disdain of the represented for those who claim (falsely) to represent them, and packed with the tender ironies of those who are said (falsely) to be lost!

And he did not stop there – this man who was telling me about the life I might never know, this man who never spoke down to anybody, and who remains for me to this day an example of the true adult, which is to say of a being who, because he has accepted life, is intimate with it – this man did not stop there, for his *penchant* for the lowly led him to keep the same kind of company *within* his single characters: he listened to their stomachs, their pains, their tumescences: he heard their first impressions, their uncensored thoughts, their ramblings, their prayers without words, their insolent grunts and heaving fantasies.

One day in the autumn of 1941 my father, who must have been anxiously surveying me for some time, decided to check out the books on the shelf by my bed. Having done so, he confiscated five, including *Ulysses*. He told me the same evening what he had done, and added that he had locked all five in the safe in his office! At this time he was doing important war work for the government on the question of how to increase factory production. I had a vision of my *Ulysses* locked away under folders of government secrets, labelled Highly Confidential.

I was furious as only a fourteen-year-old can be. I refused to compare my father's pain – as he had asked me to – with my own. I painted a portrait of him – the largest canvas I'd done to date – where I made him look diabolic, with the colours of Mephistopheles. Yet, my fury notwithstanding, I couldn't help finally acknowledging something else: the story of the confiscated books and the father in fear for the son's soul and the Chubb safe and the government files might have come straight out of the confiscated book in question, and it would have been narrated with equanimity and without hate.

Today, fifty years later, I continue to live the life for which Joyce did so much to prepare me, and I have become a writer. It was he who showed me, before I knew anything, that literature is inimical to all

hierarchies and that to separate fact and imagination, event and feeling, protagonist and narrator, is to stay on dry land and never put to sea.

Under the upswelling tide he saw the writhing weeds lift languidly and sway reluctant arms, hising up their petticoats, in whispering water swaying and upturning coy silver fronds. Day by day: night by night: lifted, flooded and let fall. Lord, they are weary; and, whispered to, they sigh. Saint Ambrose heard it, sigh of leaves and waves, waiting, awaiting the fullness of their times, *diebus ac noctibus iniurias patiens ingemiscit.* To no end gathered; vainly then released, forthflowing, wending back: loom of the moon. Weary too in sight of lovers, lascivious men, a naked woman shining in her courts, she draws a toil of waters.

13.

A Gift for Rosa Luxemburg

ROSA! I'VE KNOWN you since I was a kid. And now I'm twice as old as you were when they battered you to death in January 1919, a few weeks after you and Karl Liebknecht had founded the German Communist Party.

You often come out of a page I'm reading – and sometimes out of a page I'm trying to write – come out to join me with a toss of your head and a smile. No single page and none of the prison cells they repeatedly put you in could ever contain you.

I want to send you something. Before it was given to me, this object was in the town of Zamość in southeast Poland. In the town where you were born and your father was a timber merchant. But the link with you is not as simple as that.

The object belonged to a Polish friend of mine called Janine. She lived alone, not in the elegant main square as you did during the first two years of your life, but in a very small suburban house on the outskirts of the town.

Janine's house and her tiny garden were full of potted plants. There were even potted plants on the floor of her bedroom. And she liked nothing better when she had a visitor than to point out, with her elderly working woman's fingers, the special particularity of each one of her plants. Her plants kept her company. She gossiped and joked with them.

Although I don't speak Polish, the European country I perhaps feel most at home in is Poland. I share with the people something like their order of priorities. Most of them are not intrigued by power because they have lived through every conceivable kind of powershit. They are experts at finding a way round obstacles. They continually invent ploys for getting by. They respect secrets. They have long memories. They make sorrel soup from wild sorrel. They want to be cheerful.

You say something similar in one of your angry letters from prison. Self-pity always made you angry, and you were replying to a moaning letter from a friend. 'To be a human being', you say,

> is the main thing above all else. And that means to be firm and clear and cheerful, yes, cheerful in spite of everything and anything, because howling is the business of the weak. To be a human being means to joyfully toss your entire life in the giant scales of fate if it must be so, and at the same time to rejoice in the brightness of every day and the beauty of every cloud.

In Poland during recent years a new trade has developed, and anyone who practises it is called a *stacz*, which means 'taking the place'. One pays a man or a woman to join a queue, and after a very long while (most queues are very long), when the *stacz* is near to the head of the queue, one takes his or her place. The queues may be for food, a kitchen utensil, some kind of licence, a government stamp on a document, sugar, rubber boots . . .

They invent many ploys for getting by.

In the early 1970s, my friend Janine decided to take a train to Moscow, as several of her neighbours had done. It was not an easy decision to take. Only a year or two before, in 1970, there had been the massacre of Gdańsk and other seaports, where hundreds of ship-building workers on strike had been shot down by Polish soldi°ers and police under orders from Moscow.

You foresaw it, Rosa, the dangers implicit in the Bolshevik manner of arguing with all reasoning; you already foresaw it in 1918 in your commentary on the Russian Revolution:

> Freedom only for the members of the government, only for the members of the Party – though they are quite numerous – is no

freedom at all. Freedom is always the freedom of the one who thinks differently. Not because of any fanatical concept of justice, but because all that is instructive, wholesome and purifying in political freedom depends on this essential characteristic, and its effectiveness vanishes when 'freedom' becomes a special privilege.

Janine took the train to Moscow to buy gold. Gold cost there a third of what it did in Poland. Leaving the Belorussky Station behind her, she eventually found the backstreet where the prescribed jewellers had rings to sell. There was already a long queue of other 'foreign' women waiting to buy. For the sake of law and order, each woman had a number chalked on the palm of her hand which indicated her place in the line. A cop was there to chalk the numbers. When Janine eventually reached the counter with her prepared roubles she bought three gold rings.

On her way back to the station she caught sight of the object I want to send to you, Rosa. It cost only sixty kopeks. She bought it on the spur of the moment. It tickled her fancy. It would chat with her potted plants.

She had to wait a long while in the station for the train back. You knew, Rosa, these Russian stations that become encampments of long-waiting passengers. Janine slipped one of her rings onto the fourth finger of her left hand, and the other two she hid in more intimate places. When the train arrived and she climbed up into it, a soldier offered her a corner seat and she sighed with relief; she would be able to sleep. At the frontier she had no problems.

In Zamość she sold the rings for twice the sum she had paid for them, and they were still considerably cheaper than any which could be bought in a Polish shop. Janine, after deducting her rail fare, had made a little windfall.

The object I want to send you she placed on her kitchen windowsill.

The goal of an encyclopaedia is to assemble all the knowledge scattered on the surface of the earth, to demonstrate the general system to the people with whom we live, and to transmit it to the people who will come after us, so that the work of centuries past is not

useless to the centuries which follow, that our descendants, by becoming more learned, may become more virtuous and happier.

Diderot is explaining in 1750 the encyclopaedia he has just helped to create.

The object on the windowsill has something encyclopaedic about it. It's a thin cardboard box, the size of a quarto sheet of paper. Printed on its lid is a coloured engraving of a collared flycatcher, and underneath it two words in Cyrillic Russian: SONG BIRDS.

Open the lid. Inside are three rows of matchboxes, with six boxes to each row. And each box has a label with a coloured engraving of a different songbird. Eighteen different songsters. And below each engraving in very small print the name of the bird in Russian. You who wrote furiously in Russian, Polish and German would have been able to read them. I can't: I have to guess from my vague memories of sporadic birdwatching.

The satisfaction of identifying a live bird as it flies over, or disappears into a hedgerow, is a strange one, isn't it? It involves a weird, momentary intimacy, as if at that moment of recognition one addresses the bird – despite the din and confusions of countless other events – one addresses it by its very own particular nickname. Wagtail! Wagtail!

Of the eighteen birds on the labels, I perhaps recognise five.

The boxes are full of matches with green striking heads. Sixty in each box. The same as seconds in a minute and minutes in an hour. Each one a potential flame.

'The modern proletarian class', you wrote, 'doesn't carry out its struggle according to a plan set out in some book or theory; the modern workers' struggle is a part of history, a part of social progress, and in the middle of history, in the middle of progress, in the middle of the fight, we learn how we must fight.'

On the lid of the cardboard box there is a short explanatory note addressed to matchbox-label collectors (phillumenists, as they are called) in the USSR of the 1970s.

The note gives the following information: in evolutionary terms, birds preceded animals; in the world today there are an estimated five thousand species of birds; in the Soviet Union there are four hundred species of songbirds; in general it is the male birds who sing; songbirds

have specially developed vocal chords at the bottom of their throats; they usually nest in bushes or trees or on the ground; they are an aid to cereal agriculture because they eat and thus eliminate hordes of insects; recently, in the remotest areas of the Soviet Union, three new species of singing sparrows have been identified.

Janine kept the box on her kitchen windowsill. It gave her pleasure, and in the winter it reminded her of birds singing.

When you were imprisoned for vehemently opposing the First World War, you listened to a blue titmouse

> who always stayed close to my window, came with the others to be fed, and diligently sang its funny little song, *tseetseebay*, but it sounded like the mischievous teasing of a child. It always made me laugh and I would answer with the same call. Then the bird vanished with the others at the beginning of this month, no doubt nesting elsewhere. I had seen and heard nothing of it for weeks.
>
> Yesterday its well-known notes came suddenly from the other side of the wall which separates our courtyard from another part of the prison; but it was considerably altered, for the bird called three times in brief succession, *tseetseebay, tseetseebay, tseetseebay*, and then all was still. It went to my heart, for there was so much conveyed by this hasty call from the distance – a whole history of bird life.

After several weeks, Janine decided to put the box in her cupboard under the stairs. She thought of this cupboard as a kind of shelter, the nearest she had to a cellar, and in it she kept what she called her reserve. The reserve consisted of a tin of salt, a tin of cooking sugar, a larger tin of flour, a little sack of kasha, and matches. Most Polish housewives kept such a reserve as a means of minimal survival for the day when suddenly the shops, during some national crisis, would have nothing on their shelves.

The next such crisis would be in 1980. Again it began in Gdańsk, where workers went on strike in protest against the rising food prices and their action gave birth to the national movement of Solidarność, which brought down the government.

'The modern proletarian class', you wrote a lifetime earlier, 'doesn't carry out its struggle according to a plan set out in some book or theory;

the modern workers' struggle is a part of history, a part of social progress, and in the middle of history, in the middle of progress, in the middle of the fight, we learn how we must fight.'

When Janine died in 2010, her son Witek found the box in the cupboard under the stairs and he brought it to Paris, where he was working as a plumber and builder. He brought it to give it to me. We are old friends. Our friendship began by playing cards together evening after evening. We played a Russian and Polish game called Imbecile. In this game the first player to lose all his or her cards is the winner.

Witek guessed that the box would set me wondering.

One of the birds in the second row of matchboxes I recognise as a linnet, with his pink breast and his two white streaks on his tail. *Tsooeet! Tsooeet!* . . . often several of them sing in chorus from the top of a bush.

'The one who has done the most to restore me to reason is a small friend whose image I am sending enclosed. This comrade with the jauntily held beak, steeply rising forehead and eye of a know-it-all is called Hypolais hypolais, or in everyday language the arbour bird or also the garden mocker.' You are imprisoned in Poznań in 1917, and you continue your letter like this:

> This bird is quite an oddball. He doesn't sing just one song or one melody like other birds, but he is a public speaker by the grace of God, he holds forth, making his speeches to the garden, and does so with a very loud voice full of dramatic excitement, leaping transitions, and passages of heightened pathos. He brings up the most impossible questions, then hurries to answer them himself, with nonsense, making the most daring assertions, heatedly refuting views that no one has stated, charges through wide open doors, then suddenly exclaims in triumph: 'Didn't I say so? Didn't I say so?' Immediately after that he solemnly warns everyone who's willing or not willing to listen: 'You'll see! You'll see!' (He has the clever habit of repeating each witty remark twice.)

The linnet's box, Rosa, is full of matches.

'The masses', you wrote in 1900, 'are in reality their own leader, dialectically creating their own development procedure . . .'

How to send this collection of matchboxes to you? The thugs who killed you threw your mutilated body into a Berlin canal. It was found in the stagnant water three months later. Some doubted whether it was your corpse.

I can send it to you by writing, in this dark time, these pages.

'I was, I am, I will be', you said. You live in your example for us, Rosa. And here it is, I'm sending it to your example.

14.

The Ideal Critic and
the Fighting Critic

IF YOU TAKE a long-term historical view, ours is obviously a period of mannerism and decadence.[1] The excessive subjectivity of most of our art and criticism confirms this. The historical and social explanations are not hard to find. It may be unpopular but it is not stupid to condemn works as bourgeois, formalist and escapist.

If, on the other hand, you take a very limited view, it is possible to sympathise with almost all artists. If you accept what they themselves are trying to do, you can admire their effort. The work is then no longer proof of the validity of the artist's intentions: his intentions have to prove the validity of his work. If you want to know what it feels like to be X, his paintings will tell you as much as anything else ever will. Accept that it is necessary for him to create a kind of tidal world of flux in which solidity, weight and identity are all sucked away, and then his paintings are certainly impressive.

The limitation of the first approach is that it tends to be over-mechanical. To take a long-term historical view you must stand outside your own time and culture. You must base yourself on the past, in an imaginary future or in the centre of an alternative culture. Your general

1 Editor's note: Published in this form in *Permanent Red* (1959).

opinion will probably be right. But you will almost certainly be blind to the processes by which your own period is changing itself. You will tend to see the dramatic break between the culture with which you identify yourself and the culture that surrounds you more clearly than you will see the dialectic leading up to and away from that break. You would, for instance, have seen that Surrealism was decadent but you would have failed to understand how it nourished Eluard, who later opposed all decadence. It is an approach that assumes that your own period is finished rather than continuous.

The limitation of the second approach is its subjectivity. Intentions count for more than results. You judge the distance travelled instead of the distance still necessary to travel. You think as though history begins afresh with each individual. Your mind is open – but anything can enter it and so seem positive. You will admit the genius and the fool – and not know which is which.

So what is required is a combination of both approaches. Then you will be fully equipped to recognise that rare transformation which, when it happens, allows an artist's pursuit of his personal needs to become a pursuit of the truth. You will have the historical perspective necessary to evaluate the truth he discovers, and you will have the imaginative appreciation necessary to understand the route he must take to travel towards his discovery. In theory, such a combination would equip the ideal critic. But in fact it is impossible.

The two approaches are mutually opposed. You are demanding that the critic is simultaneously in one place (in X's imagination) and everywhere (in history). You are casting him for the role of God. Which is, of course, the role most critics cast for themselves. Their one concern and one fear is that they will fail to understand the next genius, the latest discovery, the newest trend. Yet they are not God. So they wander about, looking for they know not what, and always believing that they have just found it.

Proper criticism is more modest. First, you must answer the question: What can art serve here and now? Then you criticise according to whether the works in question serve that purpose or not. You must beware of believing that they can always do so directly. You are not simply demanding propaganda. But you need not fall over backwards in order to avoid being proved wrong by those who later take your

place. You will make mistakes. You will miss perhaps the genius who finally vindicates himself. But if you answer your initial question with historical logic and justice, you will be helping to bring about the future from which people will be able to judge the art of your own time with ease.

The question I ask is: Does this work help or encourage men to know and claim their social rights? First let me explain what I do not mean by that. When I go into a gallery, I do not assess the works according to how graphically they present, for example, the plight of our old-age pensioners. Painting and sculpture are clearly not the most suitable means for putting pressure on the government to nationalise the land. Nor am I suggesting that the artist, when actually working, can or should be primarily concerned with the justice of a social cause.

> Shut the door of the Pope's chapel,
> Keep those children out.
> There on that scaffolding reclines
> Michael Angelo.
> With no more sound than the mice make
>
> His hand moves to and fro.
> Like a long-legged fly upon the stream
> His mind moves upon silence.

Yeats understood the necessary preoccupations of the artist.

What I do mean is something less direct and more comprehensive. After we have responded to a work of art, we leave it, carrying away in our consciousness something which we didn't have before. This something amounts to more than our memory of the incident represented, and also more than our memory of the shapes and colours and spaces which the artist has used and arranged. What we take away with us – on the most profound level – is the memory of the artist's way of looking at the world. The representation of a recognisable incident (an incident here can simply mean a tree or a head) offers us the chance of relating the artist's way of looking to our own. The forms he uses are the means by which he expresses his way of looking. The truth of this is confirmed by the fact that we can often recall the experience

of a work, having forgotten both its precise subject and its precise formal arrangement.

Yet why should an artist's way of looking at the world have any meaning for us? Why does it give us pleasure? Because, I believe, it increases our awareness of our own potentiality. Not of course our awareness of our potentiality as artists ourselves. But a way of looking at the world implies a certain relationship with the world, and every relationship implies action. The kind of actions implied vary a great deal. A classical Greek sculpture increases our awareness of our own potential physical dignity; a Rembrandt of our potential moral courage; a Matisse of our potential sensual awareness. Yet each of these examples is too personal and too narrow to contain the whole truth of the matter. A work can, to some extent, increase an awareness of different potentialities in different people. The important point is that a valid work of art promises in some way or another the possibility of an increase, an improvement. Nor need the work be optimistic to achieve this; indeed, its subject may be tragic. For it is not the subject that makes the promise, it is the artist's way of viewing his subject. Goya's way of looking at a massacre amounts to the contention that we ought to be able to do without massacres.

Works can be very roughly divided into two categories, each offering, in the way just described, a different kind of promise. There are works which embody a way of looking that promises the mastering of reality – Piero, Mantegna, Poussin, Degas. Each of these suggests in a different way that space, time and movement are understandable and controllable. Life is only as chaotic as men make it or allow it to be. There are other works which embody a way of looking whose promise lies not so much in any suggested mastery, but rather in the fervour of an implied desire for change – El Greco, Rembrandt, Watteau, Delacroix, Van Gogh. These artists suggest that men in one way or another are larger than their circumstances – and so could change them. The two categories are related, perhaps, to the old distinction between Classic and Romantic, but they are broader because they are not concerned with specific historical vocabularies. (It is obviously absurd to think of El Greco as a Romantic in the same sense as Delacroix or Chopin.)

All right, you may now say, I see your point: art is born out of hope – it's a point that's often been made before, but what has it to do with

claiming social rights? Here it is essential to remember that the specific meaning of a work of art changes – if it didn't, no work could outlive its period, and no agnostic could appreciate a Bellini. The meaning of the improvement, of the increase promised by a work of art, depends upon who is looking at it when. Or, to put it dialectically, it depends upon what obstacles are impeding human progress at any given time. The rationality of a Poussin first gave hope in the context of absolute monarchism; later it gave hope in the context of free trade and Whig reforms; still later it confirmed Léger's faith in proletarian socialism.

It is our century, which is pre-eminently the century of men throughout the world claiming the right of equality; it is our own history that makes it inevitable that we can only make sense of it if we judge it by the criterion of whether or not it helps men to claim their social rights. It has nothing to do with the unchanging nature of art – if such a thing exists. It is the lives lived during the last fifty years that have now turned Michelangelo into a revolutionary artist. The hysteria with which many people today deny the present, inevitable social emphasis of art is simply due to the fact that they are denying their own time. They would like to live in a period when they'd be right.

PART II

Terrain

I'm going
 going
to lie on the earth
 the earth
will lay back both her ears
and with my forearm
 forearm
between them
the fingers of my hand
will play
 play around
with her muzzle
 kept cool
by a wind from
God knows where.

15.

The Clarity of the Renaissance

IT'S DEPRESSING. THE rain's set in. It's wet but we can't grumble. It's grey and dull. Each of these comments describes the same day from a different point of view: the subjective, the practical, the moralistic and the visual. All true painters naturally see and feel in a way that is a hundred times more acutely visual and tangible than the last, or indeed any comment, can illustrate. But what they see and feel is – normally – the same as everybody else. To say this is, I realise, platitudinous. But how often it is forgotten. Indeed, has it ever been consistently taken for granted since the sixteenth century?

I spent the other day in the National Gallery looking mainly at the Flemish and Italian Renaissance works. What is it that makes these so fundamentally different from nearly all the works – and especially our own – that have followed them? The question may seem naive. Social and stylistic historians, economists, chemists and psychologists have spent their lives defining and explaining this and many other differences between individual artists, periods and whole cultures. Such research is invaluable. But its complexity often hides from us two simple, very obvious facts. The first is that it is our own culture, not foreign ones, which can teach us the keenest lessons: the culture of individualist humanism which began in Italy in the thirteenth century. And the second fact is that, at least in painting, a fundamental break

occurred in this culture two and a half centuries after it began. After the sixteenth century artists were more psychologically profound (Rembrandt), more successfully ambitious (Rubens), more evocative (Claude); but they also lost an ease and a visual directness which precluded all pretension; they lost what Berenson has called 'tactile values'. After 1600 the great artists, pushed by lonely compulsion, stretch and extend the range of painting, break down its frontiers. Watteau breaks out towards music, Goya towards the stage, Picasso towards pantomime. A few, such as Chardin, Corot, Cézanne, did accept the strictest limitations. But before 1550 every artist did. One of the most important results of this difference is that in the great later forays only genius could triumph: before, even a small talent could give profound pleasure.

I am not advocating a new Pre-Raphaelite movement, nor am I making any qualitative judgment – in the broadest human sense – of the art of the last three and a half centuries. But now, when so many artists tend – either in terms of technique or subjective experience – to throw themselves vainly against the frontiers of painting in the hope that they will be able to cut their own unique individual passes; now, when the legitimate territory of painting is hardly definable, I think it is useful to observe the limitations within which some of the greatest painters of our culture were content to remain.

When one goes into the Renaissance galleries, it is as if one suddenly realises that in all the others one has been suffering from a blurred short-sightedness. And this is not because many of the paintings have been finely cleaned, nor because chiaroscuro was a later convention. It is because every Flemish and Italian Renaissance artist believed that it was his subject itself – not his way of painting it – which had to express the emotions and ideas he intended. This distinction may seem slight, but it is critical. Even a highly mannered artist like Tura convinces us that every woman he painted as a madonna actually had doubly sensitive, double-jointed fingers. But a Goya portrait convinces us of Goya's own insight before it convinces us of his sitter's anatomy; because we recognise that Goya's interpretation is convincing, we are convinced by his subject. In front of Renaissance works the exact opposite occurs. After Michelangelo the artist lets us follow him; before, he leads us to the image he has made. It is this difference – the difference between

the picture being a starting-off point and a destination – that explains the clarity, the visual definitiveness, the tactile values of Renaissance art. The Renaissance painter limited himself to an exclusive concern with what the spectator could see, as opposed to what he might infer. Compare Titian's *presented Venus of Urbino* of 1538 with his elusive *Shepherd and Nymph* of thirty years later.

This attitude had several important results. It forbade any attempt at literal naturalism, because the only appeal of naturalism is the inference that it's 'just life-like': it obviously isn't, in fact, like life, because the picture is only a static image. It prevented all merely subjective suggestibility. It forced the artist, as far as his knowledge allowed him, to deal simultaneously with all the visual aspects of his subject – colour, light, mass, line, movement, structure – and not, as has increasingly happened since, to concentrate only on one aspect and to infer the others. It allowed him to combine more richly than any later artists have done realism and decoration, observation and formalisation. The idea that they are incompatible is only based on today's assumption that their inferences are incompatible; visually an embroidered surface or drapery, *invented* as the most beautiful mobile architecture ever, can combine with realistic anatomical analysis as naturally as the courtly and physical combine in Shakespeare.

But, above all, the Renaissance artist's attitude made him use to its maximum the most expressive visual form in the world: the human body. Later the nude became an idea – Arcadia or Bohemia. But during the Renaissance every eyelid, breast, wrist, baby's foot, nostril, was a double celebration of fact: the fact of the miraculous structure of the human body and the fact that only through the senses of this body can we apprehend the rest of the visible, tangible world.

This lack of ambiguity is the Renaissance, and its superb combination of sensuousness and nobility stemmed from a confidence which cannot be artificially recreated. But when we eventually achieve a confident society again, its art may well have more to do with the Renaissance than with any of the moral or political artistic theories of the nineteenth century. Meanwhile, it is a salutary reminder for us even today that, as Berenson has said so often and so wisely, the vitality of European art lies in its 'tactile values and movement', which are the result of the observation of the 'corporeal significance of objects'.

16.

A *View of Delft*

In that town,
across the water
where all has been seen
and the bricks are cherished like sparrows,
in that town like a letter from home
read again and again in a port,
in that town with its library of tiles
and its addresses recalled by Johannes Vermeer
who died in debt,
in that town across the water
where the dead take the census
and there are no vacant rooms
for his gaze occupies them all,
where the sky is waiting
to have news of a birth,
in that town which pours from the eyes
of those who left it,
there
between the two chimes of the morning,
when fish are sold in the square

and the maps on the walls
show the depth of the sea,
in that town
I am preparing for your arrival.

17.

The Dilemma of the Romantics

THE TERM ROMANTICISM has recently been taken to cover almost all the art produced in Europe between about 1770 and 1860. Ingres and Gainsborough, David and Turner, Pushkin and Stendhal. Thus the pitched battles of the last century between Romanticism and Classicism are not taken at their face value, but rather it is suggested that the differences between the two schools were less important than what they both had in common with the rest of the art of their time.

What was this common element? To take a century of violent agitation and revolt and then to try to define the general, overall nature of its art, is to deny the very character of such a period. The significance of the outcome of any revolution can only be understood in relation to the specific circumstances pertaining. There is nothing less revolutionary than generalising about revolution. However, a stupid question usually gets stupid answers. Some try to define Romantic art by its subject matter. But then Piero di Cosimo is a Romantic artist along with George Morland! Others suggest that Romanticism is an irrational force present in all art, but that sometimes it predominates more than at other times over the opposite force of order and reason. Yet this would make a great deal of Gothic art Romantic! Another observes that it must all have had something to do with the English weather.

No, if one must answer the question – and as I've said, no answer is going to get us all that far – one must do so historically. The period in question falls between the growing points of two revolutions, the French and the Russian. Rousseau published *Le Contrat Social* in 1762. Marx published *Capital* in 1867. No two other single facts could reveal more. Romanticism was a revolutionary movement that rallied round a promise which was bound to be broken: the promise of the success of revolutions deriving their philosophy from the concept of the natural man. Romanticism represented and acted out the full predicament of those who created the goddess of Liberty, put a flag in her hands and followed her only to find that she led them into an ambush: the ambush of reality. It is this predicament which explains the two faces of Romanticism: its exploratory adventurousness and its morbid self-indulgence. For pure Romantics the two most unromantic things in the world were firstly to accept life as it was, and secondly to succeed in changing it.

In the visual arts the two faces reveal themselves in a sensing of new dimensions on the one hand, and in an oppressive claustrophobia on the other. There are Constable's clouds formed by land and water we can't see, and there is the typical Romantic painting of a man being buried alive in his coffin. There is Géricault looking calmly and openly at the inmates of an asylum, and there are the German Romantic painters in the Mediterranean painting the hills and sky such a legendary blue that the whole scene looks as though it could be smashed like a saucer. There is Stubbs scientifically comparing animals and looking into the eyes of a tiger, and there is James Ward reducing Gordale Scar to a rock of ages just cleft for him. There is a new awareness of the size and power of the forces in the world – an awareness which invested the word *Nature* with a completely new meaning, and there is the breathlessness of the new superstitions that protected men from the enormity of what they were discovering: above all the superstition that a feeling in the heart was somehow comparable with a storm in the sky.

Naturally the focal centres of Romantic art varied a great deal according to time and place. In England the provocation was the Industrial Revolution and the new light (literal and metaphorical) that it threw on landscape; in France the predominant stimulus was the

new mode of military heroism established by Napoleon; in Germany it was the mounting compulsion to establish a national identity. Naturally, too, the political predicament I've described often presented itself in indirect forms. More Romantic artists were directly influenced by the literary cult of the past, when life was thought to have been 'simpler' and more 'natural', than they were by, say, Chartism. Newtonian science was also relevant to Romanticism. The Romantics accepted the way science had freed thought from religion, but at the same time were intuitively in protest against its closed mechanistic system, the inhumanity of which seemed to be demonstrated in practice by the horrors of the economic system. The complexities of the situation are immense. Certain artists of the time, precisely because they were not affected by the Romantic predicament, should not be classed as Romantics even though they borrowed from the Romantic vocabulary: for example, Goya and Daumier.

Yet, despite the complexities, this historical definition is the only one that will make any general sense at all. It is confirmed by the fact that after 1860, when the predicament was no longer real because the knowledge and experience with which to overcome it were available, Romanticism degenerated into effete aestheticism. And it is confirmed most strikingly by the work which represents Romanticism at its height: Delacroix's *Massacre at Chios*.

The subtitle of the picture is *A Greek Family Awaiting Death or Slavery*. It is an acknowledged masterpiece and contains brilliant passages of painting. Its political gesture was important and also undoubtedly sincere. But it remains a gesture. It has nothing to do with any true imaginative understanding of either death or slavery. It is a voluptuous charade. The woman tied to the horse is a languorous sex-offering, the rope round her arm like an exotic snake playing with her. The couple in the centre might be lying in a harem. Indeed all the figures (with the possible exception of the old woman) are exotic. They belong to art dreams and literary legends, and have only been placed in an actual context for the sake of being 'ennobled' further by also belonging to an historical tragedy.

Delacroix records how he talked to a traveller just back from Greece, and says that on one occasion this man 'was so much impressed by the head of a Turk who appeared on the battlements that he

prevented a soldier from shooting at him'. Elsewhere Delacroix raves about a painting by Gros, and says, 'You can see the flash of the sabre as it plunges into the enemy's throats.' Such was the Romantic view of war: you could stop or start it like a film. It was a sincere view, but it was a compromisingly privileged view. And between the privilege and the reality lay the predicament.

18.

The Victorian Conscience

HOPE[1] SITS LIKE a waif on the world. The picture was as popular as *Love Locked Out* and *Bubbles*. The transience of childhood, the impossibility of love, the elusiveness of hope – these were the themes that sustained the Victorians in their confidence and comfort. The nature of their guilt may have been complex, but the resulting ambivalence of their faith is very clear in all their painting – clearer than in their literature. And Watts epitomised Victorian painting.

In almost everything he did there is a threatening gulf between his ideals and the subjects in which he chose to embody them. Nothing is taken for what it is. The wish was Victorian father to the thought. Tennyson, who in some ways resembled Watts, was painted as though he were a blind man: his eyes unseeing in order that his inner vision might be preserved. Ellen Terry (whom Watts married when she was sixteen) is a scentless flower.

It is impossible to pin down the exact cause of Watts's painful ambivalence and anxiety. He had an uneasy social conscience and sometimes made direct social protests in his work, but also his fears were highly personal. Obsessed by death, he painted several pictures

1 An allegorical painting of 1886 by George Frederick Watts (1817–1904) and assistants, now in the Tate Collection.

of Cain. In his remarks about these, both aspects of his conflict come out: 'Cain is in the grasping of riches to the hurt of others, or in indifference to others; in the building of houses unfit for dwelling in; in the polluting of streams without regret.' But also, desperately identifying himself with Cain, he wrote: 'Not only are his fellow men unconscious of his presence, but all animate nature has cast him out: no bird or living creature acknowledges his being.'

These conflicts, always partially suppressed, fatally affected his talents as an artist. He was unable to draw. What he wished his subject to stand for came between him and its form. He thought that the aim of art 'should be to give the impression of some great truth of nature, something so far too great for expression that finally it must remain indefinite. The infinite looming behind the finite'. It loomed so large that the pucker of the brow destroyed the form of the skull – or prevented him ever seeing it: the anxiety of the eyes dissolved the eye sockets. Occasionally, as in his portrait of Cardinal Manning, the intensity of feeling is tremendous. But one only wonders: Was it really possible to see a man like that? Never: Was he really like that?

Some of his small drawings are comparatively successful, but then any reasonably talented artist produces a few good sketchbook studies during his lifetime. Nor is this harsh judgment a question of changing visual taste – one has only to compare Watts with Millet. One might argue that Watts's lack of proper training explained the weakness of his drawing, but that he compensated for this by his mastery of Titianesque colour. But his colour suffers from the same fault. Ruskin wrote to him saying, 'You depend too much on blending, and too little on handling.' To handle colour is, as it were, to grasp it. Watts could not have committed himself to that extent. His colour is strong but elusive because it never *belongs* to the forms. In his early eighteenth-century-like portraits, the colour is applied like rouge to the pink cheeks. In his later allegorical works, the colour is like thick stained glass through which one sees darkly the subject on the other side. It is the same with his sculpture. He could never accept the subject as an organic whole. In his bust of *Clytie*, the muscles were modelled from a man, the face from a woman. And it is this separation of the parts which causes, among other things, the nipples to appear so incongruously blatant – one wonders what Gladstone said and noticed when Watts asked his opinion.

As in all Victorian art, it is the sexual element in Watts's work which reveals his conflicts most clearly. Swinburne talked of the 'amorous chastity' of one of his paintings: a concise if unintentional way of summing up their sensual contradiction. The folds of the draperies round Watts's figures are incredibly tortured and overworked in their complexity because they were believed to hide so much – far more than they in fact did. *Dawn's* cloak is about to slip off as she watches the day break above the mountains. Yet when it does, it will not reveal her body, but the never-to-be-looked-at sun which consumes everything.

Watts worked hard, lived in luxury and was acclaimed and petted by society, but when he looked up at the reflection of a night light on the ceiling, he got his first idea for his painting of the origin of the cosmos, *The Sower of the Systems*. When he described how he had worked on this picture, he compared himself to a child asked to draw God, and who, 'putting his paper on a soft surface, struck his pencil through the centre, making a great void'. He was a typical Victorian but he was nearer to our revolution than we tend to think. *Watchman, What of the Night?* he asked. It was Rimbaud who was to reply to that. As an artist Watts failed, but his failure was more significant than that of many contemporaries today who run away from what they believe is the void even faster, only in a different direction.

19.

The Moment of Cubism

I WOULD LIKE to dedicate this essay to Barbara Niven, who prompted it nearly twenty years ago in an ABC teashop off the Gray's Inn Road.

> Certains hommes sont des collines
> Qui s'élèvent entre les hommes
> Et voient au loin tout l'avenir
> Mieux que s'il était le présent
> Plus net que s'il était passé.
>
> *Apollinaire*

> The things that Picasso and I
> said to one another during those years will never be said again,
> and even if they were,
> no one would understand them any more.
> It was like
> being roped together on a mountain.
>
> *Georges Braque*

> There are happy moments,
> but no happy periods in history.
>
> *Arnold Hauser*

> The work of art is therefore
> only a halt in the becoming
> and not a frozen aim on its own.
> *El Lissitzky*

I find it hard to believe that the most extreme Cubist works were painted over fifty years ago. It is true that I would not expect them to have been painted today. They are both too optimistic and too revolutionary for that. Perhaps in a way I am surprised that they have been painted at all. It would seem more likely that they were yet to be painted.

Do I make things unnecessarily complicated? Would it not be more helpful to say simply: the few great Cubist works were painted between 1907 and 1914? And perhaps to qualify this by adding that a few more, by Juan Gris, were painted a little later?

And anyway is it not nonsense to think of Cubism having not yet taken place when we are surrounded in daily life by the apparent effects of Cubism? All modern design, architecture and town planning seems inconceivable without the initial example of Cubism.

Nevertheless I must insist on the sensation I have in front of the works themselves: the sensation that the works and I, as I look at them, are caught, pinned down, in an enclave of time, waiting to be released and to continue a journey that began in 1907.

Cubism was a style of painting which evolved very quickly, and whose various stages can be fairly specifically defined.[1] Yet there were also Cubist poets, Cubist sculptors, and later on so-called Cubist designers and architects. Certain original stylistic features of Cubism can be found in the pioneer works of other movements: Suprematism, Constructivism, Futurism, Vorticism, the de Stijl movement.

The question thus arises: Can Cubism be adequately defined as a style? It seems unlikely. Nor can it be defined as a policy. There was never any Cubist manifesto. The opinions and outlook of Picasso, Braque, Léger or Juan Gris were clearly very different even during the few years when their paintings had many features in common. Is it not enough that the category of Cubism includes those works that are now generally agreed to be within it? This is enough for dealers, collectors,

1 See John Golding, *Cubism* (London: Faber & Faber, 1959).

and cataloguers who go by the name of art historians. But it is not, I believe, enough for you or me.

Even those whom the stylistic category satisfies are wont to say that Cubism constituted a revolutionary change in the history of art. Later we shall analyse this change in detail. The concept of painting as it had existed since the Renaissance was overthrown. The idea of art holding up a mirror to nature became a nostalgic one: a means of diminishing instead of interpreting reality.

If the word revolution is used seriously and not merely as an epithet for this season's novelties, it implies a process. No revolution is simply the result of personal originality. The maximum that such originality can achieve is madness: madness is revolutionary freedom confined to the self.

Cubism cannot be explained in terms of the genius of its exponents. And this is emphasised by the fact that most of them became less profound artists when they ceased to be Cubists. Even Braque and Picasso never surpassed the works of their Cubist period: and a great deal of their later work was inferior.

The story of how Cubism happened in terms of painting and of the leading protagonists has been told many times. The protagonists themselves found it extremely difficult – both at the time and afterwards – to explain the meaning of what they were doing.

To the Cubists, Cubism was spontaneous. To us it is part of history. But a curiously unfinished part. Cubism should be considered not as a stylistic category but as a moment (even if a moment lasting six or seven years) experienced by a certain number of people. A strangely placed moment.

It was a moment in which the promises of the future were more substantial than the present. With the important exception of the *avant-garde* artists during a few years after 1917 in Moscow, the confidence of the Cubists has never since been equalled among artists.

D. H. Kahnweiler, who was a friend of the Cubists and their dealer, has written: 'I lived those seven crucial years from 1907 to 1914 with my painter friends . . . what occurred at that time in the plastic arts will be understood only if one bears in mind that a new epoch was being born, in which man (all mankind in fact) was

undergoing a transformation more radical than any other known within historical times.'[2]

What was the nature of this transformation? I have outlined elsewhere (in *The Success and Failure of Picasso*) the relation between Cubism and the economic, technological and scientific developments of the period. There seems little point in repeating this here; rather, I would like to try to push a little further our definition of the philosophic meaning of these developments and their coincidence.

An interlocking world system of imperialism; opposed to it, a socialist international; the founding of modern physics, physiology and sociology; the increasing use of electricity, the invention of radio and the cinema; the beginnings of mass production; the publishing of mass-circulation newspapers; the new structural possibilities offered by the availability of steel and aluminium; the rapid development of chemical industries and the production of synthetic materials; the appearance of the motor-car and the aeroplane: What did all this mean?

The question may seem so vast that it leads to despair. Yet there are rare historical moments to which such a question can perhaps be applied. These are moments of convergence, when numerous developments enter a period of similar qualitative change, before diverging into a multiplicity of new terms. Few of those who live through such a moment can grasp the full significance of the qualitative change taking place: but everybody is aware of the times changing: the future, instead of offering continuity, appears to advance towards them.

This was surely the case in Europe from about 1900 to 1914 – although one must remember, when studying the evidence, that the reaction of many people to their own awareness of change is to pretend to ignore it.

Apollinaire, who was the greatest and most representative poet of the Cubist movement, repeatedly refers to the future in his poetry:

> Where my youth fell
> You see the flame of the future
> You must know that I speak today

2 D. H. Kahnweiler, *Cubism* (Paris: Editions Braun, 1950).

> To tell the whole world
> That the art of prophecy is born at last.

The developments which converged at the beginning of the twentieth century in Europe changed the meaning of both time and space. All, in different ways, some inhuman and others full of promise, offered a liberation from the immediate, from the rigid distinction between absence and presence. The concept of the field, first put forward by Faraday when wrestling with the problem – as defined in traditional terms – of 'action at a distance', entered now, unacknowledged, into all modes of planning and calculation and even into many modes of feeling. There was a startling extension through time and space of human power and knowledge. For the first time the world, as a totality, ceased to be an abstraction and became *realisable*.

If Apollinaire was the greatest Cubist poet, Blaise Cendrars was the first. His poem *Les Pâques à New York* (1912) had a profound influence on Apollinaire, and demonstrated to him how radically one could break with tradition. The three major poems of Cendrars at this time were all concerned with travelling – but travelling in a new sense across a *realisable* globe. In *Le Panama ou Les Aventures de Mes Sept Oncles*, he writes:

> Poetry dates from today
> > The milky way round my neck
> > The two hemispheres on my eyes
> > > At full speed
> > There are no more breakdowns
> If I had the time to save a little money I'd
> > be flying in the air show
> I have reserved my seat in the first train through
> > the tunnel under the Channel
> I am the first pilot to cross the Atlantic solo
> 900 millions

The 900 millions probably refers to the then estimated population of the world.

117

It is important to see how philosophically far-reaching were the consequences of this change and why it can be termed qualitative. It was not merely a question of faster transport, quicker messages, a more complex scientific vocabulary, larger accumulations of capital, wider markets, international organisations, and so on. The process of the secularisation of the world was at last complete. Arguments against the existence of God had achieved little. But now man was able to extend *himself* indefinitely beyond the immediate: he took over the territory in space and time where God had been presumed to exist.

Zone, the poem that Apollinaire wrote under the immediate influence of Cendrars, contains the following lines:

> Christ pupil of the eye
> Twentieth pupil of the centuries knows how
> This century changed into a bird ascends like Jesus
>
> Devils in pits raise their heads to watch it
> They say it's imitating Simon Magus of Judea
> If it can fly, we'll call it the fly one
> Angels swing past its trapeze
> Icarus Enoch Elias Apollonius of Tyana
> Hover round the first aeroplane
> Dispersing at times to let through the priests
> As they bear the Holy Eucharist
> Forever ascending and raising the Host.[3]

The second consequence concerned the relation of the self to the secularised world. There was no longer any essential discontinuity between the individual and the general. The invisible and the multiple no longer intervened between each individual and the world. It was becoming more and more difficult to think in terms of having been *placed* in the world. A man was part of the world and indivisible from it. In an entirely original sense, which remains at the basis of modern consciousness, a man *was* the world which he inherited.

3 In the Penguin translation of Apollinaire a misreading of these lines unfortunately reverses the meaning of the poem.

Again, Apollinaire expresses this:

> I have known since then the bouquet of the world
> I am drunk from having drunk the universe whole.

All the previous spiritual problems of religion and morality would now be increasingly concentrated in a man's choice of attitude to the existing state of the world, considered as his own existing state.

It is now only against the world, within his own consciousness, that he can measure his stature. He is enhanced or diminished according to how he acts towards the enhancement or diminishment of the world. His self apart from the world, his self wrenched from its global context – the sum of all existing social contexts – is a mere biological accident. The secularisation of the world exacts its price as well as offering the privilege of a choice, clearer than any other in history.

Apollinaire:

> I am everywhere or rather I start to be everywhere
> It is I who am starting this thing of the centuries
> to come.

As soon as more than one man says this, or feels it, or aspires towards feeling it – and one must remember that the notion and the feeling are the consequence of numerous material developments impinging upon millions of lives – as soon as this happens, the unity of the world has been proposed.

The term *unity of the world* can acquire a dangerously utopian aura. But only if it is thought to be politically applicable to the world as it is. A *sine qua non* for the unity of the world is the end of exploitation. The evasion of this fact is what renders the term utopian.

Meanwhile the term has other significations. In many respects (the Declaration of Human Rights, military strategy, communications, and so on), the world since 1900 has been treated as a single unit. The unity of the world has received de facto recognition.

Today we know that the world should be unified, just as we know that all men should have equal rights. Insofar as a man denies this or

acquiesces in its denial, he denies the unity of his own self. Hence the profound psychological sickness of the imperialist countries, hence the corruption implicit in so much of their learning – when knowledge is used to deny knowledge.

At the moment of Cubism, no denials were necessary. It was a moment of prophecy, but prophecy as the basis of a transformation that had actually begun.

Apollinaire:

> Already I hear the shrill sound of the friend's voice to come
> Who walks with you in Europe
> Whilst never leaving America.

I do not wish to suggest a general period of ebullient optimism. It was a period of poverty, exploitation, fear and desperation. The majority could only be concerned with the means of their survival, and millions did not survive. But for those who asked questions, there were new positive answers whose authenticity seemed to be guaranteed by the existence of new forces.

The socialist movements in Europe (with the exception of that in Germany and sections of the trade union movement in the United States) were convinced that they were on the eve of revolution and that the revolution would spread to become a world revolution. This belief was shared even by those who disagreed about the political means necessary – by syndicalists, parliamentarians, communists and anarchists.

A particular kind of suffering was coming to an end: the suffering of hopelessness and defeat. People now believed, if not for themselves then for the future, in victory. The belief was often strongest where the conditions were worst. Everyone who was exploited or downtrodden and who had the strength left to ask about the purpose of his miserable life was able to hear in answer the echo of declarations like that of Lucheni, the Italian anarchist who stabbed the empress of Austria in 1898: 'The hour is not far distant when a new sun will shine upon all men alike', or like that of Kalyaev in 1905 who, on being sentenced to death for the assassination of the governor-general of Moscow, told the court 'to learn to look the advancing revolution straight in the eye'.

An end was in sight. The limitless, which until now had always reminded men of the unattainability of their hopes, became suddenly an encouragement. The world became a starting point.

The small circle of Cubist painters and writers were not directly involved in politics. They did not think in political terms. Yet they were concerned with a revolutionary transformation of the world. How was this possible? Again we find the answer in the historical timing of the Cubist moment. It was not then essential for a man's intellectual integrity to make a political choice. Many developments, as they converged to undergo an equivalent qualitative change, appeared to promise a transformed world. The promise was an overall one.

'All is possible', wrote André Salmon, another Cubist poet, 'everything is realisable everywhere and with everything.'

Imperialism had begun the process of unifying the world. Mass production promised eventually a world of plenty. Mass-circulation newspapers promised informed democracy. The aeroplane promised to make the dream of Icarus real. The terrible contradictions born of the convergence were not yet clear. They became evident in 1914, and they were first politically polarised by the Russian Revolution of 1917. El Lissitzky, one of the great innovators of Russian revolutionary art until this art was suppressed, implies in a biographical note how the moment of political choice came from the conditions of the Cubist moment:

The Film of El's Life till 1926[4]
BIRTH: My generation was born
a few dozen years
before the Great October Revolution.
ANCESTORS: A few centuries ago our ancestors had the luck
to make the great voyages of discovery.
WE: We, the grandchildren of Columbus,
are creating the epoch of the most glorious inventions.

4 El Lissitzky, *El Lissitzky: Maler, Architekt, Typograf, Fotograf / Erinnerungen, Briefe, Schriften übergeben von Sophie Lissitzky-Küppers* (Dresden: Verlag der Kunst, 1967), p. 325 (selection translated by Anya Bostock).

They have made our globe very small,
but have
expanded our space
and intensified our time.
SENSATIONS: My life is accompanied
by unprecedented sensations.
Barely five years old I had the rubber leads
of Edison's phonograph stuck in my ears.
Eight years,
and I was chasing after the first electric tram in Smolensk,
the diabolical force
which drove the peasant horses out of the town.
COMPRESSION OF MATTER: The steam engine rocked my
cradle.
In the meantime it has gone the way of all ichthyosauruses.
Machines are ceasing
to have fat bellies full of intestines.
Already we have the compressed skulls
of dynamos with their electric brains.
Matter and mind
are directly transmitted through crankshafts
and thus made to work.
Gravity and inertia are being overcome.
1918: In 1918 in Moscow before my eyes
the short-circuit sparked
which split the world in
half.
This stroke drove our present apart
like a wedge
between yesterday and tomorrow.
My work
too
forms part of driving the wedge
further
in.
One belongs here or there:
there is no middle.

The Cubist movement ended in France in 1914. With the war a new kind of suffering was born. Men were forced to face for the first time the full horror – not of hell, or damnation, or a lost battle, or famine, or plague – but the full horror of what stood in the way of their own progress. And they were forced to face this in terms of their own responsibility, not in terms of a simple confrontation as between clearly defined enemies.

The scale of the waste and the irrationality and the degree to which men could be persuaded and forced to deny their own interests led to the belief that there were incomprehensible and blind forces at work. But since these forces could no longer be accommodated by religion, and since there was no ritual by which they could be approached or appeased, each man had to live with them *within himself*, as best he could. Within him they destroyed his will and confidence.

On the last page of *All Quiet on the Western Front*, the hero thinks:

> I am very quiet. Let the months and years come, they can take nothing from me, they can take nothing more. I am so alone, and so without hope that I can confront them without fear. The life that has borne me through these years is still in my hands and my eyes. Whether I have subdued it, I know not. But so long as it is there it will seek its own way out, heedless of the will that is within me.[5]

The new kind of suffering which was born in 1914 and has persisted in Western Europe until the present day is an inverted suffering. Men fought within themselves about the meaning of events, identity, hope. This was the negative possibility implicit in the new relation of the self to the world. The life they experienced became a chaos within them. They became lost within themselves.

Instead of apprehending (in however simple and direct a way) the processes which were rendering their own destinies identical with the world's, they submitted to the new condition passively. That is to say the world, which was nevertheless indivisibly part of them, reverted *in their minds* to being the old world which was separate from them and opposed them: it was as though they had been forced to devour God,

5 E. M. Remarque, *All Quiet on the Western Front*, trans. A. W. Wheen (New York: Mayflower-Dell Paperback, 1963).

heaven and hell and live for ever with the fragments inside themselves. It was indeed a new and terrible form of suffering and it coincided with the widespread, deliberate use of false ideological propaganda as a weapon. Such propaganda preserves within people outdated structures of feeling and thinking whilst forcing new experiences upon them. It transforms them into puppets – whilst most of the strain brought about by the transformation remains politically harmless as inevitably *incoherent* frustration. The only purpose of such propaganda is to make people deny and then abandon the selves which otherwise their own experience would create.

In *La Jolie Rousse*, Apollinaire's last long poem (he died in 1918), his vision of the future, after his experience of the war, has become a source of suffering as much as of hope. How can he reconcile what he has seen with what he once foresaw? From now on there can be no unpolitical prophecies.

> We are not your enemies
> We want to take over vast strange territories
> Where the flowering mystery waits to be picked
> Where there are fires and colours never yet seen
> A thousand imponderable apparitions
> Which must be given reality
> We wish to explore the vast domain of goodness
> where everything is silent
> And time can be pursued or brought back
> Pity us who fight continually on the frontiers
> Of the infinite and the future
> Pity for our mistakes pity for our sins.
> The violence of summer is here
> My youth like the spring is dead
> Now, O sun, is the time of scorching Reason
> Laugh then laugh at me
> Men from everywhere and more particularly here
> For there are so many things I dare not tell you
> So many things you will not let me say
> Have pity on me.

We can now begin to understand the central paradox of Cubism. The spirit of Cubism was objective. Hence its calm and its comparative anonymity as between artists. Hence also the accuracy of its technical prophecies. I live in a satellite city that has been built during the last five years. The character of the pattern of what I now see out of the window as I write can be traced directly back to the Cubist pictures of 1911 and 1912. Yet the Cubist spirit seems to us today to be curiously distant and disengaged.

This is because the Cubists took no account of politics *as we have since experienced them*. In common with even their experienced political contemporaries, they did not imagine and did not foresee the extent, depth and duration of the suffering which would be involved in the political struggle to realise what had so clearly become possible and what has since become imperative.

The Cubists imagined the world transformed, but not the process of transformation.

Cubism changed the nature of the relationship between the painted image and reality, and by so doing it expressed a new relationship between man and reality.

Many writers have pointed out that Cubism marked a break in the history of art comparable to that of the Renaissance in relation to medieval art. That is not to say that Cubism can be equated with the Renaissance. The confidence of the Renaissance lasted for about sixty years (approximately from 1420 to 1480): that of Cubism lasted for about six years. However, the Renaissance remains a point of departure for appreciating Cubism.

In the early Renaissance the aim of art was to imitate nature. Alberti formulated this view: 'The function of the painter is to render with lines and colours, on a given panel or wall, the visible surface of any body, so that at a certain distance and from a certain position it appears in relief and just like the body itself.'[6]

It was not, of course, as simple as that. There were the mathematical problems of linear perspective which Alberti himself solved. There was the question of choice – that is to say, the question of the artist

6 Quoted in Anthony Blunt, *Artistic Theory in Italy, 1450–1600* (Oxford: Oxford Paperbacks, 1962).

doing justice to nature by choosing to represent what was typical of nature at her best.

Yet the artist's relation to nature was comparable to that of the scientist. Like the scientist, the artist applied reason and method to the study of the world. He observed and ordered his findings. The parallelism of the two disciplines is later demonstrated by the example of Leonardo.

Although often employed far less accurately during the following centuries, the metaphorical model for the function of painting at this time was *the mirror*. Alberti cites Narcissus when he sees himself reflected in the water as the first painter. The mirror renders the appearances of nature and simultaneously delivers them into the hands of man.

It is extremely hard to reconstruct the attitudes of the past. In the light of more recent developments and the questions raised by them, we tend to iron out the ambiguities which may have existed before the questions were formed. In the early Renaissance, for example, the humanist view and a medieval Christian view could still be easily combined. Man became the equal of God, but both retained their traditional positions. Arnold Hauser writes of the early Renaissance: 'The seat of God was the centre round which the heavenly spheres revolved, the earth was the centre of the material universe, and man himself a self-contained microcosm round which, as it were, revolved the whole of nature, just as the celestial bodies revolved round that fixed star, the earth.'[7]

Thus man could observe nature around him on every side and be enhanced both by what he observed and by his own ability to observe. He had no need to consider that he was essentially part of that nature. *Man was the eye for which reality had been made visual*: the ideal eye, the eye of the viewing-point of Renaissance perspective. The human greatness of this eye lay in its ability to reflect and contain, like a mirror, what was.

The Copernican revolution, Protestantism, the Counter-Reformation destroyed the Renaissance position. With this destruction modern subjectivity was born. The artist becomes primarily concerned

7 See Arnold Hauser's *Mannerism* (London: Routledge, 1965), p. 44 – an essential book for anybody concerned with the problematic nature of contemporary art, and its historical roots.

with creation. His own genius takes the place of nature as the marvel. It is the gift of his genius, his 'spirit', his 'grace', which makes him god-like. At the same time the equality between man and god is totally destroyed. Mystery enters art to emphasise the inequality. A century after Alberti's claim that art and science are parallel activities, Michelangelo speaks – no longer of imitating nature – but of imitating Christ: 'In order to imitate in some degree the venerable image of Our Lord, it is not enough to be a painter, a great and skilful master; I believe that one must further be of blameless life, even if possible a saint, that the Holy Spirit may inspire one's understanding.'[8]

It would take us too far from our field even to attempt to trace the history of art from Michelangelo onwards – Mannerism, the Baroque, seventeenth- and eighteenth-century Classicism. What is relevant to our purpose is that, from Michelangelo until the French Revolution, the metaphorical model for the function of painting becomes the *theatre stage*. It may seem unlikely that the same model works for a visionary like El Greco, a Stoic like Poussin (who actually worked from stage models he built himself) and a middle-class moralist like Chardin. Yet all the artists of these two centuries shared certain assumptions. For them, all the power of art lay in its *artificiality*. That is to say, they were concerned with constructing comprehensive examples of some truth such as could not be met with in such an ecstatic, pointed, sublime or meaningful way in life itself.

Painting became a schematic art. The painter's task was no longer to represent or imitate what existed: it was to summarise experience. Nature is now what man has to redeem himself from. The artist becomes responsible not simply for the means of conveying a truth, but also for the truth itself. Painting ceases to be a branch of natural science and becomes a branch of the moral sciences.

In the theatre the spectator faces events from whose consequences he is immune: he may be affected emotionally and morally, but he is physically removed, protected, separate, from what is happening before his eyes. What is happening is artificial. It is *he* who now represents nature – not the work of art. And if, at the same time, it is from himself that he must redeem himself, this represents the contradiction

8 Quoted in Blunt, *Artistic Theory in Italy*.

of the Cartesian division which prophetically or actually so dominated these two centuries.

Rousseau, Kant and the French Revolution – or rather, all the developments which lay behind the thought of the philosophers and the actions of the Revolution – made it impossible to go on believing in constructed order as against natural chaos. The metaphorical model changed again, and once more it applies over a long period despite dramatic changes of style. The new model is that of the *personal account*. Nature no longer confirms or enhances the artist as he investigates it. Nor is he any longer concerned with creating 'artificial' examples, for these depend upon the common recognition of certain moral values. He is now alone, surrounded by nature, from which his own experience separates him.

Nature is what he sees *through* his experience. There is thus in all nineteenth-century art – from the 'pathetic fallacy' of the Romantics to the 'optics' of the Impressionists – considerable confusion about where the artist's experience stops and nature begins. The artist's personal account is his attempt to make his experience as real as nature, which he can never reach, by communicating it to others. The considerable suffering of most nineteenth-century artists arose out of this contradiction: because they were alienated from nature, they needed to present *themselves* as nature to others.

Speech, as the recounting of experience and the means of making it real, preoccupied the Romantics. Hence their constant comparisons between paintings and poetry. Géricault, whose *Raft of the Medusa* was the first painting of a contemporary event consciously based on eye-witness accounts, wrote in 1821: 'How I should like to be able to show our cleverest painters several portraits, which are such close resemblances to nature, whose easy pose leaves nothing to be desired, and of which one can really say that all they lack is the power of speech.'[9]

In 1850 Delacroix wrote: 'I have told myself a hundred times that painting – that is to say, the material thing called painting – was no more than the pretext, the bridge between the mind of the painter and that of the spectator . . .'[10]

9 R. J. Goldwate and M. Treves, eds, *Artists on Art* (New York: Pantheon, 1945).
10 Ibid.

For Corot, experience was a far less flamboyant and more modest affair than for the Romantics. But nevertheless he still emphasised how essential the personal and the relative are to art. In 1856 he wrote: 'Reality is one part of art: feeling completes it . . . before any site and any object, abandon yourself to your first impression. If you have really been touched, you will convey to others the sincerity of your emotion.'[11]

Zola, who was one of the first defenders of the Impressionists, defined a work of art as 'a corner of nature seen through a temperament'. The definition applies to the whole of the nineteenth century and is another way of describing the same metaphorical model.

Monet was the most theoretical of the Impressionists and the most anxious to break through the century's barrier of subjectivity. For him (at least theoretically), the role of his temperament was reduced to that of the process of perception. He speaks of a 'close fusion' with nature. But the result of this fusion, however harmonious, is a sense of power-lessness – which suggests that, bereft of his subjectivity, he has nothing to put in its place. Nature is no longer a field for study, it has become an overwhelming force. One way or another, the confrontation between the artist and nature in the nineteenth century is an unequal one. Either the heart of man or the grandeur of nature dominates.

> I have painted for half a century [wrote Monet], and will soon have passed my sixty-ninth year, but, far from decreasing, my sensitivity has sharpened with age. As long as constant contact with the outside world can sustain the ardour of my curiosity, and my hand remains the quick and faithful servant of my perception, I have nothing to fear from old age. I have no other wish than a close fusion with nature, and I desire no other fate than (according to Goethe) to have worked and lived in harmony with her rules. Beside her grandeur, her power and her immortality, the human creature seems but a miserable atom.

I am well aware of the schematic nature of this brief survey. Is not Delacroix in some senses a transitional figure between the eighteenth and nineteenth centuries? And was not Raphael another transitional

11 Ibid.

figure who confounds such simple categories? The scheme, however, is true enough to help us appreciate the nature of the change which Cubism represented.

The metaphorical model of Cubism is the *diagram*: the diagram being a visible, symbolic representation of invisible processes, forces, structures. A diagram need not eschew certain aspects of appearances: but these too will be treated symbolically as *signs*, not as imitations or re-creations.

The model of the *diagram* differs from that of the *mirror* in that it suggests a concern with what is not self-evident. It differs from the model of the *theatre stage* in that it does not have to concentrate upon climaxes but can reveal the continuous. It differs from the model of the *personal account* in that it aims at a general truth.

The Renaissance artist imitated nature. The Mannerist and Classic artist reconstructed examples from nature in order to transcend nature. The nineteenth-century artist experienced nature. The Cubist realised that his awareness of nature was part of nature.

Heisenberg speaks as a modern physicist: 'Natural science does not simply describe and explain nature; it is part of the interplay between nature and ourselves: it describes nature as exposed to our method of questioning.'[12] Similarly, the frontal facing of nature became inadequate in art.

How did the Cubists express their intimation of the new relation existing between man and nature?

1. By their use of space

Cubism broke the illusionist three-dimensional space which had existed in painting since the Renaissance. It did not destroy it. Nor did it muffle it – as Gauguin and the Pont-Aven school had done. It broke its continuity. There is space in a Cubist painting, in that one form can be inferred to be behind another. But the relation between any two forms does not, as it does in illusionist space, establish the rule for all the spatial relationships between all the forms portrayed in the picture. This is possible without a nightmarish deformation of space, because

12 Werner Heisenberg, *Physics and Philosophy* (London: Allen & Unwin, 1959), p. 75.

the two-dimensional surface of the picture is always there as arbiter and resolver of different claims. The picture surface acts in a Cubist painting as the constant which allows us to appreciate the variables. Before and after every sortie of our imagination into the problematic spaces and through the interconnections of a Cubist painting, we find our gaze resettled on the picture surface, aware once more of two-dimensional shapes on a two-dimensional board or canvas.

This makes it impossible to *confront* the objects or forms in a Cubist work. Not only because of the multiplicity of viewpoints – so that, say, a view of a table from below is combined with a view of the table from above and from the side – but also because the forms portrayed never present themselves as a totality. The totality is the surface of the picture, *which is now the origin and sum of all that one sees.* The viewing-point of Renaissance perspective, fixed and outside the picture, but to which everything within the picture was drawn, has become a field of vision which is the picture itself.

It took Picasso and Braque three years to arrive at this extraordinary transformation. In most of their pictures from 1907 to 1910 there are still compromises with Renaissance space. The effect of this is to deform the subject. The figure or landscape becomes the construction, instead of the construction being the picture acting as an expression of the relation between viewer and subject.[13]

After 1910 all references to appearances are made as signs on the picture surface. A circle for a top of a bottle, a lozenge for an eye, letters for a newspaper, a volute for the head of a violin, and so on. Collage was an extension of the same principle. Part of the actual or imitation surface of an object was stuck on to the surface of the picture as a sign referring to, but not imitating, its appearance. A little later painting borrowed from this experience of collage, so that, say, a pair of lips or a bunch of grapes might be referred to by a drawing which 'pretended' to be on a piece of white paper stuck on to the picture surface.

13 For a similar analysis of Cubism, written thirty years earlier but unknown to the author at the time of writing, see Max Raphael's great work, *The Demands of Art* (London: Routledge, 1969), p. 162.

2. *By their treatment of form*

It was this which gave the Cubists their name. They were said to paint everything in *cubes*. Afterwards this was connected with Cézanne's remark: 'Treat nature by the cylinder, by the sphere, the cone, everything in proper perspective . . .' And from then on the misunderstanding has continued – encouraged, let it be said, by a lot of confused assertions by some of the lesser Cubists themselves.

The misunderstanding is that the Cubist wanted to simplify – for the sake of simplification. In some of the Picassos and Braques of 1908 it may look as though this is the case. Before finding their new vision, they had to jettison traditional complexities. But their aim was to arrive at a far more complex image of reality than had ever been attempted in painting before.

To appreciate this, we must abandon a habit of centuries: the habit of looking at every object or body as though it were complete in itself, its completeness making it separate. The Cubists were concerned with the interaction between objects.

They reduced forms to a combination of cubes, cones, cylinders – or, later, to arrangements of flatly articulated facets or planes with sharp edges – so that the elements of any one form were interchangeable with another, whether a hill, a woman, a violin, a carafe, a table or a hand. Thus, as against the Cubist discontinuity of space, they created a continuity of structure. Yet when we talk of the Cubist discontinuity of space, it is only to distinguish it from the convention of linear Renaissance perspective.

Space is part of the continuity of the events within it. It is in itself an event, comparable with other events. It is not a mere container. And this is what the few Cubist masterpieces show us. The space between objects is part of the same structure as the objects themselves. The forms are simply reversed so that, say, the top of a head is a convex element and the adjacent space which it does not fill is a concave element.

The Cubists created the possibility of art revealing processes instead of static entities. The content of their art consists of various modes of interaction: the interaction between different aspects of the same event, between empty space and filled space, between structure and movement, between the seer and the thing seen.

Rather than ask of a Cubist picture: Is it true? or: Is it sincere? one should ask: Does it continue?

∾

TODAY IT IS easy to see that, since Cubism, painting has become more and more diagrammatic, even when there has been no direct Cubist influence – as, say, in Surrealism. Eddie Wolfram, in an article about Francis Bacon, writes: 'Painting today functions directly as a conceptual activity in philosophical terms and the art object acts only as a cypher reference to tangible reality.'[14]

This was part of the Cubist prophecy. But only part. Byzantine art might equally well be accommodated within Wolfram's definition. To understand the full Cubist prophecy we must examine the content of their art.

A Cubist painting like Picasso's *Bottle and Glasses* of 1911 is two-dimensional insofar as one's eye comes back again and again to the surface of the picture. We start from the surface, we follow a sequence of forms which leads into the picture, and then suddenly we arrive back at the surface again and deposit our newly acquired knowledge upon it, before making another foray. This is why I called the Cubist picture-surface the origin and sum of all that we can see in the picture. There is nothing decorative about such two-dimensionality, nor is it merely an area offering possibilities of juxtaposition for dissociated images – as in the case of much recent Neo-Dadaist or Pop Art. We begin with the surface, but since everything in the picture refers back to the surface we begin with the conclusion. We then search, not for an explanation, as we do if presented with an image with a single, predominant meaning (a man laughing, a mountain, a reclining nude), but for some understanding of the configuration of events whose interaction is the conclusion from which we began. When we 'deposit our newly acquired knowledge upon the picture surface', what we in fact do is to find the sign for what we have just discovered: a sign which was always there but which previously we could not read.

To make the point clearer it is worth comparing a Cubist picture with any work in the Renaissance tradition. Let us say Pollaiuolo's

14 Eddie Wolfram, *Art and Artists* (London), September 1966.

*Terrain*

Martyrdom of St Sebastian. In front of the Pollaiuolo the spectator completes the picture. It is the spectator who draws the conclusions and infers all except the aesthetic relations between the pieces of evidence offered – the archers, the martyr, the plain laid out behind, and so on. It is he who through his reading of what is portrayed seals its unity of meaning. The work is presented to him. One has the feeling almost that St Sebastian was martyred so that he should be able to explain this picture. The complexity of the forms and the scale of the space depicted enhance the sense of achievement, of grasp.

In a Cubist picture, the conclusion and the connections are given. They are what the picture is made of. They are its content. The spectator has to find his place *within* this content whilst the complexity of the forms and the 'discontinuity' of the space remind him that his view from that place is bound to be only partial.

Such content and its functioning was prophetic because it coincided with the new scientific view of nature which rejected simple causality and the single permanent all-seeing viewpoint.

Heisenberg writes:

One may say that the human ability to understand may be in a certain sense unlimited. But the existing scientific concepts cover always only a very limited part of reality, and the other part that has not yet been understood is infinite. Whenever we proceed from the known to the unknown we may hope to understand, but we may have to learn at the same time a new meaning of the word understanding.[15]

Such a notion implies a change in the methodology of research and invention. W. Grey Walter, the physiologist, writes:

Classical physiology, as we have seen, tolerated only one single unknown quantity in its equations – in any experiment there could be only one thing at a time under investigation . . . We cannot extract one independent variable in the classical manner; we have to deal with the interaction of many unknowns and variables, all

15 Heisenberg, *Physics and Philosophy*, p. 172.

*134*

the time ... In practice, this implies that not one but many – as many as possible – observations must be made at once and compared with one another, and that whenever possible a simple known variable should be used to modify the several complex unknowns so that their tendencies and interdependence can be assessed.[16]

The best Cubist works of 1910, 1911 and 1912 were sustained and precise models for the method of searching and testing described above. That is to say, they force the senses and imagination of the spectator to calculate, omit, doubt and conclude according to a pattern which closely resembles the one involved in scientific observation. The difference is a question of appeal. Because the act of looking at a picture is far less concentrated, the picture can appeal to wider and more various areas of the spectator's previous experience. Art is concerned with memory: experiment is concerned with predictions.

Outside the modern laboratory, the need to adapt oneself constantly to presented totalities – rather than making inventories or supplying a transcendental meaning, as in front of the Pollaiuolo – is a feature of modern experience which affects everybody through the mass media and modern communication systems.

Marshall McLuhan is a manic exaggerator, but he has seen certain truths clearly:

> In the electric age, when our central nervous system is technologically extended to involve us in the whole of mankind and to incorporate the whole of mankind in us, we necessarily participate, in depth, in the consequences of our every action ... The aspiration of our time for wholeness, empathy and depth of awareness is a natural adjunct of electric technology. The age of mechanical industry that preceded us found vehement assertion of private outlook the natural mode of expression ... The mark of our time is its revolution against imposed patterns. We are suddenly eager to have things and people declare their beings totally.[17]

16 W. Grey Walter, *The Living Brain* (Harmondsworth: Penguin, 1961 [1953]), p. 69.

17 Marshall McLuhan, *Understanding Media* (London: Routledge & Kegan Paul, 1964), pp. 4, 5.

The Cubists were the first artists to attempt to paint totalities rather than agglomerations.

I must emphasise again that the Cubists were not aware of all that we are now reading into their art. Picasso and Braque and Léger kept silent because they knew that they might be doing more than they knew. The lesser Cubists tended to believe that their break with tradition had freed them from the bondage of appearances so that they might deal with some kind of spiritual essence. The idea that their art coincided with the implications of certain new scientific and technological developments was entertained but never fully worked out. There is no evidence at all that they recognised as such the qualitative change which had taken place in the world. It is for these reasons that I have constantly referred to their *intimation* of a transformed world: it amounted to no more than that.

One cannot explain the exact dates of the maximum Cubist achievement. Why 1910 to 1912 rather than 1905 to 1907? Nor is it possible to explain *exactly* why certain artists, at exactly the same time, arrived at a very different view of the world – artists ranging from Bonnard to Duchamp or de Chirico. To do so we would need to know an *impossible* amount about each separate individual development. (In that impossibility – which is an absolute one – lies our freedom from determinism.)

We have to work with partial explanations. With the advantage of sixty years' hindsight, the correlations I have tried to establish between Cubism and the rest of history seem to me to be undeniable. The precise route of the connections remains unknown. They do not inform us about the intentions of the artists: they do not explain exactly why Cubism took place in the manner it did: but they do help to disclose the widest possible continuing meaning of Cubism.

Two more reservations. Because Cubism represented so fundamental a revolution in the history of art, I have had to discuss it as though it were pure theory. Only in this way could I make its revolutionary content clear. But naturally it was not pure theory. It was nothing like so neat, consistent or reduced. There are Cubist paintings full of anomalies and marvellous gratuitous tenderness and confused excitement. We see the beginning in the light of the conclusions it suggested. But it was only a beginning, and a beginning cut short.

For all their insight into the inadequacy of appearances and of the frontal view of nature, the Cubists used such appearances as their means of reference to nature. In the maelstrom of their new constructions, their liaison with the events which provoked them is shown by way of a simple, almost naive reference to a pipe stuck in the 'sitter's' mouth, a bunch of grapes, a fruit dish or the title of a daily newspaper. Even in some of the most 'hermetic' paintings – for example Braque's *Le Portugais* – you can find naturalistic allusions to details of the subject's appearance, such as the buttons on the musician's jacket, buried intact within the construction. There are only a very few works – for instance Picasso's *Le Modèle* of 1912 – where such allusions have been totally dispensed with.

The difficulties were probably both intellectual and sentimental. The naturalistic allusions seemed necessary in order to offer a measure for judging the transformation. Perhaps also the Cubists were reluctant to part with appearances because they suspected that in art they could never be the same again. The details are smuggled in and hidden as mementos.

The second reservation concerns the social content of Cubism – or, rather, its lack of it. One cannot expect of a Cubist painting the same kind of social content as one finds in a Bruegel or a Courbet. The mass media and the arrival of new publics have profoundly changed the social role of the Fine Arts. It remains true, however, that the Cubists – during the moment of Cubism – were unconcerned about the personalised human and social implications of what they were doing. This, I think, is because they had to simplify. The problem before them was so complex that their manner of stating it and their trying to solve it absorbed all their attention. As innovators they wanted to make their experiments in the simplest possible conditions; consequently, they took as subjects whatever was at hand and made fewest demands. The content of these works is the relation between the seer and the seen. This relation is only possible given the fact that the seer inherits a precise historical, economic and social situation. Otherwise they become meaningless. They do not illustrate a human or social situation, they posit it.

I spoke of the continuing meaning of Cubism. To some degree this meaning has changed and will change again according to the needs of

the present. The bearings we read with the aid of Cubism vary according to our position. What is the reading now?

It is being more and more urgently claimed that 'the modern tradition' begins with Jarry, Duchamp and the Dadaists. This confers legitimacy upon the recent developments of Neo-Dadaism, Auto-Destructive Art, Happenings, and so on. The claim implies that what separates the characteristic art of the twentieth century from the art of all previous centuries is its acceptance of unreason, its social desperation, its extreme subjectivity and its forced dependence upon existential experience.

Hans Arp, one of the original Dadaist spokesmen, wrote: 'The Renaissance taught men the haughty exaltation of their reason. Modern times, with their science and technology, turned men towards megalomania. The confusion of our epoch results from this over-estimation of reason.'

And elsewhere: 'The law of chance, which embraces all other laws and is as unfathomable to us as the depths from which all life arises, can only be comprehended by complete surrender to the Unconscious.'[18]

Arp's statements are repeated today with a slightly modified vocabulary by all contemporary apologists of outrageous art. (I use the word outrageous descriptively and not in a pejorative sense.)

During the intervening years, the Surrealists, Picasso, de Chirico, Miró, Klee, Dubuffet, the Abstract Expressionists and many others can be drafted into the same tradition: the tradition whose aim is to cheat the world of its hollow triumphs, and disclose its pain.

The example of Cubism forces us to recognise that this is a one-sided interpretation of history. Outrageous art has many earlier precedents. In periods of doubt and transition the majority of artists have always tended to be preoccupied with the fantastic, the uncontrollable and the horrific. The greater extremism of contemporary artists is the result of their having no fixed social role; to some degree they can create their own. Thus there is no precedent in art history for, say, auto-destructive art. But there are precedents for the spirit of it in the history of other activities: heretical religions, alchemy, witchcraft, and so on.

The real break with tradition, or the real reformation of that tradition, occurred with Cubism itself. The modern tradition, based on a

18 Quoted in Hans Richter, *Dada* (London: Thames & Hudson, 1965), p. 55.

qualitatively different relationship being established between man and the world, began, not in despair, but in affirmation.

The proof that this was the objective role of Cubism lies in the fact that, however much its spirit was rejected, it supplied to all later movements the primary means of their own liberation. That is to say, it re-created the syntax of art so that it could accommodate modern experience. The proposition that a work of art is a new object and not simply the expression of its subject, the structuring of a picture to admit the coexistence of different modes of space and time, the inclusion in a work of art of extraneous objects, the dislocation of forms to reveal movement or change, the combining of hitherto separate and distinct media, the diagrammatic use of appearances – these were the revolutionary innovations of Cubism.

It would be foolish to underestimate the achievements of post-Cubist art. Nevertheless it is fair to say that in general the art of the post-Cubist period has been anxious and highly subjective. What the evidence of Cubism should prevent us doing is concluding from this that anxiety and extreme subjectivity constitute the nature of modern art. They constitute the nature of art in a period of extreme ideological confusion and inverted political frustration.

During the first decade of this century a transformed world became theoretically possible and the necessary forces of change could already be recognised as existing. Cubism was the art which reflected the possibility of this transformed world and the confidence it inspired. Thus, in a certain sense, it was the most modern art – as it was also the most philosophically complex – which has yet existed.

The vision of the Cubist moment still coincides with what is technologically possible. Yet three-quarters of the world remain undernourished and the foreseeable growth of the world's population is outstripping the production of food. Meanwhile millions of the privileged are the prisoners of their own sense of increasing powerlessness.

The political struggle will be gigantic in its range and duration. The transformed world will not arrive as the Cubists imagined it. It will be born of a longer and more terrible history. We cannot see the end of the present period of political inversion, famine and exploitation. But the moment of Cubism reminds us that, if we are to be representative of our century – and not merely its passive

creatures – the aim of achieving that end must constantly inform our consciousness and decisions.

The moment at which a piece of music begins provides a clue to the nature of all art. The incongruity of that moment, compared to the uncounted, unperceived silence which preceded it, is the secret of art. What is the meaning of that incongruity and the shock which accompanies it? It is to be found in the distinction between the actual and the desirable. All art is an attempt to define and make *unnatural* this distinction.

For a long time it was thought that art was the imitation and celebration of nature. The confusion arose because the concept of nature itself was a projection of the desired. Now that we have cleansed our view of nature, we see that art is an expression of our sense of the inadequacy of the given – which we are not obliged to accept with gratitude. Art mediates between our good fortune and our disappointment. Sometimes it mounts to a pitch of horror. Sometimes it gives permanent value and meaning to the ephemeral. Sometimes it describes the desired.

Thus art, however free or anarchic its mode of expression, is always a plea for greater control and an example, within the artificial limits of a 'medium', of the advantages of such control. Theories about the artist's inspiration are all projections back on to the artist of the effect which his work has upon us. The only inspiration which exists is the intimation of our own potential. Inspiration is the mirror-image of history: by means of it we can see our past, whilst turning our back upon it. And it is precisely this which happens at the instant when a piece of music begins. We suddenly become aware of the previous silence at the same moment as our attention is concentrated upon following sequences and resolutions which will contain the desired.

The Cubist moment was such a beginning, defining desires which are still unmet.

20.

Parade, 1917

AFTER *LES DEMOISELLES D'AVIGNON* (1909) Picasso became caught up in what he had provoked. He became part of a group. That is not just to say that he had his own circle of friends – for this he had had before and would have afterwards. He became part of a group who, although they did not formulate a programme, were all working in the same direction. This is the only period in Picasso's whole life when his work to some extent resembles that of other contemporary painters. It is also the one period of his life when his work (despite his own denial of this) reveals an absolutely consistent line of development: from *Landscape with a Bridge* in 1908 to, say, *The Violin* of 1913. It was a period of great excitements, but also a period of inner certainty and security. It was, I believe, the only time when Picasso felt entirely at home. It is from that period, as much as from Spain, that he has since been exiled.

Within the group (although *group* is a word that is already a little too formal), within the companionship established, Picasso's energy and extremism were still outstanding. It was probably he who mostly pushed the arguments and logic to their full pictorial conclusions. (It was he who first thought of sticking extraneous material on to a canvas.) But it was probably his friends who sensed the pressure of what I have called the historical convergence which made Cubism possible. It was

they, rather than he, who belonged to the modern world, and so were committed to it. He was committed to his work with them.

<p style="text-align:center">ℭℛ</p>

IN 1914 THE group dispersed. Braque, Derain, Léger, Apollinaire went to fight. Kahnweiler, who was Picasso's dealer, had to flee the country because he was German. Equivalent changes affected millions of people's lives.

Picasso was unconcerned about the war. It was not *his* war – another example of how tenuously he belonged to the life around him. Yet he suffered because he was left alone, and his loneliness was increased in 1915 by the tragic death of his young mistress. Under the pressure of this loneliness, he reverted to type. He re-became a vertical invader from the past. But before we examine the full consequences of this, I would like to show by example how, after 1914, the whole relationship between art and reality shifted.

It was not simply a question of dispersal. After the war most of the Cubists came back to Paris. Yet it was quite impossible for them to find or re-create the spirit and atmosphere of 1910. Not only was the whole aspect of the world different, not only had disillusion taken the place of hope, but their own position relative to the world had altered. Up to 1914 they had been ahead of events, and their work prophetic. After the war events were ahead of them. Reality outstripped them. They no longer sensed – even intuitively – the drift of what was happening. The age of essential politics had begun. What was revolutionary was now inevitably political. The great innovator, the great revolutionary artist of the 1920s, was Eisenstein. (James Joyce belonged essentially to the pre-war world.) Some of the Cubists, such as Léger, and some of their followers, like Le Corbusier, acquired a political view and moved forward to become a new *avant-garde*. Others retreated. Max Jacob, for example, once sceptical and heretical, became a baptised Catholic in 1915 and went to live in a monastery.

Nothing illustrates this change more vividly than the story of the ballet *Parade*. The Cubists had always despised the ballet as a pretentious and bourgeois form of entertainment. They preferred fairgrounds and the circus. In 1917, however, Jean Cocteau persuaded Picasso to collaborate with him and the composer Erik Satie in the creation of a

ballet for Diaghilev. Diaghilev's company had been fashionable in Paris for ten years. In Russia it was a favourite of the Tsar. But Cocteau's plan was to break with tradition and produce a 'modern' spectacle. The title *Parade* was meant to suggest the circus and music-hall, and so exorcise the bourgeois ghosts.

Picasso went to Rome to work on the ballet. He designed the drop-curtain, the costumes, and the scenery. He also contributed ideas and suggestions. The drop-curtain is sentimental, perhaps deliberately so. But it fits the new milieu in which Picasso now found himself. 'We made *Parade*', wrote Cocteau, 'in a cellar in Rome where the troupe rehearsed, we walked by moonlight with the dancers, we visited Naples and Pompeii. We got to know the gay futurists.' It is a long way from the violence of the *Demoiselles d'Avignon*, a long way from the austerity of the Cubist still lifes, and a very long way from the Western Front in the third year of the World War.

The ballet itself was less conventional. And it might be argued that the drop-curtain was deliberately designed to lull the audience. There were seven characters in the ballet: a Chinese conjurer, an American girl, two acrobats and three stage-managers. These last wore constructions made up of 'Cubist' elements which made them ten feet tall. One of them was French and 'wore' the trees of the boulevards, another was American and 'wore' skyscrapers, and the third was a horse. They moved about the stage like moving scenery, and their purpose was to dwarf the dancers, so that these looked like puppets.

There was no coherent story, but a lot of mimicry. Here are two of Cocteau's typical directions for the dancers. For the Chinese conjurer:

> He takes an egg out of his pigtail, eats it, finds it again on the end of his shoe, spits out fire, burns himself, stamps on the sparks, etc.

For the American girl:

> She runs a race, rides a bicycle, quivers like the early movies, imitates Charlie Chaplin, chases a thief with a revolver, boxes, dances a ragtime, goes to sleep, gets shipwrecked, rolls on the grass on an April morning, takes a snapshot, etc.

The ballet opened on 17 May at the Théâtre du Châtelet in Paris. The highly distinguished audience was outraged, and suspected that the ballet had been designed to make them look ridiculous. As the curtain went down, there were threats to attack the producer, and cries of 'Sales Boches!' Apollinaire saved the situation. Wounded, with a bandage round his head, in uniform, and wearing the Croix de Guerre, he was able to appeal, as a patriotic hero, for tolerance.

He had also written the Introduction to the programme. In this he was enthusiastic and said that the ballet was a proof that the modern movement, the new spirit in the arts, could survive the war. To the surviving spirit he gave the name super-realism, or Surrealism.

In eighteen months Apollinaire would be dead. (He died as Paris celebrated the armistice, and when, in his fever, he heard the crowds shouting that Kaiser William should be hanged, he thought, since his name was William, that they meant him.) Yet he had already named the next phase of the modern movement.

We do not know what Apollinaire would have thought later. I think he would have soon recognised that 'the new spirit' was not a simple continuation of that of the Cubists. The latter were prophets – whose prophecies, still to some extent unfulfilled, remain convincing. The Surrealists were wry commentators on a reality that was already outbidding them.

Exactly one month and one day before *Parade* opened in Paris, the French had begun their offensive against the Hindenburg line. Their objective was the river Aisne. The attack was a total disaster. The number of casualties was kept secret, but it is estimated that 120,000 Frenchmen were killed. This was happening about 150 miles away from the Théâtre du Châtelet. Utterly disillusioned and partly prompted by the example of the Russian Revolution of February, large sections of the French army were mutinying when the ballet opened. Once again the figures have been kept secret. But, without doubt, it was the most serious mutiny in a great army in modern history. There were many strange incidents. Everything had lost its reason. One small incident has since become famous. A contingent of infantrymen marched through the streets of a town. As they marched in proper order, they baa-ed like sheep to indicate that they were lambs being absurdly led to the slaughter.

Does not the grotesque absurdity of this scene which *was actually happening* make Cocteau's and Picasso's American girl seem unstartling and commonplace?

We must try to be very clear about the significance of this – for there, in the Théâtre du Châtelet in 1917, was posed one of the recurring problems of art in our time.

Events in our century occur on a global scale. And the area of our knowledge has widened in order to encompass these events. Every day we can be aware of life-and-death issues affecting millions of people. Most of us close our minds to such thoughts except in times of crisis or war. Artists, whose imaginations are less controllable than most, have been obsessed with the problem: How can I justify what I am doing at such a time? This has led some to renounce the world, others to become over-ambitious or pretentious, yet others to stifle their imaginations. But since 1914 there cannot have been a serious artist who has not asked himself the question.

It would take a whole book to examine this dilemma fully. I want to make just one point in order to show why it is relevant to mention the Battle of the Aisne whilst discussing *Parade.* In 1917, Juan Gris was continuing to paint Cubist pictures – his best and some of the most advanced Cubist pictures ever painted. (Because he was the most intellectual of the Cubists, Gris was the only one who, for a few years, could continue after Cubism as a movement had died. He could see the theoretical problems still to be solved, and he set out to solve them with all his intelligence.) These paintings are as far from the war as *Parade* – in fact farther. Yet why is it here irrelevant to mention the 8 million dead – or as irrelevant as it can ever be?

The problem is a social one and it can only be answered socially. We have to consider the social function and content of Juan Gris's paintings and of *Parade.* We have already examined the social content of Cubism. As for the social function of Gris's paintings, at the time they had almost none. Gris was extremely poor during the war, and had the greatest difficulty in selling or exhibiting any of his pictures. In the long-term sense, their function was to express and preserve a way of seeing, based upon an order which accepted all the positive possibilities of modern knowledge. In other words, Gris painted these pictures *as though the war had not happened.* You can say: he chose to

fiddle whilst Rome burned. But, unlike Nero, he was not ultimately responsible for the fire, and he was not in public. It was Gris's loneliness that made it possible for him to ignore the war without a loss of integrity. Even today there are still liable to be pockets of *exemption* anywhere, and if an artist finds himself in one of these, the result can, paradoxically and in the fullness of time, be of considerable social value. European culture would be poorer if Gris had not continued to paint benign, untroubled still lifes during the First World War. But one must always remember that success, by qualifying the loneliness, also destroys the genuineness of the exemption. Success turns an artist who continues to claim exemption into an escapist, and those who are escapists from their time are the first to be forgotten with their time. They are like flatterers who never outlast their patron.

The case of *Parade* was quite different from that of Juan Gris. *Parade* was very much a *public* manifestation. It was meant to be provocative and to shock. The justification given for this was that it expressed contemporary 'reality'. Cocteau rejected Apollinaire's adjective of Surrealist, and actually insisted upon calling the work a *ballet réaliste*.

Obviously its 'reality' was not that of the Cubists – austere, ordered, hopeful. It was frenetic and irrational and, whether its creators realised it or not, it could only be justified by reference to the war. The audience who shouted 'Sales Boches!' made the right connection. But, according to their habit, they only used the connection to add to their complacency.

The objective social function which *Parade* performed was to console the bourgeoisie whom it shocked. (I say *objective* to distinguish the true effect of the ballet from what its creators may subjectively have hoped it would achieve.) In this respect *Parade* set the precedent for a good deal of so-called 'outrageous' art that was to follow. Its shock-value was the result of its particular spirit – its disjointedness, its frenzy, its mechanisation, its puppetry. This spirit was a reflection, however pale, of what was happening. And what was happening was infinitely more shocking on an infinitely more serious level. Why *Parade* – however beautifully Massine danced – can be criticised and finally dismissed as frivolous is not because it ignored the war, but because it pretended to be realistic. As a result of this pretence it shocked in such a way as to distract people from the truth. It substituted, as it were, an

ounce for a ton. The madness of the world, they could say, was the invention of artists! The audience who shouted 'Sales Boches!' felt, at the end of their evening, more patriotic than ever, more certain than ever that the war was noble, reasonable, and so on. A performance of *Les Sylphides* would not have had the same effect.

The age of essential politics had begun. The baa-ing infantrymen knew this – even if they could not see a way out. Cocteau, Picasso, even Apollinaire did not yet realise it, because they still believed in the possibility of art staying separate. The bitter irony of this is revealed in the spectacle of Apollinaire pacifying a bourgeois audience, whom he loathed and despised, on account of the wounds he had received as their war hero: wounds from which in eighteen months he would die.

Stupid people often accuse Marxists of welcoming the intrusion of politics into art. On the contrary, we protest against the intrusion. The intrusion is most marked in times of crisis and great suffering. But it is pointless to deny such times. They must be understood so that they can be ended: art and men will then be freer. Such a time began in Europe in 1914, and continues still. The ballet *Parade* is one of the first examples in which we can see the difficulties facing art in the present situation. For the first time we see the modern artist serving, despite his own intentions, the bourgeois world, and therefore sharing a position of doubtful privilege. The rest of the story of Picasso's life is the story of how he has struggled to overcome the disadvantages of this position.

CR

WHEN PICASSO CAME to London in 1918 he stayed at the Savoy Hotel. He no longer saw couples at a café table beyond hope or redemption. And the place of acrobats or horse-thieves was taken by waiters and valets. It would be trivial to mention this, were it not typical of Picasso's new life. Having 'shocked' the distinguished and the wealthy, he joined them.

His former friends, and especially Braque and Juan Gris, considered his new life a betrayal of what they had once striven for. Yet the problem was not simple. Braque and Gris, in order to continue as before, had to retreat within themselves. Picasso chose instead to go the way of the world. The private details involved need not concern us. What we need to know is how his spirit, his attitudes, were changed.

21.

Judgment on Paris

FOR EIGHTY YEARS or so Paris has been the painters' capital of Europe. Recently there have been signs that this is no longer so, and that more significant ideas are being worked out in Rome or Milan or Warsaw. The superstition, however, persists, and the English art critic still sets out for Paris rather as a small-town journalist might set out to visit London. He then returns full of an 'exclusive' story about the secret truths of the great city, half patronising and half admiring. In fact, any large city is large enough to supply any journalist with the story he wants to find. I offer this as an explanation of why my views on Paris may differ from those of others, and to warn the reader that although I am naturally convinced that they are, they may not really be conclusive.

Paris today seems to me to be a city sick with art, the victim in the second or third generation of its own genius. Or, to put it less fancifully, Paris suffers from the inevitable over-specialisation of international industrial capitalism, has become the mere sale-room and factory of a snob-commodity. One has the impression of paintings one on top of the other to form a huge emporium-house of cards: insubstantial, and yet, when once one has entered, claustrophobically screening any view of the outside world. Economically there is a glut; intellectually, a drought.

Typical of the general atmosphere is the present scandal about the re-hanging of the Louvre. I have no space to describe this in detail, but the affair was well summed up by a French painter who wrote that, if the present tendency continues, it will be no surprise to discover that the directors of the Moulin Rouge have taken over the Museum management. Everything has been done to make the presentation chic and easily superficial to eye and mind: décor for décor's sake without any consideration for the paintings shown: the separation of works from their period and school in order to make a smart arrangement of timeless cosmopolitan 'styles': the criminal neglect of French painting (nine out of forty Poussins on show) in order to attract visitors to an all-nation jamboree – the whole scheme amounting to the destruction of the Museum as a place of serious study and to its establishment as an amusement arcade for cultural trippers.

The debilitating ideas behind this move are familiar. Namely: that national traditions can be ignored, that a work of art is a complete entity in itself, that 'style' can be separated from intention and function, and that the luxury of aesthetics is pure and absolute. If this were all there was to be said about the atmosphere in Paris, it would hardly be worth saying again. The Political Prisoner competition, the Venice Biennale and most of the post-war productions in highbrow book-shops have emphasised the same theme. Happily, however, there is also in Paris a successful movement running directly counter to this development: the movement, headed by Lurçat and centred on Aubusson, of artists working for the Association des Peintres Cartonniers de Tapisserie.

Lurçat was concerned with tapestries long before the war. But it was during and immediately after the war that the movement grew to be a real influence in French art. Painters such as Picasso, Léger, Gromaire, Braque, Dufy, Miró, Rouault, have all produced designs. The best work, though, has been and is being produced by those artists who have concentrated their whole energy on mastering the technique of the medium: most particularly Lurçat himself, Marc Saint-Saens and Jean Picard le Doux.

It would be easy to write paragraph after lyrical paragraph describing the character of their work: its simple, innocent but profound poetry woven from images of birds, flowers, fishes, heroes, the sun, the

moon and lovers: its affirmation of the range of man's poetic sensuous experience, from the acute recognitions of childhood (a bird in a cage by Picard le Doux) through the militant force and possessiveness of maturity (*Theseus and Minotaur* by Saint-Saens) to the reflections of old age, the summing up of knowledge and sensations long valued ('Le ciel . . . la terre . . . la paix' by Lurçat): the simplicity of their colours (at the Gobelins tapestries where oil paintings are pointlessly copied, 14,000 colours are sometimes used: these artists employ about forty) made intangibly varied by the intrinsic qualities of the wools themselves and by the use of tones following the vertical woof to give an undulating flow of light, such as shimmers on leaves, feathers, or the fins of fishes. It would be easy to do so: but it is more important to understand the reasons for the vitality of their work.

They have steeped themselves in their national tradition, and have learnt from the great medieval tapestries. They have assumed that if they apply themselves to the formidable technical problems involved, and if they choose essentially visual themes illustrating simple, physical life, the aesthetic question will look after itself. They have been content to pool their knowledge, to re-create a tradition rather than to break it with the individuality of their separate personalities. They have taken pleasure in gearing their work to facts existing outside the studio – the demands of the sites for which they design, the skill of the tapestry workers at Aubusson. They are men who have lived long enough with their progressive humanist faith to be optimistic at heart, and to know that finally to celebrate pleasure is one of the supreme duties of the artist.

As a result, they have made their work, although it is full of poetic illogicalities, distortions, and so on, truly popular. Their tapestries condense common aspirations and experiences (nailing the illusion that poetry is rare) rather as anonymous songs or legends do, or, in a more complex way, as certain films can. Also, because they have set themselves a job and not set themselves *up*, they have found a way of using their talents – for none of them apes genius – to produce works of immediate human value. And if that sounds platitudinous, it is worth remembering that today talent is generally considered a possession, instead of an aptitude. The parable still applies.

22.

Soviet Aesthetic

'I KNOW YOUR Socialist Realist novels,' sighed the Moscow television comedian. 'On the first page there is a description of a turbine. On the second page a description of a hydraulic drill. On the third page a description of a dynamo. On the hundred and fortieth you come to the words I LOVE – followed by MY MACHINE.'

The Soviet attitude to the arts is not static. Recently there has been much discussion and criticism. But before I describe this new development, it is necessary to understand the basis of their approach, which does not change. First and foremost, every work of art is a moral problem. We tend to see the constant argument about realism and formalism as a question of the relative importance of content and form. They see it as a question of whether a work is moral or amoral – which, to them, is immoral. They are not concerned with a work of art as an object in itself, but with its effect. Its qualities are not absolute, but functional. This is what Stalin meant when he said that writers were 'the engineers of the soul'.

What you are really saying is that the Russians consider all art as propaganda?

Yes, so long as one remembers that propaganda has now come to mean any insistent interpretation of life made according to values with which one happens to disagree. And also as long as one takes into

account that the tradition which they claim is not only one of political lampoonists, but of, for instance, Goya, Shakespeare, Balzac, and, most particularly, of all their own great eighteenth- and nineteenth-century artists. The principal and obvious result of the Soviet emphasis on the *use* of art is that it is really taken seriously. The training of art students and architects is far longer, more comprehensive and rigorous than ours. A student of seventeen spends thirty working hours on a portrait drawing. As a result of such discipline he is twice as competent as I am – who teach in an art school.

But what about the artists who don't conform, who don't want to follow the party line?

A good deal of wishful thinking really lies behind this question. It is usually asked with far too dramatic a picture in mind. Rather as if one heard of a house built four hundred feet above the sea, and immediately assumed that it was perched on a crag, instead of being one building in a town nestling in the dip of a hill. First, because there is far more variety in what is produced – both in terms of local tradition and individual personality – than is generally imagined. I met two Fauve painters who were doing very well. Second, because the main Russian tradition of painting and literature (Pushkin, Tolstoy, Surikov, and so on) has always emphasised social conscience. Third, because the revolution occurred thirty-six years ago. Contemporary Soviet art can only be seen in relation to the whole established Soviet way of life. It is no good thinking of the artist in Russia as a tragic *victim*; if one is set on pitying him, one must say that he is a tragic *product*, that he has been conditioned to know no better. But he won't thank you for that. What you call independence he will call irresponsibility.

The first Socialist Realist paintings were produced immediately after the Revolution by a group of painters working in Leningrad. The most outstanding of these was Brodsky. Their subjects were portraits or scenes from the Revolutionary struggle. Lenin arriving from Finland at Petersburg railway station and addressing the workers from the famous armoured car, for instance. Their style was austere: somewhat in the tradition of Courbet – although in fact they owed far more to their own nineteenth-century Realists who were painting social themes as early as the 1860s. Many of Brodsky's canvases are large and contain hundreds of figures. In reproduction they look a little like

over-exposed photographs. But in fact they have zest, dignity, clarity and a sense of structure that are truly remarkable: the rough equivalent in painting to Eisenstein's films – the same intensity of focus.

About ten or fifteen years later the character of Soviet painting began to change. It became far less austere, more colourful and far more academic – roughly what most people in the West now think of as typical 'Victorian' Soviet art. There were landscapes, genre subjects, historical scenes, portraits of workers, pictures of factories, Stalin, collective farms, new towns, Stakhanovites – but the vast majority were photographic and trite. Yet, for all its banality, this art was a serious attempt to solve a problem. The revolution was over. Socialism was being built. For the first time ever, large-scale popular taste became a positive factor to be considered by painters. Somehow art should celebrate the people's achievements. The mistake they made was to assume that people only wanted and needed reassurance, that they must be constantly patted on the back. They forgot the true optimism of Gorki's remark that 'Life will always be bad enough for the desire for something better not to be extinguished in man', and substituted instead a trivial optimism. This led to a naturalistic art lacking either tension or conflict. Since everything was – or was going to be – all right with the world, there was no need for the artist to *select* experience. They were rightly proud of what they had achieved, but they wrongly considered that therefore all that was necessary was to hold up a mirror to their achievements. Or to put it another way, art drew so close to life that it had neither space nor time to resolve itself. It could stimulate but could not satisfy. Satisfaction only came from life itself.

Then, a few years ago, there ensued a great debate about these questions. Artists and critics began to realise that it was not enough simply to record any scene and to hope that it reflected the progress of life at large; rather, the artist must choose the typical, releasing and demonstrating the hidden potentialities of what he painted. This implied that there was struggle and conflict – otherwise such potentialities would be obvious. In psychological terms it meant seeing action in relation to motive; in purely visual terms it meant seeing superficial appearance in relation to underlying structure.

Now the results of this reassessment are becoming evident. The dreary academic painters still remain. The national Russian emphasis

on anecdote is still strong. One expects to see an encyclopaedia as well as a palette in a painter's studio. (Incidentally, it is for this reason that there are few mural paintings. They realise that to make a synthesis between the broadly decorative and the precisely literary is still at the moment beyond their powers.) But at the same time the character of the work of students and young painters is new, strikingly different. In subject matter it is less directly didactic; in formal investigation far more searching. It is no longer sufficient to capture a 'frozen' snap-shot image of an arm; its structure has got to be established. Then its capability of alternative movement can be fully realised and so (in human terms) the decision behind the movement taken into account. If one paints a smile one must also imply that the human face is capable of weeping.

I would sum up in this way. The majority of Russian painting is bad – the new developments are still embryonic. The majority of Western art is equally bad, but for the opposite reasons. In one case it is a question of art being too superficially literal; in the other of it being too profoundly remote. They have made art cheap. We have made it a luxury. Were I a critic in Moscow I would attack the old sentimental academic there, just as I attack the new heartless academic of formal-isation and abstraction here. (Having read some of their criticism, I also think that I should be published.) But – and this is the crux of the matter – I believe that they are creating the foundations of a true tradi-tion, whereas we, for the most part, are destroying the tradition we inherited. A true tradition can only be built on the general awareness that art should be an inspiration to life – not a consolation.

23.

The Biennale

THE LARGEST PART of the international exhibition of the Venice Bien-
nale is organised by an Italian committee. This year (1958) this
committee has been much criticised for its very obvious bias towards
abstract art, and has been accused of provincialism. Lionello Venturi,
the art historian and grand old man of Italian criticism, has leapt to its
defence by stating that the best artists of the last sixty years have been
abstract, and that anyway the pavilions organised by other countries
show the same bias – the implication being that they can't all be
wrong. But the truth is that they can be and are. The satirists are justi-
fied in calling this Biennale *The Banale*.

Let us be clear about the issues involved. (It is worth it because in
this exhibition one can read the political future of the world; it may
lack masterpieces but it is full of unconscious revelations and portents.)
It is not – and never has been – a question of all abstract art being
fundamentally opposed to figurative art. No student of twentieth-
century European culture can reasonably deny that certain abstract
artists have contributed to the development of painting, sculpture and
architecture. The division now is between those artists who have a
sense of responsibility and those who have not; or, to put it another
way, between those artists whose view of life can sustain a minimum
faith in the value of human exchange, and those whom alienation has

made pathological. Abstract art has long since ceased to be an affair of pure 'aesthetics'. The ivory tower has now become the padded cell – which implies 'provincialism' carried to its absolute extreme.

Thousands of works now at Venice – works from the United States, Germany, Italy, Holland, France – have one image in common: the image of muck, of garbage. Nor am I making a judgment when I say that: I am being literal. One walks from gallery to gallery to look at the forms of decay and the dirt of putrefaction. Some canvases have open holes torn in them, others have gauze stuffed into sheer gashes, others are overlaid with cement, others consist of nothing but one thick coating of the same colour which has been artificially made to crack and peel. Again, however, one must protest tolerance in order to make credible the absolute decadence of the phenomenon one is discussing. There is no reason why painters should not use new materials and 'play' with the surface of their pictures; Braque in some of his most beautiful still lifes mixed sand with his pigment. But we are now discussing something in a completely different category. We are discussing not additions but violations. And if one single proof of the hopeless, indulgent decadence of these works is needed, it lies in the fact that quite obviously the vast majority of them will not – physically – endure for more than a couple of years. They are not objects that have been made, they are objects that have been used – like cigarette butts, broken bottles or – most suitably of all – old contraceptives.

I have on other occasions tried to explain the social and psychological factors which have made this kind of non-art possible. It does, of course, reflect unconsciously, and entirely passively, a reality: the reality of the fears, the cynicism, the human alienations that are accompanying the death throes of imperialism. It reflects, passively, the reality of our own Mau Mau superstitions, rituals and crimes – a reality against which the African Mau Mau was only a countermeasure. Yet we cannot, with complacent satisfaction, leave the argument there: partly because the West is not truly represented by its imperialism – there are also all the opposition movements; and partly because this non-art is now being exported. The Spanish pavilion is almost entirely devoted to it, and it is beginning to appear in the Polish and Yugoslav pavilions. It is exportable because it appeals to that destructive egotism which every artist has to face as a temptation

within himself; it gives the sacred value of art to his smallest gesture – even to the imprint of his thumb – and to the most petty of his ideas.

This pettiness, this poverty and 'thinness' of ideas and aims, is the most striking characteristic of the present cultural atmosphere of the West, even where the final decline into non-art has not taken place. Even in the galleries where abstract art still has a certain decorative function or where the works are still figurative, one has the impression that each artist has desperately searched for some little novelty of his own and then been content to mass-produce it and market it. The most extreme example of this gimmick mentality is a painting which simply consists of the Stars and Stripes as they appear on the American flag. A more serious and therefore tragic example is that of the highly talented English sculptor, Kenneth Armitage. He has hit upon the idea of making the torsos of his figures look like table tops, so that the legs and arms stick out like the limbs of a man in the stocks. Certainly it has a surprise value which generates a superficial emotion. But after a while one thinks: if only this man could use his talent, if only he was free, if only he wasn't compelled to turn out gimmicks! Yet who compels him?

There is the irony. For the art of the self-styled Free World is quickly becoming the most cramped and limited art ever produced. By comparison the Soviet pavilion, which is full of old-style Stalinist works, is rich and various and ingenious. Admittedly the richness is literary, and visually the Russian paintings are very sentimental; admittedly they are painted with clichés distributed by bureaucrats. But if one has to choose between the unimaginativeness of bureaucrats and the fantasies of the sick . . . ?

In fact, for questions of art, one does not have to make that choice. Among the five hundred or so artists on show at Venice there are perhaps a dozen who were possibly born with no more talent than their fellow exhibitors but who encouragingly remind us that art is independent to exactly the same degree as it discloses reality. There are Kewal Soni, Indian sculptor; Padamsee, Indian painter; Ivan Peries, Ceylonese painter; Raul Anguiano, Mexican follower of Rivera; Brusselmans of Belgium; Ichiro Fukuzawa, Japanese Expressionist. And then there is the pavilion of the United Arab Republic. Only occasionally do history and art correspond with one another as directly

as they do here; but it remains a fact that this pavilion is the most affirmative and vital of all in the 1958 Biennale. I do not, of course, mean that geniuses have appeared overnight in Cairo. What makes these works outstanding is that they affirm. They are not defensive treaties. Men come before things. Their language is largely traditional. Its sun-dyed colours, its expressive use of decorative silhouettes and its easy and unselfconscious simplifications derive from traditional Egyptian art and design. Yet it is the art of the West that appears by contrast not only to be academic but also, in the context of the emerging twentieth-century world, finished, exhausted, outlived.

24.

Art and Property Now

A LOVE OF art has been a useful concept to the European ruling classes for over a century and a half. The love was said to be their own. With it they could claim kinship with the civilisations of the past and the possession of those moral virtues associated with 'beauty'. With it they could also dismiss as inartistic and primitive the cultures they were in the process of destroying at home and throughout the world. More recently they have been able to equate their love of art with their love of freedom, and to oppose both loves to the alleged or real abuse of art in the socialist countries.

The usefulness of the concept had to be paid for. There were demands that a love of art, which was so apparently a privilege and was so apparently and intimately connected with morality, should be encouraged in all deserving citizens. This demand led to many nineteenth-century movements of cultural philanthropy – of which Western ministries of culture are the last, absurd and doomed manifestations.

It would be exaggeration to claim that the cultural facilities concerned with the arts and open to the public at large have yielded no benefits at all. They have contributed to the cultural development of many thousands of individuals. But all these individuals remain exceptions because the fundamental division between the initiated

and the uninitiated, the 'loving' and the indifferent, the minority and the majority, has remained as rigid as ever. And it is inevitable that this should be so; for, quite apart from the related economic and educational factors, there is a hopeless contradiction within the philanthropic theory itself. The privileged are not in a position to teach or give to the underprivileged. Their own love of art is a fiction, a pretension. What they have to offer as lovers is not worth taking.

I believe that this is finally true concerning all the arts. But – for reasons which we shall examine in a minute – it is most obvious in the field of the visual arts. For twenty years I have searched like Diogenes for a true lover of art: if I had found one I would have been forced to abandon as superficial, as an act of bad faith, my own regard for art which is constantly and openly political. I never found one.

Not even among artists? Least of all. Failed artists wait to be loved for themselves. Working artists love their next, as yet non-existent, project. Most artists alternate between being one and the other.

During the summer, at the Uffizi Palace in Florence, the crowds, packed together, hot, their vision constantly obstructed, submit to a one- or two-hour guided tour in which nothing reveals itself or is revealed. They suffer an ordeal, but their reward is that they are able to claim that they have been to the Uffizi Palace. They have been near enough to the Botticellis to make sure that they are framed bits of wood or canvas which are possessible. They have, in a certain sense, acquired them; or, rather, they have acquired the right to refer to them in a proprietary context. It is as though – in a highly attenuated way – they have been, or they have played at being, the guests of the Medicis. All museums are haunted by the ghosts of the powerful and the wealthy, and on the whole we visit them to walk with the ghosts.

I know a private collector who owns some of the finest Cubist paintings ever painted, who has an encyclopaedic knowledge of the art of the period in which he is interested, who has excellent discrimination, and who was or is a personal friend of several important artists. He has no business distractions; his inherited wealth is assured. He would seem to represent the antithesis of the uninformed and unseeing crowds who suffer the ordeal of the Uffizi Palace. He lives with his paintings in a large house with the time and quiet and knowledge to come as close to them as anybody has ever done. Here, surely, we have found a love

of art? No, here we find a manic obsession to prove that everything he has bought is incomparably great and that anybody who in any way questions this is an ignorant scoundrel. So far as the psychological mechanism is concerned, the paintings could as well be conkers.

Walk down a street of private galleries – but it is unnecessary to describe the dealers with their faces like silk purses. Everything they say is said to disguise and hide their proper purpose. If you could fuck works of art as well as buy them, they would be pimps: but, if that were the case, one might assume a kind of love; as it is they dream of money and honour.

Critics? John Russell speaks for the vast majority of his colleagues when – without any sense of incongruity or shame – he explains how one of the excitements of art criticism lies in the opportunity it affords of acquiring an 'adventurous' private collection.

The truth is that a painting or a sculpture is a significant form of property – in a sense in which a story, a song, a poem is not. Its value as property supplies it with an aura which is the last debased expression of the quality which art objects once possessed when they were used magically. It is around property that we piece together our last tattered religion, and our visual works of art are its ritual objects.

It is for this reason that, during the last decade, with the emergence of the new ideology of the consumer society, the visual arts have acquired a glamour such as they have not enjoyed for centuries. Exhibitions, art books, artists carry an urgent message even when the works themselves remain unintelligible. The message is that the work of art is the ideal (and therefore magical, mysterious, incomprehensible) commodity. It is dreamed of as the *spiritualised* possession. Nobody dreams or thinks of music, the theatre, the cinema or literature in the same way.

The extremism of most recent visual art is a consequence of the same situation. The artist welcomes the prestige and liberty accorded him; but insofar as he has an imaginative vision he profoundly resents his work being treated as a commodity. (The argument that there is nothing new in this situation, because works of art have been bought and sold for centuries, cannot be taken very seriously: the concept of private property has been stripped of its ideological disguise only very slowly.) Abstract Expressionism, L'Art Brut, Pop

Art, Auto-Destructive Art, Neo-Dada – these and other movements, despite profound differences of spirit and style, have all tried to exceed the limits within which a work of art can remain a desirable and valuable possession. All have questioned what makes a work of art art. But the significance of this questioning has been widely misunderstood – sometimes by the artists themselves. It does not refer to the process of creating art: it refers to the now blatantly revealed role of art as property.

I have never believed and still do not that Francis Bacon is a tragic artist. The violence he records is not the violence of the world; nor is it even the violence such as an artist might subjectively feel within himself. It is violence done to the idea that a painting might be desirable. The 'tragedy' is the tragedy of the easel painting, which cannot escape the triviality of becoming a desirable possession. And all the protesting art of recent years has been defeated in the same way. Hence its oppressiveness. It cannot liberate itself. The more violent, the more extreme, the rawer it becomes, the more appeal it acquires as an unusual and rare possession.

Marcel Duchamp – much admired today by the young because he was the first to question what makes a work of art art, and who already in 1915 bought a ready-made snow-shovel from a hardware store and did no more than give it a title (several editions of it are now in museums) – Duchamp himself recently admitted defeat as an iconoclast when he said: 'Today there is no shocking. The only thing shocking is no shocking.'

I do not mean it metaphorically when I say that soon a dealer will mount an exhibition of shit and collectors will buy it. Not, as is repeatedly said, because the public is gullible or because the art world is crazy, but because the passion to own has become so distorted and exacerbated that it now exists as an absolute need, abstracted from reality.

A certain number of artists have understood this situation, instead of merely reacting to it, and have tried to produce art which by its very nature resists the corruption of the property nexus: I refer to kinetic art and certain allied branches of Op Art and Constructivism.

Twelve years ago, Vasarely wrote:

We cannot leave the pleasure to be got out of art in the hands of an elite of connoisseurs for ever. The new art forms are open to all.

> The art of tomorrow will be for all or it will not exist . . . In the past
> the idea of plastic art was tied to an artisan attitude and to the myth
> of the unique product: today the idea of plastic art suggests possibil-
> ities of re-creation, multiplication, expansion.[1]

That is to say, the work of art can now be produced industrially and
need have no scarcity value. It does not even have a fixed and proper
state in which it can be preserved: it is constantly open to change and
alteration. Like a toy, it wears out.

Such art differs qualitatively from all art that preceded it and that
still surrounds it, because its value resides in what it *does*, not in what
it *is*. What it does is to encourage or provoke the spectator by the stim-
ulus of its movements to become conscious of, and then to play with
the processes of, his own visual perception: in doing this it also renews
or extends his awareness and interest in what is immediately surround-
ing both him and the work. The kinds of movement involved can vary;
they may be optical or mechanical, planned or haphazard. The only
essential is that the work is dependent upon changes whose origins are
outside itself. Even if it moves regularly, driven by its own motor, this
movement is only to start and set in motion changes which are beyond
itself. Its nature is environmental. It is a device, of little intrinsic value,
placed for our pleasure to interact between our senses and the space
and time that surround them.

The promise of such art to date is limited. Its proper application to
those environments in which the majority work and live must involve
political and economic decisions beyond the control of artists.
Meanwhile it has to be sold on the private market.

More profoundly, such art is limited because as yet its content does
not admit the stuff of social relations: that is to say, it cannot treat of trag-
edy, struggle, morality, cooperation, hatred, love. It is for this reason that
one might categorise it so far (but not to belittle it) as a decorative art.

Nevertheless its essential nature, its mode of production and its
refusal to exploit the individual personality of the artist (which is inev-
itably unique) allow it to be free of the inversions and to escape the
contradictions which cripple the rest of art today. The experiments of

1 Victor Vasarely, *Notes pour un Manifeste* (Paris: Galerie Denise René, 1955).

these artists will eventually be useful. As artists they have found a way of partly transcending their historical situation.

Does all this mean that the enduring and unique work of art has now served its purpose? Its heyday coincided with that of the bourgeoisie – will they both disappear together? If one takes the long historical view, this seems quite probable. But meanwhile the unevenness of historical development can hide unexpected, even unforeseeable possibilities. In the socialist countries the development of art has been artificially restrained. In much of the Third World the autonomous work of art exists only as an export to feed the sick appetite of Europe. It may be that elsewhere the unique work will be given a different social context.

What is certain is that, in our European societies as they are now, the unique work of art is doomed: it cannot escape being a ritual object of property, and its content, if not entirely complacent, cannot help but be an oppressive, because hopeless, attempt to deny this role.

25.

No More Portraits

IT SEEMS TO me unlikely that any important portraits will ever be painted again. Portraits, that is to say, in the sense of portraiture as we now understand it. I can imagine multi-medium memento-sets devoted to the character of particular individuals. But these will have nothing to do with the works now in the National Portrait Gallery.

I see no reason to lament the passing of the portrait – the talent once involved in portrait painting can be used in some other way to serve a more urgent, modern function. It is, however, worthwhile inquiring why the painted portrait has become outdated; it may help us to understand more clearly our historical situation.

The beginning of the decline of the painted portrait coincided roughly speaking with the rise of photography, and so the earliest answer to our question – which was already being asked towards the end of the nineteenth century – was that the photographer had taken the place of the portrait painter. Photography was more accurate, quicker and far cheaper; it offered the opportunity of portraiture to the whole of society: previously such an opportunity had been the privilege of a very small elite.

To counter the clear logic of this argument, painters and their patrons invented a number of mysterious, metaphysical qualities with which to prove that what the painted portrait offered was

incomparable. Only a man, not a machine (the camera), could inter-
pret the soul of a sitter. An artist dealt with the sitter's destiny: the
camera with mere light and shade. An artist judged: a photographer
recorded. Etcetera, etcetera.

All this was doubly untrue. First, it denies the interpretative role of
the photographer, which is considerable. Secondly, it claims for
painted portraits a psychological insight which 99 per cent of them
totally lack. If one is considering portraiture as a genre, it is no good
thinking of a few extraordinary pictures but rather of the endless
portraits of the local nobility and dignitaries in countless provincial
museums and town halls. Even the average Renaissance portrait –
although suggesting considerable presence – has very little
psychological content. We are surprised by ancient Roman or Egyptian
portraits, not because of their *insight*, but because they show us very
vividly how little the human face has changed. It is a myth that the
portrait painter was a revealer of souls. Is there a qualitative difference
between the way Velázquez painted a face and the way he painted a
bottom? The comparatively few portraits that reveal true psychological
insight (certain Raphaels, Rembrandts, Davids, Goyas) suggest
personal, obsessional interests on the part of the artist which simply
cannot be accommodated within the *professional* role of the portrait
painter. Such pictures have the same kind of intensity as self-portraits.
They are in fact works of self-discovery.

Ask yourself the following hypothetical question. Suppose that
there is somebody in the second half of the nineteenth century in
whom you are interested but of whose face you have never seen a
picture. Would you rather find a painting or a photograph of this
person? And the question itself posed like that is already highly favour-
able to painting, since the logical question should be: Would you
rather find a painting or a whole album of photographs?

Until the invention of photography, the painted (or sculptural)
portrait was the only means of recording and presenting the likeness of
a person. Photography took over this role from painting and at the
same time raised our standards for judging how much an informative
likeness should include.

This is not to say that photographs are *in all ways* superior to painted
portraits. They are more informative, more psychologically revealing,

and in general more accurate. But they are less tensely unified. Unity in a work of art is achieved as a result of the limitations of the medium. Every element has to be transformed in order to have its proper place within these limitations. In photography the transformation is to a considerable extent mechanical. In a painting each transformation is largely the result of a conscious decision by the artist. Thus the unity of a painting is permeated by a far higher degree of intention. The total effect of a painting (as distinct from its truthfulness) is less arbitrary than that of a photograph; its construction is more intensely socialised because it is dependent on a greater number of human decisions. A photographic portrait may be more revealing and more accurate about the likeness and character of the sitter; but it is likely to be less persuasive, less (in the very strict sense of the word) conclusive. For example, if the portraitist's intention is to flatter or idealise, he will be able to do so far more convincingly with a painting than with a photograph.

From this fact we gain an insight into the actual function of portrait painting in its heyday: a function we tend to ignore if we concentrate on the small number of exceptional 'unprofessional' portraits by Raphael, Rembrandt, David, Goya, and so on. The function of portrait painting was to underwrite and idealise a chosen social role of the sitter. It was not to present him as 'an individual' but, rather, as an individual monarch, bishop, landowner, merchant and so on. Each role had its accepted qualities and its acceptable limit of discrepancy. (A monarch or a pope could be far more idiosyncratic than a mere gentleman or courtier.) The role was emphasised by pose, gesture, clothes and background. The fact that neither the sitter nor the successful professional painter was much involved with the painting of these parts is not to be entirely explained as a matter of saving time: they were thought of and were meant to be read as the accepted attributes of a given social stereotype.

The hack painters never went much beyond the stereotype; the good professionals (Memlinck, Cranach, Titian, Rubens, Van Dyck, Velázquez, Hals, Philippe de Champaigne) painted individual men, but they were nevertheless men whose character and facial expressions were seen and judged in the exclusive light of an ordained social role. The portrait must fit like a hand-made pair of shoes, but the type of shoe was never in question.

The satisfaction of having one's portrait painted was the satisfaction of being personally recognised and *confirmed in one's position*: it had nothing to do with the modern lonely desire to be recognised 'for what one really is'.

If one were going to mark the moment when the decline of portraiture became inevitable by citing the work of a particular artist, I would choose the two or three extraordinary portraits of lunatics by Géricault, painted in the first period of Romantic disillusion and defiance which followed the defeat of Napoleon and the shoddy triumph of the French bourgeoisie. The paintings were neither morally anecdotal nor symbolic: they were straight portraits, traditionally painted. Yet their sitters had no social role and were presumed to be incapable of fulfilling any. In other pictures Géricault painted severed human heads and limbs as found in the dissecting theatre. His outlook was bitterly critical: to choose to paint dispossessed lunatics was a comment on men of property and power, but it was also an assertion that the essential spirit of man was independent of the role into which society forced him. Géricault found society so negative that, although sane himself, he found the isolation of the mad more meaningful than the social honour accorded to the successful. He was the first and, in a sense, the last profoundly anti-social portraitist. The term contains an impossible contradiction.

After Géricault, professional portraiture degenerated into servile and crass personal flattery, cynically undertaken. It was no longer possible to believe in the value of the social roles chosen or allotted. Sincere artists painted a number of 'intimate' portraits of their friends or models (Corot, Courbet, Degas, Cézanne, Van Gogh), but in these the social role of the sitter is reduced to *that of being painted*. The implied social value is either that of personal friendship (proximity) or that of being seen in such a way (being 'treated') by an original artist. In either case the sitter, somewhat like an arranged still life, becomes subservient to the painter. Finally it is not his personality or his role which impresses us but the artist's vision.

Toulouse-Lautrec was the one important latter-day exception to this general tendency. He painted a number of portraits of tarts and cabaret personalities. As we survey them, they survey us. A social reciprocity is established through the painter's mediation. We are presented

neither with a disguise – as with official portraiture – nor with mere creatures of the artist's vision. His portraits are the only late nineteenth-century ones which are persuasive and conclusive in the sense that we have defined. They are the only painted portraits in whose social evidence we can believe. They suggest not the artist's studio, but 'the world of Toulouse-Lautrec': that is to say, a specific and complex social milieu. Why was Lautrec such an exception? Because in his own eccentric manner he believed in the social roles of his sitters. He painted the cabaret performers because he admired their performances: he painted the tarts because he recognised the usefulness of their trade.

Increasingly for over a century fewer and fewer people in capitalist society have been able to believe in the social value of the social roles offered. This is the second answer to our original question about the decline of the painted portrait.

The second answer suggests, however, that given a more confident and coherent society, portrait-painting might revive. And this seems unlikely. To understand why, we must consider the third answer.

The measures, the scale-change of modern life, have changed the nature of individual identity. Confronted with another person today, we are aware, through this person, of forces operating in directions which were unimaginable before the turn of the century, and which have only become clear relatively recently. It is hard to define this change briefly. An analogy may help.

We hear a lot about the crisis of the modern novel. What this involves, fundamentally, is a change in the mode of narration. It is scarcely any longer possible to tell a straight story sequentially unfolding in time. And this is because we are too aware of what is continually traversing the story-line laterally. That is to say, instead of being aware of a point as an infinitely small part of a straight line, we are aware of it as an infinitely small part of an infinite number of lines, as the centre of a star of lines. Such awareness is the result of our constantly having to take into account the simultaneity and extension of events and possibilities.

There are many reasons why this should be so: the range of modern means of communication; the scale of modern power; the degree of personal political responsibility that must be accepted for events all

over the world; the fact that the world has become indivisible; the unevenness of economic development within that world; the scale of the exploitation. All these play a part. Prophesy now involves a geographical rather than historical projection; it is space, not time, that hides consequences from us. To prophesy today, it is only necessary to know men as they are throughout the whole world in all their inequality. Any contemporary narrative which ignores the urgency of this dimension is incomplete, and acquires the oversimplified character of a fable.

Something similar but less direct applies to the painted portrait. We can no longer accept that the identity of a man can be adequately established by preserving and fixing what he looks like from a single viewpoint in one place. (One might argue that the same limitation applies to the still photograph, but as we have seen, we are not led to expect a photograph to be as conclusive as a painting.) Our terms of recognition have changed since the heyday of portrait painting. We may still rely on 'likeness' to identify a person, but no longer to explain or place him. To concentrate upon 'likeness' is to isolate falsely. It is to assume that the outermost surface *contains* the man or object: whereas we are highly conscious of the fact that nothing can contain itself.

There are a few Cubist portraits of about 1911 in which Picasso and Braque were obviously conscious of the same fact, but in these 'portraits' it is impossible to identify the sitter, and so they cease to be what we call portraits.

It seems that the demands of a modern vision are incompatible with the singularity of viewpoint which is the prerequisite for a static painted 'likeness'. The incompatibility is connected with a more general crisis concerning the meaning of individuality. Individuality can no longer be contained within the terms of manifest personality traits. In a world of transition and revolution, individuality has become a problem of historical and social relations, such as cannot be revealed by the mere characterisations of an already established social stereotype. Every mode of individuality now relates to the whole world.

26.

The Historical Function
of the Museum

THE ART MUSEUM curators of the world (with perhaps three or four exceptions) are simply not with us. Inside their museums they live in little châteaux or, if their interests are contemporary, in Guggenheim fortresses. We, the public, have our hours of admission and are accepted as a diurnal necessity: but no curator dreams of considering that his work actually begins with us.

Curators worry about heating, the colours of their walls, hanging arrangements, the provenances of their works, and visitors of honour. Those concerned with contemporary art worry about whether they are striking the right balance between discretion and valour.

Individuals vary, but as a professional group their character is patronising, snobbish and lazy. These qualities are, I believe, the result of a continuous fantasy in which to a greater or lesser degree they all indulge. The fantasy weaves round the notion that they have been asked to accept as a *grave civic responsibility* the prestige accruing from the ownership of the works under their roof.

The works under their protection are thought of primarily as property – and therefore have to be owned. Most curators may believe that it is better for works of art to be owned by the state or city than by private collectors. But owned they must be. And so somebody must

stand in an honorary owning relation to them. The idea that works of art, before they are property, are expressions of human experience and a means to knowledge is utterly distasteful to them because it threatens, not their position, but what they have constructed for themselves on the basis of their position.

Since the 'museum world' forms a large sector of the 'art world' which has recently acquired very considerable commercial and even diplomatic power, what I am saying is bound to be attacked as jaundiced. Nevertheless it is my considered opinion after years of treating with museum directors throughout Europe and in both the socialist and capitalist countries. Leningrad in this respect is the same as Rome or Berlin.

It would be quite wrong to suggest that what curators now do is useless. They conserve – in the full sense of the word – what is already there; and some of them acquire new works intelligently. It is not useless but it is inadequate. And it is inadequate because it is outdated. Their view of art as a self-evident source of pleasure appealing to a well-formed Taste, their view of Appreciation being ultimately based on Connoisseurship – that is to say, the ability to compare product with product within a very narrow range – all this derives from the eighteenth century. Their sense of heavy civic responsibility – transformed, as we have seen, into honorary prestige; their view of the public as a passive mass to whom works of art, embodying spiritual value, should be made available, this belongs to the nineteenth-century tradition of public works and benevolence. Anybody who is not an expert entering the average museum today is made to feel like a cultural pauper receiving charity, whilst the phenomenal sales of fifth-rate art books reflect the consequent belief in Self-Help.

The influence of the twentieth century on the thinking of museum curators has been confined to décor or to technical innovations for facilitating the passing of the public through their domain. In a book published a few years ago and written by an important curator in France it is suggested that the museum of the future will be mechanised: the visitors will sit still in little viewing boxes and the canvases will appear before them on a kind of vertical escalator. 'In this way, in one hour and a half, a thousand visitors will be able to see a thousand paintings without leaving their seats.' Frank Lloyd Wright's

conception of the Guggenheim Museum in New York as a machine for having seen pictures in is only a more sophisticated example of the same attitude.

What then constitutes a truly modern attitude? Naturally, every museum poses a different problem. A solution which might suit a provincial city would be absurd for the National Gallery. For the moment we can only discuss general principles.

First it is necessary to make an imaginative effort which runs contrary to the whole contemporary trend of the art world: it is necessary to see works of art freed from all the mystique which is attached to them as property objects. It then becomes possible to see them as testimony to the process of their own making instead of as products; to see them in terms of action instead of finished achievement. The question: What went into the making of this? supersedes the collector's question of: What is this?

It is worth noticing that this change of emphasis has already deeply affected art. From Action Painting onwards, artists have become more and more concerned with revealing a process rather than coming to a conclusion. Harold Rosenberg, who was the spokesman for the American innovators, has put it quite simply: 'Action painting . . . indicated a new motive for painting in the twentieth century: that of serving as a means for the artist's re-creation of himself and as an evidence to the spectator of the kind of activities involved in this adventure.'

The new emphasis is the result of a revolution in our mode of general thinking and interpreting. Process has swept away all fixed states; the supreme human attribute is no longer knowledge as such, but the self-conscious awareness of process. The more original artists of the last twenty-five years have felt the shock of this revolution more keenly than most other people; but because they have also felt isolated in an indifferent society (success when it eventually came in no way qualified this indifference), they have been able to find no content for their new art except their own loneliness. Hence the narrowness of interest of their art; but hence also the relevance of its intimation.

In practical terms this means that, in the modern museum, works of art of any period need to be shown within the context of various processes: the technical process of the artist's means, the biographical process of his life, and, above all, the historical process which he may

reflect, influence, prophesy or be annulled by. This context will need to be established by the sequence in which paintings are hung and, whenever necessary, by texts on the wall. Photographs of paintings which are elsewhere will need to be hung next to real paintings. In the case of watercolours and drawings, facsimiles will need to be mixed with originals. Inferior works will need to be presented and explained as such. The Connoisseur's categories of nation and period will frequently need to be broken: a Boucher nude might be hung next to a Courbet. All décors will need to be neutral and mobile. The chatelain will lose his red velour South Room.

I might continue the list of other possible practical consequences, but I can already hear the protests. Puritan, didactic propaganda! The philistine enslavement of art to historicism! With these and a thousand other cries and guffaws the sanctity of art as property will be defended: and the present curators will save themselves the humiliation of trying to think about their subject as a whole.

If the application of ideas to the understanding of art implies propaganda, that is indeed what I am proposing. On the other hand, I am certainly not suggesting that a museum should arrange its work along the line of a single permanent argument. Each group of works might be treated in a different way. No argument should be permanent, and even within one grouping of works there would be the possibility – by hanging pictures along screen-walls which intersect at the key work – of presenting a number of different arguments simultaneously. In the great collections, works not being temporarily used as part of an argument would be hung as now, for reference and for the pleasure of those who already know them, without comment.

In the case of all but the great metropolitan museums, the approach I am suggesting would transform them utterly. Their reputation would no longer depend upon the small number of unrivalled masterpieces they can claim. Second- and third-rate works could, by their context, be made significant and moving. Imagine a Greuze child study put beside a formal official Baroque portrait by one of his contemporaries. Inferior and boring works would suddenly acquire a positive function – for they would illuminate the problems which another work had resolved. If museums collaborated with one another, every museum could have a fabulous collection of facsimile watercolours and drawings to suit its

arguments or studies. Photographs could 'borrow' for many compara-
tive purposes works from any collection in the world. In brief, the
museum, instead of being a depository of so many unique sights or
treasures, would become a living school with the very special advan-
tage of dealing in visual images, which, given a simple framework of
historical and psychological knowledge, can convey experience far
more deeply to people than most literary and scientific expositions.

I have not the slightest doubt that museums will eventually serve the
kind of function I am suggesting. I am certain about this, not only because
museums will finally be forced to recognise their century, and here is an
obvious solution to many of their already existing problems, but also
because of the only possible future function of the art we have inherited.

The purely aesthetic appeal and justification of art is based on less
than a half-truth. Art must also serve an extra-artistic purpose. A great
work often outlives its original purpose. But it does so because a later
period is able to discern, within the profundity of the experience it
contains, another purpose. For example: Villon wrote to introduce
himself as he was to God. We read him today as perhaps the first poet
of the 'free' man alone in Christian Europe.

We can no longer 'use' most paintings today as they were intended
to be used: for religious worship, for celebrating the wealth of the
wealthy, for immediate political enlightenment, for proving the
romantic sublime, and so on. Nevertheless, painting is especially well
suited to developing the very faculty of understanding which has
rendered its earlier uses obsolete: that is to say, to developing our
historical and evolutionary self-consciousness.

In front of a work from the past, by means of our aesthetic response
as well as by imaginative intelligence, we become able to recognise
the choices which reality allowed an artist four thousand, four hundred
or forty years ago. This recognition need never be academic. We are
given (as we are not in literature) the sensuous data through which the
alternatives of his choice must have presented themselves to him. It is
as though we can benefit from our sensations and responses to the
form and content of his work, being interpreted by his mind, condi-
tioned by his period, as well as by our own mind. An extraordinary
dialectic working across time! An extraordinary aid to realising how we
have historically arrived at becoming ourselves!

27.

The Work *of Art*

IT HAS TAKEN me a long time to come to terms with my reactions to Nicos Hadjinicolaou's book *Art History and Class Consciousness.*[1] These reactions are complex for both theoretical reasons and personal ones. Nicos Hadjinicolaou sets out to define the possible practice of a scientific Marxist art history. How necessary it is to produce this initiative, first proposed by Max Raphael nearly fifty years ago!

The exemplary figure of the book, one could almost say its chosen father, is the late Frederick Antal. To see at last this great art historian's work being recognised is a heartening experience; the more so for me personally because I was once an unofficial student of Antal's. He was my teacher, he encouraged me, and a great deal of what I understand by art history I owe to him. Two pupils of the same exemplary master might be likely to make common cause.

Yet I am obliged to argue against this book as a matter of principle. Hadjinicolaou's scholarship is impressive and well used; his arguments are courageously clear. In France, where he lives, he has helped to form with other Marxist colleagues the Association Histoire et Critiques

1 Nicos Hadjinicolaou, *Art History and Class Consciousness* (London: Pluto, 1978).

des Arts, which has held several notable and important conferences. My argument will, I hope, be fierce but not dismissive.

Let me first try to summarise the book as fairly as I can. 'The history of all hitherto existing society is the history of class struggles.' Opening with this quotation from the *Communist Manifesto*, Hadjinicolaou asks: How should this apply to the discipline of art history? He dismisses as over-simple the answers of 'vulgar' Marxism, which seek direct evidence of the class struggle in the class origins and political opinions of the painter or, alternatively, in the story the painting tells. He recognises the relative autonomy of the production-of-pictures (a term which he prefers to *art* because implicit in the latter is a value judgment deriving from bourgeois aesthetics). He argues that pictures have their own ideology – a visual one, which must not be confused with political, economic, colonial and other ideologies.

For him an ideology is the systematic way in which a class or a section of a class projects, disguises and justifies its relations to the world. Ideology is a social/historical element – encompassing like water – from which it is impossible to emerge until classes have been abolished. The most one can do is identify an ideology and relate it to its precise class function.

By *visual ideology* he means the way that a picture makes you see the scene it represents. In some ways it is similar to the category of *style*, yet it is more comprehensive. He regrets totally the ordinary connotations of style. There is no such thing as the style of an artist. Rembrandt has no style, everything depends upon which picture Rembrandt was producing under what circumstances. The way each picture renders experience visible constitutes its visual ideology.

Yet in considering the visible – and this is my gloss, not his – one must remember that, according to such a theory of ideology (which owes a lot to Althusser and Poulantzas), we are, in some ways, like blind men who have to learn to allow for and overcome our blindness, but to whom sight itself, whilst class societies continue, cannot be accorded. The negative implication of this becomes crucial, as I shall try to show later.

The task of a scientific art history is to examine any picture, to identify its visual ideology and to relate it to the class history of its time, a

complex history because classes are never homogeneous and consist of many conflicting groups and interests.

The traditional schools of art history are unscientific. He examines each in turn. The first treats art history as if it were no more than a history of great painters, and then explains them in psychological, psychoanalytical or environmental terms. To treat art history as if it were a relay race of geniuses is an individualist illusion, whose origins in the Renaissance corresponded with the phase of the primitive accumulation of private capital. I argue something similar in *Ways of Seeing*. The immense theoretical weakness of my own book is that I do not make clear what relation exists between what I call 'the exception' (the genius) and the normative tradition. It is at this point that work needs to be done. It could well be the theme of a conference.

A second school sees art history as part of the history of ideas (Jacob Burckhardt, Aby Warburg, Panofsky, Saxl). The weakness of this school is to avoid the specificity of the language of painting and to treat it as if it were a hieroglyphic text of ideas. As for the ideas themselves, they tend to be thought of as emanating from a *Zeitgeist* which, in class terms, is immaculate and virgin. I find the criticisms valid.

The third school is that of formalism (Wölfflin, Riegl), which sees art as a history of formal structures. Art, independent of both artists and society, has its own life coiled in its forms. This life develops through stages of youthfulness, maturity, decadence. A painter inherits a style at a certain stage of its spiral development. Like all organic theories applied to highly socialised activities – mistaking *history* for *nature* – the formalist school leads to reactionary conclusions.

Against each of these schools Hadjinicolaou fights as valiantly as David, armed with his sling of *visual ideology*. The proper subject matter of 'art history as an autonomous science' is 'the analysis and explanation of the visual ideologies which have appeared in history'. Only such ideologies can explain art. 'Aesthetic effect' – the enhancement that a work of art offers – 'is none other than the pleasure felt by the observer when he recognises himself in a picture's visual ideology.' The 'disinterested' emotion of classical aesthetics turns out to be a precise class interest.

Now, within the logic of Althusserian Marxism and its field of ideological formulations, this is an elegant if abstract formula. And it has

the advantage of cutting the interminable knotting of the obsolete discourse of bourgeois aesthetics. It may also go some way to explaining the dramatic fluctuations which have occurred in the history of taste: for example, the neglect during centuries after their original fame of painters as different as Franz Hals and El Greco.

The formula would seem to cover retrospectively Antal's practice as an art historian. In his formidable study on Florentine painting – as well as in other works – Antal set out to show in detail how sensitive painting was to economic and ideological developments. Single-handed he disclosed, with all the rigour of a European scholar, a new seam of content in pictures, and through this seam ran the class struggle. But I do not think that he believed that this explained the phenomenon of art. His respect for art was such that he could not forgive, as Marx could not forgive, the history he studied.

And Marx himself posed the question which the formula of visual ideology cannot answer. If art is bound up with certain phases of social historical development, how is it that we still find, for example, classical Greek sculpture beautiful? Hadjinicolaou replies by arguing that what is seen as 'art' changes all the while, that the sculptures seen by the nineteenth century were no longer the same *art* as seen by the third century BC. Yet the question remains: What, then, is it about certain works which allows them to 'receive' different interpretations and continue to offer a mystery? (Hadjinicolaou would consider the last word unscientific, but I do not.)

Max Raphael, in his two essays, *The Struggle to Understand Art* and *Towards an Empirical Theory of Art* (1941), began with the same question posed by Marx, and proceeded in exactly the opposite direction. Whereas Hadjinicolaou begins with the work as an object and looks for explanations prior to its production and following its production, Raphael believed that the explanation had to be sought in the process of production itself: the power of paintings lay in their *painting*. 'Art and the study of art lead from the work to the process of creation.'

For Raphael, 'The work of art holds man's creative powers in a crystalline suspension from which they can again be transformed into living energies.' Everything therefore depends upon this crystalline suspension, which occurs in history, subject to its conditions, and yet at another level defies those conditions. Raphael shared Marx's doubt;

he recognised that historical materialism and its categories as so far developed could only explain certain aspects of art. They could not explain why art is capable of defying the flow of historical process and time. Yet Raphael proposed an empirical – not an idealist – answer.

'Art is an interplay, an equation of three factors – the artist, the world and the means of figuration.' A work of art cannot be considered as either a simple object or simple ideology.

> It is always a synthesis between nature (or history) and the mind, and as such it acquires a certain autonomy vis-à-vis both these elements. This independence seems to be created by man and hence to possess a psychic reality; but in point of fact the process of creation can become an existent only because it is embedded in some concrete material.

Wood, pigment, canvas and so on. When this material has been worked by the artist it becomes like no other existing material: what the image represents (a head and shoulders, say) is pressed, embedded into this material, whilst the material by being worked into a representational image acquires a certain immaterial character. And it is this which gives works of art their incomparable energy. They exist in the same sense that a current exists: it cannot exist without substances, and yet it is not in itself a simple substance.

None of this precludes 'visual ideologies'. But Raphael's theory is bound to situate them as one factor among others within the act of painting; they cannot form the simple grid through which the artist sees and the spectator looks. Hadjinicolaou wants to avoid the reductionism of vulgar Marxism, yet he replaces it with another because he has no theory about *the act* of painting or *the act* of looking at pictures.

The lack becomes obvious as soon as he considers the visual ideology of particular pictures. There is nothing in common, he says, between a Louis David portrait painted in 1781, the David painting of *The Death of Marat* of 1793, and his painting of *Madame Récamier* of 1800. He has to say this because, if a painting consists of nothing but visual ideology, and these three paintings clearly have different visual ideologies reflecting the history of the Revolution, they cannot have anything in common. David's experience as a painter is irrelevant, and

our experience as spectators of David's experience is also irrelevant. And there's the rub. The real experience of looking at paintings has been eliminated.

When Hadjinicolaou goes further and equates the visual ideology of *Madame Récamier* with that of a portrait by Girodet, one realises that the visual content to which he is referring goes no deeper than the *mise-en-scène*. The correspondence is at the level of clothes, furniture, hair-style, gesture, pose: at the level, if you wish, of manners and appearances!

Of course, there are paintings which do only function at this level, and his theory may help to fit some of these paintings into history. But no painting of value is about appearances: it is about a totality of which the visible is no more than a code. And in face of such paintings the theory of visual ideology is helpless.

To this Hadjinicolaou would reply that the term 'painting of value' is meaningless. And in a sense I cannot answer his objection because my own theory is weak about the relation existing between the exceptional work and the average. Nevertheless I would beg Hadjinicolaou and his colleagues to consider the possibility that their approach is self-defeating and retrograde, leading back to a reductionism not dissimilar in degree to Zhdanov's and Stalin's.

The refusal of comparative judgments about art ultimately derives from a lack of belief in the purpose of art. One can only qualify X as better than Y if one believes that X achieves more, and this achievement has to be measured in relation to a goal. If paintings have no purpose, have no value other than their promotion of a visual ideology, there is little reason for looking at old pictures except as specialist historians. They become no more than a text for experts to decipher.

The culture of capitalism has reduced paintings, as it reduces everything which is alive, to market commodities, and to an advertisement for other commodities. The new reductionism of revolutionary theory, which we are considering, is in danger of doing something similar. What the one uses as an advertisement (for a prestige, a way of life and the commodities that go with it), the other sees as only a visual ideology of a class. Both eliminate art as a potential model of freedom, which is how artists and the masses have always treated art when it spoke to their needs.

When a painter is working he is aware of the means which are available to him – these include his materials, the style he inherits, the conventions he must obey, his prescribed or freely chosen subject matter – as constituting both an opportunity and a restraint. By working and using the opportunity he becomes conscious of some of its limits. These limits challenge him, at either an artisanal, a magical or an imaginative level. He pushes against one or several of them. According to his character and historical situation, the result of his pushing varies from a barely discernible variation of a convention – changing no more than the individual voice of a singer changes a melody – to a fully original discovery, a breakthrough. Except in the case of the pure hack, who, needless to say, is a modern invention of the market, every painter from palaeolithic times onwards has experienced this will to push. It is intrinsic to the activity of rendering the absent present, of cheating the visible, of making images.

Ideology partly determines the finished result, but it does not determine the energy flowing through the current. And it is with this energy that the spectator identifies. Every image used by a spectator is a *going further* than he could have achieved alone, towards a prey, a Madonna, a sexual pleasure, a landscape, a face, a different world.

'On the margin of what man can do', wrote Max Raphael, 'there appears that which he cannot or cannot yet do – but which lies at the root of all creativeness.' A revolutionary scientific history of art has to come to terms with such creativeness.

28.

1968/1979 *Preface to*
Permanent Red *(1960)*

THIS BOOK WAS first published in 1960. Most of it was written between 1954 and 1959. It seems to me that I have changed a lot since then. As I re-read the book today I have the impression that I was trapped at that time: trapped in having to express all that I felt or thought in art-critical terms. Perhaps an unconscious sense of being trapped helps to explain the puritanism of some of my judgments. In some respects I would be more tolerant today: but on the central issue I would be even more intransigent. I now believe that there is an absolute incompatibility between art and private property, or between art and state property – unless the state is a plebeian democracy. Property must be destroyed before imagination can develop any further. Thus today I would find the function of regular current art criticism – a function which, whatever the critic's opinions, serves to uphold the art market – impossible to accept. And thus today I am more tolerant of those artists who are reduced to being largely destructive.

Yet it is not only I who have changed. The future perspective of the world has changed fundamentally. In the early 1950s, when I began writing art criticism, there were two poles, and only two, to which any political thought and action inevitably led. The polarisation was between Moscow and Washington. Many people struggled to escape

this polarisation but, objectively speaking, it was impossible, because it was not a consequence of *opinions* but of a crucial world-struggle. Only when the USSR achieved (or was recognised to have achieved) parity in nuclear arms with the United States could this struggle cease to be the primary political factor. The achieving of this parity just preceded the Twentieth Congress of the CPSU and the Polish and Hungarian uprisings, to be followed later by the victory of the Cuban Revolution. Revolutionary examples and possibilities have since multiplied. The *raison d'être* of polarised dogmatism has collapsed.

I have always been outspokenly critical of the Stalinist cultural policy of the USSR, but during the 1950s my criticism was more restrained than now. Why? Ever since I was a student, I have been aware of the injustice, hypocrisy, cruelty, wastefulness and alienation of our bourgeois society as reflected and expressed in the field of art. And my aim has been to help, in however small a way, to destroy this society. It exists to frustrate the best man. I know this profoundly and am immune to the apologetics of liberals. Liberalism is always for the alternative *ruling* class: never for the exploited class. But one cannot aim to destroy without taking account of the state of existing forces. In the early 1950s the USSR represented, despite all its deformations, a great part of the force of the socialist challenge to capitalism. It no longer does.

A third change, although trivial, is perhaps worth mentioning. It concerns my conditions of work. Most of this book was first written as articles for the *New Statesman*. They were written, as I have explained, at the height of the Cold War, during a period of rigid conformism. I was in my twenties (at a time when to be young was inevitably to be patronised). Consequently, every week, after I had written my article, I had to fight for it line by line, adjective by adjective, against constant editorial cavilling. During the last years of the 1950s I had the support and friendship of Kingsley Martin, but my own attitude towards writing for the paper and being published by it had already been formed by then. It was an attitude of belligerent wariness. Nor were the pressures only from within the paper. The vested interests of the art world exerted their own through the editors. When I reviewed an exhibition of Henry Moore, arguing that it revealed a falling-off from his earlier achievements, the British Council actually telephoned the artist to

apologise for such a regrettable thing having occurred in London. The art scene has now changed. And on the occasions when I now write about art I am fortunate enough to be able to write quite freely.

Re-reading this book, I have the sense of myself being trapped and many of my statements being coded. And yet I have agreed to the book being reissued as a paperback. Why? The world has changed. Conditions in London have changed. Some of the issues and artists I discuss no longer seem of urgent concern. I have changed. But precisely because of the pressures under which the book was written – professional, political, ideological, personal pressures – it seems to me that I needed at that time to formulate swift but sharp generalisations and to cultivate certain long-term insights in order to transcend the pressures and escape the confines of the genre. Today most of these generalisations and insights strike me as still valid. Furthermore, they seem consistent with what I have thought and written since. The short essay on Picasso is in many ways an outline for my later book on Picasso. The recurring theme of the present book is the disastrous relation between art and property, and this is the only theme connected with art on which I would still like to write a whole book.

The title *Permanent Red* was never meant to imply that I would not change. It was to claim that I would never compromise my opposition to bourgeois culture and society. In agreeing to the reissue of the book I repeat the claim.

29.

Historical Afterword to the
Into Their Labours *Trilogy*

The earth shows up those of value and those who are good for nothing.
A peasant judgment quoted by Jean-Pierre Vernant in *Mythe et*
Pensée chez les Grecs

The peasantry consists of small agricultural producers who with
the help of simple equipment and the labour of their families
produce mainly for their own consumption and for the fulfilment
of obligations to the holders of political and economic power.
Theodor Shanin, *Peasants and Peasant Societies*

IN THE NINETEENTH century there was a tradition whereby novelists,
storytellers and even poets offered the public an historical explanation
of their work, often in the form of a preface. Inevitably a poem or a
story deals with particular experience: how this experience relates to
developments on a world scale can and should be implied within the
writing itself – this is precisely the challenge posed by the 'resonance'
of a language (in one sense any language, like a mother, knows all);
nevertheless, it is not usually possible in a poem or story to make the
relation between particular and universal fully explicit. Those who try
to do so end up by writing parables. Hence the writer's desire to write
an explanation *around* the work or works he is offering the reader. The
tradition became established in the nineteenth century exactly because
it was a century of revolutionary change in which the relation between
the individual and history was becoming a conscious one.

The scale and rate of change in our century is even greater. Yet now it is rare for a writer to try to explain his book. The argument has been that the work of imagination he has created should be sufficient unto itself. Literature has elevated itself into a pure art. Or so it is assumed. The truth is that most literature, whether addressed to an elite or mass readership, has degenerated into pure entertainment.

I am opposed to this development for many reasons, of which the simplest is that it is an insult to the dignity of the reader, the experience communicated, and the writer. Hence the following essay.

<center>ɉ</center>

Peasant life is a life committed completely to survival. Perhaps this is the only characteristic fully shared by peasants everywhere. Their implements, their crops, their earth, their masters may be different, but whether they labour within a capitalist society, a feudal one, or others which cannot be so easily defined, whether they grow rice in Java, wheat in Scandinavia, or maize in South America, whatever the differences of climate, religion and social history, the peasantry everywhere can be defined as a class of survivors. For a century and a half now the tenacious ability of peasants to survive has confounded administrators and theorists. Today it can still be said that the majority in the world are peasants. Yet this fact masks a more significant one. For the first time ever it is possible that the class of survivors may not survive. Within a century there may be no more peasants. In Western Europe, if the plans work out as the economic planners have foreseen, there will be no more peasants within twenty-five years.

Until recently, the peasant economy was always an economy within an economy. This is what has enabled it to survive global transformations of the larger economy – feudal, capitalist, even socialist. With these transformations the peasant's mode of struggle for survival often altered, but the decisive changes were wrought in the methods used for extracting a surplus from him: compulsory labour services, tithes, rents, taxes, sharecropping, interests on loans, production norms, and so on.

Unlike any other working and exploited class, the peasantry has always supported itself, and this made it, to some degree, a class apart. Insofar as it produced the necessary surplus, it was integrated into the

historical economic-cultural system. Insofar as it supported itself, it was on the frontier of that system. And I think one can say this, even where and when peasants make up the majority of the population.

If one thinks of the hierarchical structure of feudal or Asian societies as being roughly pyramidal, the peasantry were on the base frontier of the triangle. This meant, as with all frontier populations, that the political and social system offered them the minimum of protection. For this they had to look to themselves – within the village community and the extended family. They maintained or developed their own unwritten laws and codes of behaviour, their own rituals and beliefs, their own orally transmitted body of wisdom and knowledge, their own medicine, their own techniques, and sometimes their own language. It would be wrong to suppose that all this constituted an independent culture, unaffected by the dominant one and by its economic, social or technical developments. Peasant life did not stay exactly the same throughout the centuries, but the priorities and values of peasants (their strategy for survival) were embedded in a tradition which outlasted any tradition in the rest of society. The undeclared relation of this peasant tradition, at any given moment, to the dominant class culture was often heretical and subversive. 'Don't run away from anything', says the Russian peasant proverb, 'but don't do anything.' The peasant's universal reputation for cunning is a recognition of this secretive and subversive tendency.

No class has been or is more economically conscious than the peasantry. Economics consciously determines or influences every ordinary decision which a peasant takes. But his economics are not those of the merchant, nor those of bourgeois or Marxist political economy. The man who wrote with most understanding about lived peasant economics was the Russian agronomist Chayanov. Anyone who wishes to understand the peasant should, among other things, go back to Chayanov.

The peasant did not conceive of what was extracted from him as a surplus. One might argue that the politically unconscious proletarian is equally unaware of the surplus value he creates for his employer, yet the comparison is misleading – for the worker, working for wages in a money economy, can be easily deceived about the value of what he produces, whereas the peasant's *economic* relation to the rest of society

was always transparent. His family produced or tried to produce what they needed to live on, and he saw part of this produce, the result of his family's labour, being appropriated by those who had not laboured. The peasant was perfectly aware of what was being extracted from him, yet he did not think of this as a surplus for two reasons, the first material and the second epistemological. 1) It was not a surplus because his family needs had not already been assured. 2) A surplus is an end-product, the result of a long-completed process of working and of meeting requirements. To the peasant, however, his enforced social obligations assumed the form of a *preliminary obstacle*. The obstacle was often insurmountable. But it was on the other side of it that the other half of the peasant economy operated, whereby his family worked the land to assure its own needs.

A peasant might think of his imposed obligations as a natural duty, or as some inevitable injustice, but in either case they were something which had to be endured *before* the struggle for survival opened. He had first to work for his masters, later for himself. Even if he were sharecropping, the master's share came *before* the basic needs of his family. If the word were not too light in the face of the almost unimaginable burden of labour placed on the peasant, one might say that his enforced obligations assumed the form of a permanent handicap. It was *despite this* that the family had to open the already uneven struggle with nature to gain by their own work their own subsistence.

Thus the peasant had to survive the permanent handicap of having a 'surplus' taken from him; he had to survive, in the subsistence half of his economy, all the hazards of agriculture – bad seasons, storms, droughts, floods, pests, accidents, impoverished soil, animal and plant diseases, crop failures; and furthermore, at the base frontier, with the minimum of protection, he had to survive social, political and natural catastrophes – wars, plagues, brigands, fire, pillaging, and so on.

The word *survivor* has two meanings. It denotes somebody who has survived an ordeal. And it also denotes a person who has continued to live when others disappeared or perished. It is in this second sense that I am using the word in relation to the peasantry. Peasants were those who remained working, as distinct from the many who died young, emigrated or became paupers. At certain periods those who survived were certainly a *minority*. Demographic statistics give some idea of the

dimensions of the disasters. The population of France in 1320 was 17 million. A little over a century later it was 8 million. By 1550 it had climbed to 20 million. Forty years later it fell to 18 million.

In 1789 the population was 27 million, of whom 22 million were rural. The revolution and the scientific progress of the nineteenth century offered the peasant land and physical protection such as he had not known before; at the same time they exposed him to capital and the market economy; by 1848 the great peasant exodus to the cities had begun, and by 1900 there were only 8 million French peasants. The deserted village has probably almost always been – and certainly is again today – a feature of the countryside: it represents a site of no survivors.

A comparison with the proletariat in the early stages of the industrial revolution may clarify what I mean by a class of survivors. The working and living conditions of the early proletariat condemned millions to early death or disabling illness. Yet the class as a whole, its numbers, its capacity, its power, was growing. It was a class engaged in, and submitting to, a process of continual transformation and increase. It was not the victims of its ordeals who determined its essential class character, as in a class of survivors, but rather its demands and those who fought for them.

From the eighteenth century onwards, populations all over the world mounted, at first slowly and later dramatically. Yet for the peasantry this general experience of a new security of life could not overlay its class memory of earlier centuries, because the new conditions, including those brought about by improved agricultural techniques, entailed new threats: the large-scale commercialisation and colonialisation of agriculture, the inadequacy of ever smaller plots of land to support entire families, hence large-scale emigration to the cities where the sons and daughters of peasants were absorbed into another class.

The nineteenth-century peasantry was still a class of survivors, with the difference that those who disappeared were no longer those who ran away or who died as a result of famine and disease, but those who were forced to abandon the village and become wage earners. One should add that under these new conditions a few peasants became rich, but in doing so they also ceased, within a generation or two, to be peasants.

To say that peasants are a class of survivors may seem to confirm what the cities with their habitual arrogance have always said about peasants – that they are backward, a relic of the past. Peasants themselves, however, do not share the view of time implicit in such a judgment.

Inexhaustibly committed to wresting a life from the earth, bound to the present of endless work, the peasant nevertheless sees life as an interlude. This is confirmed by his daily familiarity with the cycle of birth, life and death. Such a view may predispose him to religion, yet religion is not at the origin of his attitude and, anyway, the religion of peasants has never fully corresponded with the religion of rulers and priests.

The peasant sees life as an interlude because of the dual contrary movement through time of his thoughts and feelings, which in turn derives from the dual nature of the peasant economy. His dream is to return to a life that is not handicapped. His determination is to hand on the means of survival (if possible made more secure, compared to what he inherited) to his children. His ideals are located in the past; his obligations are to the future, which he himself will not live to see. After his death he will not be transported into the future – his notion of immortality is different: he will return to the past.

These two movements, towards the past and the future, are not as contrary as they might first appear, because basically the peasant has a cyclic view of time. The two movements are different ways of going round a circle. He accepts the sequence of centuries without making that sequence absolute. Those who have a unilinear view of time cannot come to terms with the idea of cyclic time: it creates a moral vertigo, since all their morality is based on cause and effect. Those who have a cyclic view of time are easily able to accept the convention of historic time, which is simply the trace of the turning wheel.

The peasant imagines an unhandicapped life, a life in which he is not first forced to produce a surplus before feeding himself and his family, as a primal state of being which existed before the advent of injustice. Food is man's first need. Peasants work on the land to produce food to feed themselves. Yet they are forced to feed others first, often at the price of going hungry themselves. They see the grain in the fields which they have worked and harvested – on their

own land or on the landowner's – being taken away to feed others, or to be sold for the profit of others. However much a bad harvest is considered an act of God, however much the master/landowner is considered a natural master, whatever ideological explanations are given, the basic fact is clear: they who can feed themselves are instead being forced to feed others. Such an injustice, the peasant reasons, cannot always have existed, so he assumes a just world at the beginning. At the beginning a primary state of justice towards the primary work of satisfying man's primary need. All spontaneous peasant revolts have had the aim of resurrecting a just and egalitarian peasant society.

This dream is not the usual version of the dream of paradise. Paradise, as we now understand it, was surely the invention of a relatively leisured class. In the peasant's dream, work is still necessary. Work is the condition for equality. Both the bourgeois and Marxist ideals of equality presume a world of plenty; they demand equal rights for all before a cornucopia, a cornucopia to be constructed by science and the advancement of knowledge. What the two understand by equal rights is of course very different. The peasant ideal of equality recognises a world of scarcity, and its promise is for mutual fraternal aid in struggling against this scarcity and a just sharing of what the work produces. Closely connected with the peasant's recognition, as a survivor, of scarcity, is his recognition of man's relative ignorance. He may admire knowledge and the fruits of knowledge, but he never supposes that the advance of knowledge reduces the extent of the unknown. This non-antagonistic relation between the unknown and knowing explains why some of his knowledge is accommodated in what, from the outside, is defined as superstition and magic. Nothing in his experience encourages him to believe in final causes, precisely because his experience is so wide. The unknown can only be eliminated within the limits of a laboratory experiment. Those limits seem to him to be naive.

Opposing the movement of the peasant's thoughts and feelings about a justice in the past are other thoughts and feelings directed towards the survival of his children in the future. Most of the time the latter are stronger and more conscious. The two movements balance each other only insofar as together they convince him that the

interlude of the present cannot be judged in its own terms; morally it is judged in relation to the past, materially it is judged in relation to the future. Strictly speaking, nobody is less opportunist (taking the immediate opportunity regardless) than the peasant.

How do peasants think or feel about the future? Because their work involves intervening in or aiding an organic process, most of their actions are future-orientated. The planting of a tree is an obvious example, but so, equally, is the milking of a cow: the milk is for cheese or butter. Everything they do is anticipatory – and therefore never finished. They envisage this future, to which they are forced to pledge their actions, as a series of ambushes. Ambushes of risks and dangers. The most likely future risk, until recently, was hunger. The fundamental contradiction of the peasant's situation, the result of the dual nature of the peasant economy, was that they who produced the food were the most likely to starve. A class of survivors cannot afford to believe in an arrival point of assured security or well-being. The only, but great, future hope is survival. This is why the dead do better to return to the past where they are no longer subject to risk.

The future path through future ambushes is a continuation of the old path by which the survivors from the past have come. The image of a path is apt, because it is by following a path, created and maintained by generations of walking feet, that some of the dangers of the surrounding forests or mountains or marshes may be avoided. The path is tradition handed down by instructions, example and commentary. To a peasant the future is this future narrow path across an indeterminate expanse of known and unknown risks. When peasants cooperate to fight an outside force, and the impulse to do this is always defensive, they adopt a guerrilla strategy – which is precisely a network of narrow paths across an indeterminate hostile environment.

☙

THE PEASANT VIEW of human destiny, such as I am outlining, was not, until the advent of modern history, essentially different from the view of other classes. One has only to think of the poems of Chaucer, Villon, Dante; in all of them Death, whom nobody can escape, is the

surrogate for a generalised sense of uncertainty and menace in face of the future.

Modern history begins – at different moments in different places – with the principle of progress as both the aim and motor of history. This principle was born with the bourgeoisie as an ascendant class, and has been taken over by all modern theories of revolution. The twentieth-century struggle between capitalism and socialism is, at an ideological level, a fight about the content of progress. Today within the developed world the initiative of this struggle lies, at least temporarily, in the hands of capitalism, which argues that socialism produces backwardness. In the underdeveloped world the 'progress' of capitalism is discredited.

Cultures of progress envisage future expansion. They are forward-looking because the future offers ever larger hopes. At their most heroic these hopes dwarf Death (*La Rivoluzione o la Morte!*). At their most trivial they ignore it (consumerism). The future is envisaged as the opposite of what classical perspective does to a road. Instead of appearing to become ever narrower as it recedes into the distance, it becomes ever wider.

A culture of survival envisages the future as a sequence of repeated acts for survival. Each act pushes a thread through the eye of a needle, and the thread is tradition. No overall increase is envisaged.

If, now, comparing the two types of culture, we consider their view of the past as well as the future, we see that they are mirror-opposites of one another.

194

This may help to explain why an experience within a culture of survival can have the opposite *significance* to the comparable experience within a culture of progress. Let us take, as a key example, the much proclaimed conservatism of the peasantry, their resistance to change; the whole complex of attitudes and reactions which often (not invariably) allows a peasantry to be counted as a force for the right wing.

First, we must note that the counting is done by the cities, according to an historical scenario opposing left to right, which belongs to a culture of progress. The peasant refuses that scenario, and he is not stupid to do so, for the scenario, whether the left or right wins, envisages his disappearance. His conditions of living, the degree of his exploitation and his suffering, may be desperate, but he cannot contemplate the disappearance of what gives meaning to everything he knows, which is, precisely, his will to survive. No worker is ever in that position, for what gives meaning to his life is either the revolutionary hope of transforming it, or money, which is received in exchange against his life as a wage earner, to be spent in his 'true life' as a consumer.

Any transformation of which the peasant dreams involves his re-becoming 'the peasant' he once was. The worker's political dream is to transform everything which up to now has condemned him to be a worker. This is one reason why an alliance between workers and peasants can only be maintained if it is for a specific aim (the defeat of a foreign enemy, the expropriation of large landowners) to which both parties are agreed. No general alliance is normally possible.

To understand the significance of peasant conservatism related to the sum of peasant experience, we need to examine the idea of change with a different optic. It is an historical commonplace that change,

questioning, experiment, flourished in the cities and emanated outwards from them. What is often overlooked is the character of everyday urban life which allowed for such an interest in research. The city offered to its citizens comparative security, continuity, permanence. The degree offered depended upon the class of the citizen, but compared to life in a village, all citizens benefited from a certain protection.

There was heating to counteract changes of temperature, lighting to lessen the difference between night and day, transport to reduce distances, relative comfort to compensate for fatigue; there were walls and other defences against attack, there was effective law, there were almshouses and charities for the sick and aged, there were libraries of permanent written knowledge, there was a wide range of services – from bakers and butchers through mechanics and builders to doctors and surgeons – to be called upon whenever a need threatened to disrupt the customary flow of life; there were conventions of social behaviour which strangers were obliged to accept (when in Rome . . .), there were buildings designed as promises of, and monuments to, continuity.

During the last two centuries, as urban theories and doctrines of change have become more and more vehement, the degree and efficacy of such everyday protection have correspondingly increased. Recently the insulation of the citizen has become so total that it has become suffocating. He lives alone in a serviced limbo – hence his newly awakened, but necessarily naive, interest in the countryside.

By contrast, the peasant is unprotected. Each day a peasant experiences more change more closely than any other class. Some of these changes, like those of the seasons or like the process of ageing and failing energy, are foreseeable; many – like the weather from one day to the next, like a cow choking to death on a potato, like lightning, like rains which come too early or too late, like fog that kills the blossom, like the continually evolving demands of those who extract the surplus, like an epidemic, like locusts – are unpredictable.

In fact the peasant's experience of change is more intense than any list, however long and comprehensive, could ever suggest. For two reasons. First, his capacity for observation. Scarcely anything changes in a peasant's entourage, from the clouds to the tail feathers of a cock,

without his noticing and interpreting it in terms of the future. His active observation never ceases, and so he is continually recording and reflecting upon changes. Secondly, his economic situation. This is usually such that even a slight change for the worse – a harvest which yields 25 per cent less than the previous year, a fall in the market price of the harvest produce, an unexpected expense – can have disastrous or near-disastrous consequences. His observation does not allow the slightest sign of change to pass unnoticed, and his debt magnifies the real or imagined threat of a great part of what he observes.

Peasants live with change hourly, daily, yearly, from generation to generation. There is scarcely a constant given to their lives except the constant necessity of work. Around this work and its seasons they themselves create rituals, routines and habits in order to wrest some meaning and continuity from a cycle of remorseless change: a cycle which is in part natural and in part the result of the ceaseless turning of the millstone of the economy within which they live.

The very great variety of these routines and rituals which attach themselves to work and to the different phases of a working life (birth, marriage, death) are the peasant's own protection against a state of continual flux. Work routines are traditional and cyclic – they repeat themselves each year, and sometimes each day. Their tradition is retained because it appears to assure the best chance of the work's success, but also because, in repeating the same routine, in doing the same thing in the same way as his father or his neighbour's father, the peasant assumes a continuity for himself and thus consciously experiences his own survival.

The repetition, however, is essentially and only formal. A work routine for a peasant is very different from most urban work routines. Each time a peasant does the same job there are elements in it which have changed. The peasant is continually improvising. His faithfulness to tradition is never more than approximate. The traditional routine determines the ritual of the job: its content, like everything else he knows, is subject to change.

When a peasant resists the introduction of a new technique or method of working, it is not because he cannot see its possible advantages – his conservatism is neither blind nor lazy – but because he believes that these advantages cannot, by the nature of things, be

guaranteed, and that, should they fail, he will then be cut off alone and isolated from the routine of survival. (Those working with peasants for improved production should take this into account. A peasant's ingenuity makes him open to change, his imagination demands continuity. Urban appeals for change are usually made on the opposite basis: ignoring ingenuity, which tends to disappear with the extreme division of labour, they promise the imagination a new life.)

Peasant conservatism, within the context of peasant experience, has nothing in common with the conservatism of a privileged ruling class or the conservatism of a sycophantic petty-bourgeoisie. The first is an attempt, however vain, to make their privileges absolute; the second is a way of siding with the powerful in exchange for a little delegated power over other classes. Peasant conservatism scarcely defends any privilege. Which is one reason why, much to the surprise of urban political and social theorists, small peasants have so often rallied to the defence of richer peasants. It is a conservatism not of power but of meaning. It represents a depository (a granary) of meaning preserved from lives and generations threatened by continual and inexorable change.

Many other peasant attitudes are frequently misunderstood, or understood in an exactly opposite sense – as the diagram of the mirror-image has already suggested. For example, peasants are thought to be money-minded, whereas, in fact, the behaviour which gives rise to this idea derives from a profound suspicion of money. For example, peasants are said to be unforgiving, yet this trait, insofar as it is true, is the result of the belief that life without justice becomes meaningless. It is rare for any peasant to die unforgiven.

<div align="center">℞</div>

WE MUST NOW ask this question. What is the contemporary relation between peasants and the world economic system of which they form part? Or, to put this question in terms of our consideration of peasant experience, what significance can this experience have today in a global context?

Agriculture does not necessarily require peasants. The British peasantry was destroyed (except in certain areas of Ireland and Scotland) well over a century ago. In the United States there have been no

peasants in modern history because the rate of economic development based on monetary exchange was too rapid and too total. In France 150,000 peasants now leave the land every year. The economic planners of the EEC envisage the systematic elimination of the peasant by the end of the century, if not before. For short-term political reasons, they do not use the word elimination but the word modernisation. Modernisation entails the disappearance of the small peasants (the majority) and the transformation of the remaining minority into totally different social and economic beings. The capital outlay for intensive mechanisation and chemicalisation, the necessary size of the farm exclusively producing for the market, the specialisation of produce by area, all mean that the peasant family ceases to be a productive and consuming unit, and that, instead, the peasant becomes the dependant of the interests which both finance him and buy from him. The economic pressure on which such a plan depends is supplied by the falling market value of agricultural produce. In France today the buying power of the price of one sack of wheat is three times less than it was fifty years ago. The ideological persuasion is supplied by all the promises of consumerism. An intact peasantry was the only class with an in-built resistance to consumerism. When a peasantry is dispersed, markets are enlarged.

In much of the Third World the systems of land tenure (in large parts of Latin America 1 per cent of landowners own 60 per cent of the farm land, and 100 per cent of the best land), the imposition of monocultures for the benefit of corporate capitalism, the marginalisation of subsistence farming, and, only because of these other factors, the mounting population, cause more and more peasants to be reduced to such a degree of absolute poverty that, without land or seed or hope, they lose all previous social identity. Many of these ex-peasants make for the cities where they form a millionfold mass such as has never existed before, a mass of static vagrants, a mass of unemployed attendants: attendants in the sense that they wait in the shantytowns, cut off from the past, excluded from the benefits of progress, abandoned by tradition, serving nothing.

Engels and most early twentieth-century Marxists foresaw the disappearance of the peasant in face of the greater profitability of capitalist agriculture. The capitalist mode of production would do away

with small peasant production 'as a steam engine smashes a wheelbarrow'. Such prophecies underestimated the resilience of the peasant economy and overestimated the attraction of agriculture for capital. On the one hand, the peasant family could survive without profitability (cost accounting was inapplicable to the peasant economy); and on the other hand, for capital, land, unlike other commodities, is not infinitely reproducible, and investment in agricultural production finally meets a constraint and yields decreasing returns.

The peasant has survived far longer than was predicted. But within the last twenty years monopoly capital, through its multinational corporations, has created the new highly profitable structure of agribusiness whereby it controls, not necessarily the production, but the market for agricultural inputs and outputs and the processing, packaging and selling of every kind of foodstuff. The penetration of this market into all corners of the globe is eliminating the peasant: in the developed countries by more or less planned conversion; in the underdeveloped countries catastrophically. Previously cities were dependent on the countryside for their food, peasants being forced, in one way or another, to part with their so-called surplus. Soon the world countryside may be dependent on the cities even for the food its own rural population requires. When and if this happens, peasants will have ceased to exist.

During the same period of the last twenty years, in other parts of the Third World – China, Cuba, Vietnam, Cambodia, Algeria – revolutions have been made by peasants, and in their name. It is too soon to know what kind of transformation of the peasant experience these revolutions will achieve, and how far their governments can or cannot maintain a different set of priorities to those imposed by the world market of capitalism.

It must follow from what I have already said that nobody can reasonably argue for the preservation and maintenance of the traditional peasant way of life. To do so is to argue that peasants should continue to be exploited, and that they should lead lives in which the burden of physical work is often devastating and always oppressive. As soon as one accepts that peasants are a class of survivors – in the sense in which I have defined the term – any idealisation of their way of life becomes impossible. In a just world such a class would no longer exist.

Yet to dismiss peasant experience as belonging only to the past, as having no relevance to modern life; to imagine that the thousands of years of peasant culture leave no heritage for the future – simply because it was seldom embodied in lasting objects; to continue to maintain, as has been maintained for centuries, that peasant experience is marginal to civilisation, is to deny the value of too much history and too many lives. No line of exclusion can be drawn across history in that manner, as if it were a line across a closed account.

The point can be made more precisely. The remarkable continuity of peasant experience and the peasant view of the world acquires, as it is threatened with extinction, an unprecedented and unexpected urgency. It is not only the future of peasants which is now involved in this continuity. The forces which in most parts of the world are today eliminating or destroying the peasantry represent the contradiction of most of the hopes once contained in the principle of historical progress. Productivity is not reducing scarcity. The dissemination of knowledge is not leading unequivocally to greater democracy. The advent of leisure – in the industrialised societies – has not brought personal fulfilment but greater mass manipulation. The economic and military unification of the world has not brought peace but genocide. The peasant suspicion of 'progress', as it has finally been imposed by the global history of corporate capitalism and by the power of this history even over those seeking an alternative to it, is not altogether misplaced or groundless.

Such a suspicion cannot in itself form the basis for an alternative political development. The precondition for such an alternative is that peasants should achieve a world view of themselves as a class, and this implies, not their elimination, but their achieving power as a class: a power which, in being achieved, would transform their class experience and character.

Meanwhile, if one looks at the likely future course of world history, envisaging either the further extension and consolidation of corporate capitalism in all its brutalism, or a prolonged, uneven struggle waged against it, a struggle whose victory is not certain, the peasant experience of survival may well be better adapted to this long and harsh perspective than the continually reformed, disappointed, impatient progressive hope of an ultimate victory.

Finally, there is the historic role of capitalism itself, a role unforeseen by Adam Smith or Marx: its historic role is to destroy history, to sever every link with the past and to orientate all effort and imagination to that which is about to occur. Capital can only exist as such if it continually reproduces itself; its present reality is dependent upon its future fulfilment. This is the metaphysic of capital. The word *credit*, instead of referring to a past achievement, refers only in this metaphysic to a future expectation. How such a metaphysic eventually came to inform a world system, how it has been translated into the practice of consumerism, how it has lent its logic to the categorisation of those whom the system impoverishes as backward (i.e. bearing the stigma and shame of the past), is beyond the scope of this essay. Henry Ford's remark that 'History is bunk' has generally been underestimated; he knew exactly what he was saying. Destroying the peasantries of the world could be a final act of historical elimination.[1]

1 The 1999 edition of *Pig Earth* (London: Bloomsbury) adds: 'This trilogy has been written in a spirit of solidarity with the so-called "backward", whether they live in villages or have been forced to emigrate to a metropolis. Solidarity, because it is such women and men who have taught me the little I know.'

30.

The White Bird

FROM TIME TO time I have been invited by institutions – mostly American – to speak about aesthetics. On one occasion I considered accepting, and I thought of taking with me a bird made of white wood. But I didn't go. The problem is that you can't talk about aesthetics without talking about the principle of hope and the existence of evil. During the long winters the peasants in certain parts of the Haute Savoie used to make wooden birds to hang in their kitchens and perhaps also in their chapels. Friends who are travellers have told me that they have seen similar birds, made according to the same principle, in certain regions of Czechoslovakia, Russia and the Baltic countries. The tradition may be more widespread.

The principle of the construction of these birds is simple enough, although to make a fine bird demands considerable skill. You take two bars of pine wood, about six inches in length, a little less than one inch in height and the same in width. You soak them in water so that the wood has the maximum pliability, then you carve them. One piece will be the head and body with a fan tail, the second piece will represent the wings. The art principally concerns the making of the wing and tail feathers. The whole block of each wing is carved according to the silhouette of a single feather. Then the block is sliced into thirteen thin layers and these are gently opened out, one by one, to make a fan

shape. Likewise for the second wing and for the tail feathers. The two pieces of wood are joined together to form a cross and the bird is complete. No glue is used and there is only one nail where the two pieces of wood cross. Very light, weighing only two or three ounces, the birds are usually hung on a thread from an overhanging mantelpiece or beam so that they move with the air currents.

It would be absurd to compare one of these birds to a Van Gogh self-portrait or a Rembrandt crucifixion. They are simple, homemade objects, worked according to a traditional pattern. Yet, by their very simplicity, they allow one to categorise the qualities which make them pleasing and mysterious to everyone who sees them.

First there is a figurative representation – one is looking at a bird, more precisely a dove, apparently hanging in mid-air. Thus, there is a reference to the surrounding world of nature. Secondly, the choice of subject (a flying bird) and the context in which it is placed (indoors where live birds are unlikely) render the object symbolic. This primary symbolism then joins a more general, cultural one. Birds, and doves in particular, have been credited with symbolic meanings in a very wide variety of cultures.

Thirdly, there is a respect for the material used. The wood has been fashioned according to its own qualities of lightness, pliability and texture. Looking at it, one is surprised by how well wood becomes bird. Fourthly, there is a formal unity and economy. Despite the object's apparent complexity, the grammar of its making is simple, even austere. Its richness is the result of repetitions which are also variations. Fifthly, this man-made object provokes a kind of astonishment: How on earth was it made? I have given rough indications above, but anyone unfamiliar with the technique wants to take the dove in his hands and examine it closely to discover the secret which lies behind its making.

These five qualities, when undifferentiated and perceived as a whole, provoke at least a momentary sense of being before a mystery. One is looking at a piece of wood that has become a bird. One is looking at a bird that is somehow more than a bird. One is looking at something that has been worked with a mysterious skill and a kind of love.

Thus far I have tried to isolate the qualities of the white bird which provoke an aesthetic emotion. (The word 'emotion', although

designating a motion of the heart and of the imagination, is somewhat confusing, for we are considering an emotion that has little to do with the others we experience, notably because the self here is in a far greater degree of abeyance.) Yet my definitions beg the essential question. They reduce aesthetics to art. They say nothing about the relation between art and nature, art and the world.

Before a mountain, a desert just after the sun has gone down, or a fruit tree, one can also experience aesthetic emotion. Consequently we are forced to begin again – not this time with a man-made object but with the nature into which we are born.

Urban living has always tended to produce a sentimental view of nature. Nature is thought of as a garden, or as a view framed by a window, or as an arena of freedom. Peasants, sailors, nomads have known better. Nature is energy and struggle. It is what exists without any promise. If it can be thought of by man as an arena, a setting, it has to be thought of as one which lends itself as much to evil as to good. Its energy is fearsomely indifferent. The first necessity of life is shelter. Shelter against nature. The first prayer is for protection. The first sign of life is pain. If the Creation was purposeful, its purpose is a hidden one which can only be discovered intangibly within signs, never by the evidence of what happens.

It is within this bleak natural context that beauty is encountered, and the encounter is by its nature sudden and unpredictable. The gale blows itself out, the sea changes from the colour of grey shit to aquamarine. Under the fallen boulder of an avalanche a flower grows. Over the shantytown the moon rises. I offer dramatic examples so as to insist upon the bleakness of the context. Reflect upon more everyday examples. However it is encountered, beauty is always an exception, always *in despite of*. This is why it moves us.

It can be argued that the origin of the way we are moved by natural beauty was functional. Flowers are a promise of fertility, a sunset is a reminder of fire and warmth, moonlight makes the night less dark, the bright colours of a bird's plumage are (atavistically even for us) a sexual stimulus. Yet such an argument is too reductionist, I believe. Snow is useless. A butterfly offers us very little.

Of course the range of what a given community finds beautiful in nature will depend upon its means of survival, its economy, its

geography. What Eskimos find beautiful is unlikely to be the same as what the Ashanti found beautiful. Within modern class societies there are complex ideological determinations: we know, for instance, that the British ruling class in the eighteenth century disliked the sight of the sea. Equally, the social use to which an aesthetic emotion may be put changes according to the historical moment: the silhouette of a mountain can represent the home of the dead or a challenge to the initiative of the living. Anthropology, comparative studies of religion, political economy and Marxism have made all this clear.

Yet there seem to be certain constants which all cultures have found 'beautiful': among them, certain flowers, trees, forms of rock, birds, animals, the moon, running water . . .

One is obliged to acknowledge a coincidence or perhaps a congruence. The evolution of natural forms and the evolution of human perception have coincided to produce the phenomenon of a potential recognition: what *is* and what we can see (and by seeing also feel) sometimes meet at a point of affirmation. This point, this coincidence, is two-faced: what has been seen is recognised and affirmed and, at the same time, the seer is affirmed by what he sees. For a brief moment one finds oneself – without the pretensions of a creator – in the position of God in the first chapter of Genesis . . . And he saw that *it was* good. The aesthetic emotion before nature derives, I believe, from this double affirmation.

Yet we do not live in the first chapter of Genesis. We live – if one follows the biblical sequence of events – after the Fall. In any case, we live in a world of suffering in which evil is rampant, a world whose events do not confirm our Being, a world that has to be resisted. It is in this situation that the aesthetic moment offers hope. That we find a crystal or a poppy beautiful means that we are less alone, that we are more deeply inserted into existence than the course of a single life would lead us to believe. I try to describe as accurately as possible the experience in question; my starting point is phenomenological, not deductive; its form, perceived as such, becomes a message that one receives but cannot translate because, in it, all is instantaneous. For an instant, the energy of one's perception becomes inseparable from the energy of the creation.

The aesthetic emotion we feel before a man-made object – such as the white bird with which I started – is a derivative of the emotion we

feel before nature. The white bird is an attempt to translate a message received from a real bird. All the languages of art have been developed as an attempt to transform the instantaneous into the permanent. Art supposes that beauty is not an exception – is not *in despite of* – but is the basis for an order.

Several years ago, when considering the historical face of art, I wrote that I judged a work according to whether or not it helped men in the modern world claim their social rights. I hold to that. Art's other, transcendental face raises the question of man's ontological right.

The notion that art is the mirror of nature is one that only appeals in periods of scepticism. Art does not imitate nature, it imitates a creation, sometimes to propose an alternative world, sometimes simply to amplify, to confirm, to make social the brief hope offered by nature. Art is an organised response to what nature allows us to glimpse occasionally. Art sets out to transform the potential recognition into an unceasing one. It proclaims man in the hope of receiving a surer reply . . . the transcendental face of art is always a form of prayer.

The white wooden bird is wafted by the warm air rising from the stove in the kitchen where the neighbours are drinking. Outside, in minus 25°C, the real birds are freezing to death!

The Soul and the Operator

THE PHOTOS COME from Warsaw, Leipzig, Budapest, Bratislava, Riga, Sofia. Every nation has a slightly different way of physically standing shoulder to shoulder during mass demonstrations. But what interests me in all the photos is something that is invisible.

Like most moments of great happiness, the events of 1989 in Eastern Europe were unforeseeable. Yet is happiness the right word to describe the emotion shared by millions that winter? Was not something graver than happiness involved?

Just as the events were unforeseeable, so still is the future. Would it not be more apt to talk of concern, confusion, relief? Why insist upon happiness? The faces in the photos are tense, drawn, pensive. Yet smiles are not obligatory for happiness. Happiness occurs when people can give the whole of themselves to the moment being lived, when Being and Becoming are the same thing.

As I write, I remember leaving Prague in a train more than twenty years ago. It was as if we were leaving a city in which every stone of every building was black. I hear again the words of a student leader, who stayed behind, as he addressed the last meeting: 'What are the plans of my generation for this year of 1969? To pursue a current of political thought opposed to all forms of Stalinism, and yet not to indulge in dreams. To reject the utopia of the New Left, for with such

dreams we could be buried. To maintain somehow our links with the trade unions, to continue to work for and prepare an alternative model of socialism. It may take us one year, it may take us ten . . .'

Now the student leader is middle-aged. And Dubček is the prime minister of his country.

Many refer to what is happening as a revolution. Power has changed hands as a result of political pressure from below. States are being transformed – economically, politically, juridically. Governing elites are being chased from office. What more is needed to make a revolution? Nothing. Yet it is unlike any other one in modern times.

First because the ruling elite (except in the case of Romania) did not fight back, but abdicated or reneged, although the revolutionaries were unarmed. And secondly, because it is being made without utopian illusions. Made step by step, with an awareness that speed is necessary, yet without the dreaded classic exhortation of *Forward!*

Rather, the hope of a return. To the past, to the time before all the previous revolutions? Impossible. And it is only small minorities who demand the impossible. These are spontaneous mass demonstrations. People of every generation, muffled up against the cold, their faces grave, happy, keeping a rendezvous. With whom?

Before answering, we have to ask: What is it that has just ended? The Berlin Wall, the one-party system, in many countries the Communist Party, the Red Army occupation, the Cold War? Something else which was older than these and less easy to name has also ended. Voices are not lacking to tell us what it is. History! Ideology! Socialism! Such answers are unconvincing, for they are made by wishful thinkers. Nevertheless, something vast has ended.

Occasionally, history seems to be oddly mathematical. Last year – as we were often reminded – was the two hundredth anniversary of the French Revolution, which, although not the first, became the classic model for all other modern revolutions. 1789–1989. Sufficient to write down these dates to ask whether they do not constitute a period. Is it this that has ended? If so, what made this a period? What was its distinguishing historical feature?

During these two centuries the world was 'opened up', 'unified', modernised, created, destroyed and transformed on a scale such as had never occurred before. The energy for these transformations was

generated by capitalism. It was the period when self-interest, instead of being seen as a daily human temptation, was made heroic. Many opposed the new Promethean energy in the name of the General Good, of Reason and of Justice. But the Prometheans and their opponents had certain beliefs in common. Both believed in Progress, Science, and a new future for Man. Everyone had their particular personal set of beliefs (one reason why so many novels could be written) but in their *practice*, their traffic with the world, their exchanges, all were subject to systems based exclusively on a materialist interpretation of life.

Capitalism, following the doctrines of its philosophers – Adam Smith, Ricardo and Spencer – installed a practice in which only materialist considerations and values counted. Thus the spiritual was marginalised; its prohibitions and pleas were ruled out of court by the priority given to economic laws, laws given the authority (as they still have today) of natural laws.

Official religion became an evasive theatre, turning its back on real consequences and blessing principally the powerful. And in face of the 'creative destruction' of capitalism – as Joseph Schumpeter, one of its own eminent theorists, defined it – the modern rhetoric of bourgeois politics developed, so as to hide the pitiless logic of the underlying practice.

The socialist opposition, undeceived by the rhetoric and hypocrisy, insisted upon the practice. This insistence was Marx's genius. Nothing diverted him. He unveiled the practice layer by layer until it stood exposed once and for all. The shocking vastness of the revelation gave prophetic authority to historical materialism. Here was the secret of history and all its sufferings! Everything in the universe could now be explained (and resolved!) on a material basis, open to human reason. Egoism itself would eventually become outdated.

<div align="center">⚬</div>

THE HUMAN IMAGINATION, however, has great difficulty in living strictly within the confines of a materialist practice or philosophy. It dreams, like a dog in its basket, of hares in the open. And so, during these two centuries, the spiritual persisted, but in new, marginalised forms.

Take Giacomo Leopardi, who was born in exactly the year our period opens. He was to become Italy's greatest modern lyric poet. As a child of his time, he was a rationalist of the existent and studied the universe as a materialist. Nevertheless, his sadness and the stoicism with which he bore it became, within his poetry, even larger than the universe. The more he insisted on the materialist reality surrounding him, the more transcendent became his melancholy.

Likewise, people who were not poets tried to make exceptions to the materialism which dominated their epoch. They created enclaves of the *beyond*, of what did not fit into materialist explanations. These enclaves resembled hiding-places; they were often kept private. Visited at night. Thought of with bated breath. Sometimes transformed into theatres of madness. Sometimes walled in like gardens.

What they contained, the forms of the *beyond* stored away in these enclaves, varied enormously according to period, social class, personal choice, and fashion. Romanticism, the Gothic revival, vegetarianism, Rudolf Steiner, art for art's sake, theosophy, sport, nudism . . . Each movement saved for its adepts fragments of the spiritual which had been banished.

The question of fascism, of course, cannot be avoided here. It did the same thing. Nobody should presume that evil has no spiritual power. Indeed, one of the principal errors of the two centuries concerned evil. For the philosophical materialists the category was banished, and for the rhetoricians of the establishment evil became Marxist materialism! This left the field wide open for what Kierkegaard correctly called the prattle of the Devil, the prattle that erects a terrible screen between name and thing, act and consequence.

Yet the most original marginalised spiritual form of the period was the transcendent yet secular faith of those struggling for social justice against the greed of the rich. This struggle extended from the Club des Cordeliers of the French Revolution to the sailors in Kronstadt to my student friends in the University of Prague. It included members of all classes – illiterate peasants and professors of etymology. Their faith was mute in the sense that it lacked ritual declaration. Its spirituality was implicit, not explicit. It probably produced more acts of willing self-sacrifice, of nobility (a word from which some might have shrunk), than any other historical movement of the period. The explanations

and strategies of the men and women concerned were materialist; yet their hopes and the unexpected tranquillity they sometimes found in their hearts were those of transcendent visionaries.

To say, as is often said, that communism was a religion is to understand nothing. What counted was that the material forces in the world carried for millions – in a way such as had never happened before – a promise of *universal* salvation. If Nietzsche had announced that God was dead, these millions felt that he was hiding in history and that, if together they could carry the full weight of the material world, souls would again be given wings. Their faith marked a road for mankind across the usual darkness of the planet.

Yet in their sociopolitical analyses there was no space for such faith, so they treated their own as an illegitimate but loved child who was never given a name. And here the tragedy began. Since their faith was unnamed, it could easily be usurped. It was in the name of their determination and their solidarity that the party-machines justified the first crimes, and, later, the crimes to cover up further crimes, till finally there was no faith left anywhere.

<div align="center">☙</div>

SOMETIMES, BECAUSE OF its immediacy, television produces a kind of electronic parable. Berlin, for instance, on the day the Wall was opened. Rostropovich was playing his cello by the Wall that no longer cast a shadow, and a million East Berliners were thronging to the West to shop with an allowance given them by West German banks! At that moment the whole world saw how materialism had lost its awesome historic power and become a shopping list!

A shopping list implies consumers. And this is why capitalism believes it has won the world. Chunks of the Berlin Wall are now being sold across the world. Forty marks for a large piece from the Western side, ten marks for a piece from the Eastern side. Last month the first McDonald's opened in Moscow; last year the first Kentucky Fried Chicken in Tiananmen Square. The multinationals have become global in the sense that they are more powerful than any single nation-state. The free market is to be installed everywhere.

Yet if the materialist philosophy of the last two centuries has run out, what is to happen to the *materialist fantasy* on which

consumerism and therefore global capitalism are now utterly dependent?

Marketing punctuates our lives as regularly and systematically as any prayer cycle in a seminary. It transfigures the product or package being sold so that it gains an aura, wins a radiance, which promises a kind of temporary immunity from suffering, a sort of provisional salvation, the salutary act always being the same one of buying. Thus any commodity becomes a way of dreaming, but, more importantly, the imagination itself becomes acquisitive, accepting the credo of Ivan Boesky addressing graduates at Berkeley business school: 'I think greed is healthy. You can be greedy and still feel good about yourself.'

The poverty of our century is unlike that of any other. It is not, as poverty was before, the result of natural scarcity, but the result of a set of priorities imposed upon the rest of the world by the rich. Consequently, the modern poor are not pitied – except by individuals – but written off as trash. The twentieth-century consumer economy has produced the first culture for which a beggar is a reminder of nothing.

<center>෪</center>

MOST COMMENTATORS ON the events in Eastern Europe emphasise the return to religion and nationalism. This is part of a worldwide tendency, yet the word 'return' may be misleading. For the religious organisations in question are not the same as they previously were, and the people who make up this 'return' are living with transistors at the end of the *twentieth* century, not the eighteenth.

For example, in Latin America it is a branch of the Catholic Church (much to the pope's embarrassment) which today leads the revolutionary struggle for social justice and offers means of survival to those being treated as historical trash. In many parts of the Middle East the growing appeal of Islam is inseparable from the social conscience it promises on behalf of the poor, or (as with the Palestinians) the landless and the exiled, up against the remorseless economic and military machinery of the West.

The resurgent nationalisms reflect a similar tendency. Independence movements all make economic and territorial demands, but their first claim is of a spiritual order. The Irish, the Basques, the Corsicans, the Kurds, the Kosovans, the Azerbaijanis, the Puerto

Ricans and the Latvians have little in common culturally or historically, but all of them want to be free of distant, foreign centres which, through long, bitter experience, they have come to know as soulless.

All nationalisms are at heart deeply concerned with names: with the most immaterial and original human invention. Those who dismiss names as a detail have never been displaced; but the peoples on the peripheries are always being displaced. This is why they insist upon their identity being recognised, insist upon their continuity – their links with their dead and the unborn.

If the 'return' to religion is in part a protest against the heartlessness of the materialist systems, the resurgence of nationalism is in part a protest against the anonymity of those systems, their reduction of everything and everybody to statistics and ephemerality.

Democracy is a political demand. But it is something more. It is a moral demand for the individual right to decide by what criteria an action is called right or wrong. Democracy was born of the principle of conscience. Not, as the free market would today have us believe, from the principle of choice which, if it is a principle at all, is a relatively trivial one.

CR

THE SPIRITUAL, MARGINALISED, driven into the corners, is beginning to reclaim its lost terrain. Above all, this is happening in people's minds. The old reasoning, the old common sense, even old forms of courage, have been abandoned, and unfamiliar recognitions and hopes, long banished to the peripheries, are returning to claim their own. This is where the happiness behind the faces in the photo starts. But it does not end there.

A reunion has occurred. The separated are meeting – those separated by frontiers and by centuries. Throughout the period which is ending, daily life, with all its harshness, was continually justified by promises of a radiant future. The promise of the new communist man for whom the living were ceaselessly sacrificed. The promise of science forever rolling back the frontiers of ignorance and prejudice. More recently, the promise of credit cards buying the next instant happiness.

This excessive need of a radiant future separated the present from all past epochs and past experience. Those who had lived before were

further away than they had ever been in history. Their lives became remote from the unique exception of the present. Thus for two centuries the future 'promise' of history assured an unprecedented solitude for the living.

Today the living are re-meeting the dead, even the dead of long ago, sharing their pain and their hope. And, curiously, this too is part of the happiness behind the faces in the photos.

How long can this moment last? All the imaginable dangers of history are waiting in the wings – bigotry, fanaticism, racism. The colossal economic difficulties of ongoing everyday survival are, in theory, going to be solved by the free market. With such a market comes the risk of new ravenous appetites for money, and with their voraciousness jungle law. But nothing is finally determined. The soul and the operator have come out of hiding together.

32.

The Third Week of August 1991

IN 1958, WHEN Nâzim Hikmet, after being imprisoned for many years as a communist in Turkey, was living as an exile in Moscow, he wrote a poem for my friend, the Turkish painter and poet, Abidin Dino.

> These men Dino
> grasping rags of torn light in their hands
> where are they going Dino
> these men in the depth of the darkness?
> You and I also Dino
> we are among them
> we too Dino we too have seen
> a sky which was blue.

The poem was inspired by a painting of Dino's which I have never seen but can imagine a little. Abidin is a visionary painter, inspired in his turn by traditions which come from the wandering Sufis.

Nâzim Hikmet's poem comes to me tonight after watching the news on TV. Like everybody else I have been watching for a week. Tonight in Moscow the crowds in the Lubyanka Square were living a moment which not a single one of them will ever forget. The gigantic statue of Felix Dzerzhinski outside the notorious KGB building was

being dismantled. Known as Iron Felix, he was the founder in 1918 of the Cheka, the political police who were the precursors of the KGB. A crane lifted the bronze figure off its pedestal. What the word Lubyanka meant until tonight – but, in another sense, for ever – Anna Akhmatova has conveyed. The statue, in mid-air and horizontal, was slowly manoeuvred away. It will join others.

Castings and carvings, Marx, Engels, Kalinin, Sverdlov are falling everywhere. Overturned, they all look like wrecks, like write-offs. Yet they weren't involved in a road or air accident: they were idols which justified or demanded, over the years, sacrifice after sacrifice. That they now look, when horizontal and suspended from a cable, like write-offs is the result of their aesthetic style and iconography.

Among monumental sculptures only certain Crucifixions would remain meaningful when suspended horizontally in mid-air. The Crucifixion happened on a tree that had already been felled and the figure on the cross, if carved truthfully, was a man humiliated and suffering. By contrast idols, when set up as sculptures, have to remain vertical.

<center>∝</center>

DESPITE THE EASTERN European example of 1989, the speed of events took everyone by surprise. After the putsch – which apparently the CIA did not foresee – the newly acquired will-power of Russian civil society must have surprised even those it was motivating. The pace in the third week of August was no longer that of an historical process but of a sudden resurgence of nature. It resembled fire, wind, or desire. Not only statues fell, but also institutions, citadels, networks, files, arsenals. 'All fall down,' as the English nursery rhyme says.

The organic nature of the energy involved was confirmed by the unforeseeable yet crucial participation of the young. What happened in Parliament Square on Wednesday, 21 August, was the birth of a generation. And Gorbachev aged overnight.

<center>∝</center>

THE TRIUMPH AND drama of Gorbachev is astounding. We can see now that he, with his advisers, calculated many years ago – well before he acquired power – that there was no real chance of bringing about

<center>217</center>

any changes in the Soviet state apparatus until a potential civil society had been created at home and the Soviet satellites had been dismantled abroad. Hence, first glasnost. And then, later, the road to the Red Square in Moscow, which had to begin in Berlin. The irony of it having to be like this – after the heroic advance of the Red Army in the opposite direction in 1944 – must have struck him many times.

His calculations were proved correct, and consequently something happened on a scale which has no parallel in history. Never before has such a massive power system been dismantled in such a short time with so little loss of life. The face of Europe utterly transformed, and almost everybody sleeping in his usual bed every night. This is why I quoted from a nursery rhyme.

Hans Magnus Enzensberger has named Gorbachev a genius of withdrawal, the great master of retreat. He is right. But the conception, the carrying out, and the success of the great withdrawal depended on one thing, which is the axis of the man's drama.

Gorbachev believed in the possibility and the desirability of reforming the Communist Party. If he hadn't believed this, he could never have gained the necessary power, convinced his comrades, intimidated his opponents, or moved with the visionary power that he did.

He might have written a book of political theory, but the immense transformations we have lived through during the past five years would not have taken place in the way they have. Probably the economic collapse of the USSR would eventually have provoked very violent and desperate confrontations.

Gorbachev is a man, formed within the Communist Party, who undertook to change his party and its role in the world. He failed to imagine only one thing: that, due to all the other changes he'd brought about or stage-managed, the CPSU would overnight be declared illegal.

At the end of the third week of August, he turns to the audience, which is a world set free, and at the same instant he finds himself empty-handed.

CR

I THOUGHT OF Hikmet's poem because it refers to another but similar paradox and drama. It is small, a postcard of a poem, suffused with sadness and, differently – as with so many of Hikmet's poems – with

pity. Applied to a poem, the word pity presents no problems. In life, during modern times, the notion of pity became suspect. Unfortunately there was thought to be an insult in it.

Its opposite, pitilessness, remained terrible and simple. The idols are being torn down because they embodied pitilessness. The party is being banned for the same reason. No appeal can be made to the pitiless. And the iconoclasm of this moment is the revenge of those who learnt that it was hopeless to appeal.

Yet, in the beginning, communists became communists because moved by pity, Marx included. He wrote into what he saw as the laws of history the salvation of the pitiful. Nothing less. Gradually these laws were used to make ever wider and more dogmatic generalisations so that they finally became lies, as all generalisations which become dogma are bound to do. The reality of the living was obscured by the writing of these laws, and whenever this happens evil reigns.

Communism, today certified as dead, represented at one and the same time an ardent hope born of pity and a pitiless practice.

These men . . . 'grasping rags of torn light in their hands'.

❧

WHAT THEN IS pity? Simone Weil defined it better than anyone else I know. It 'consists in seeing that no harm is done to men. Whenever a man cries inwardly, "why am I being hurt?" harm is being done to him. He is often mistaken when he tries to define the harm, and why and by whom it is being inflicted on him. But the cry itself is infallible.'

❧

I DON'T BELIEVE other statues in bronze will take the place of the write-offs in Russian cities. The nightmare of the merciless fallen idols there has already been replaced by a dream. The free market carries with it the right to dream. We are here, as the French magazine *Marie Claire* so succinctly put it, we are here to offer names to your longings. Russian longings, after so much hardship, are intense. The world network of media exchanges seems to answer, more consistently at this moment than any other proposal, many of their longings. The statues are being replaced by far more volatile images, which are working like

a screen onto which is being projected a preview of the future. What lies behind the screen is contradictory.

On one hand, the Gulf War showed how politicians have reason to fear the media; or, rather, have reason to fear public reaction to what the media may show. Satellite transmission has given the world a new meaning for the term 'moment of truth'. (Like the moment in Parliament Square when a soldier in a Red Army tank threw in his lot with the unarmoured crowd.)

On the other hand, the Gulf War showed – as did events in Romania last year – that a scenario of lies can be written for the media which will then transmit it, with excitement, commentary, analysis, and so on, as if it was the truth.

Perhaps, as was the case with the statues, the essential nature of the media network is most clearly revealed by its aesthetic and iconography. These are not stamped on everything which passes – sometimes dispatches come from life itself – but they are dominant, and they fashion a style not only of presentation but also of perception.

It is a style of winners and would-be winners, not of conquerors, not really of supermen, but simply of those who do well and succeed because they have come to believe that success is natural. (Sport is a significant field for this style, since it allows for winners who can temporarily lose whilst remaining winners.)

Like all aesthetics, this one entails an anaesthetic: a numbed area without feeling. The winning aesthetic excludes experience of loss, defeat, affliction, except insofar as those suffering these ills may be presented as exceptions requiring the aid of winners. The anaesthetic protects from any assertion or evidence or cry which shows life as a site of hopes forever deferred. And it does this despite the fact that such a vision of life remains the experience of the majority of people in the world today.

The media network has its idols, but its principal idol is its own style, which generates an aura of winning and leaves the rest in darkness. It recognises neither pity nor pitilessness.

33.

Ten Dispatches about Place (June 2005)

1

Somebody enquires: are you still a Marxist? Never before has the devastation caused by the pursuit of profit, as defined by capitalism, been more extensive than it is today. Almost everybody knows this. How then is it possible not to heed Marx, who prophesied and analysed the devastation? The answer might be that people, many people, have lost all their political bearings. Mapless, they do not know where they are heading.

2

Every day people follow signs pointing to some place which is not their home but a chosen destination. Road signs, airport embarkation signs, terminal signs. Some are making their journeys for pleasure, others on business, many out of loss or despair. On arrival they come to realise they are not in the place indicated by the signs they followed. Where they now find themselves has the correct latitude, longitude, local time, currency, yet it does not have the specific gravity of the destination they chose.

They are beside the place they chose to come to. The distance which separates them from it is incalculable. Maybe it's only the width of a thoroughfare, maybe it's a world away. The place has lost what made it a destination. It has lost its territory of experience.

Sometimes a few of these travellers undertake a private journey and find the place they wished to reach, which is often harsher than they foresaw, although they discover it with boundless relief. Many never make it. They accept the signs they follow and it's as if they don't travel, as if they always remain where they already are.

3

Month by month, millions leave their homelands. They leave because there is nothing there, except their *everything*, which does not offer enough to feed their children. Once it did. This is the poverty of the new capitalism.

After long and terrible journeys, after they have experienced the baseness of which others are capable, after they have come to trust their own incomparable and dogged courage, emigrants find themselves waiting on some foreign transit station, and then all they have left of their home continent is *themselves*: their hands, their eyes, their feet, shoulders, bodies, what they wear and what they pull over their heads at night to sleep under, wanting a roof.

In some photos taken in the Red Cross shelter for refugees and emigrants at Sangatte (near Calais) by Anabell Guerrero, we can take account of how a man's fingers are all that remain of a plot of tilled earth, his palms what remain of some riverbed, and how his eyes are a family gathering he will not attend.

4

'I'm going down the stairs in an underground station to take the B line. Crowded here. Where are you? Really! What's the weather like? Getting into the train – call you later . . .'

Of the billions of mobile telephone conversations taking place every hour in the world's cities and suburbs, most, whether they are private or business calls, begin with a statement about the caller's whereabouts. People need straightaway to pinpoint where they are. It is as if they are pursued by doubts suggesting that they may be nowhere. Surrounded by so many abstractions, they have to invent and share their own transient landmarks.

More than thirty years ago, Guy Debord prophetically wrote: 'The accumulation of mass-produced commodities for the abstract space of the market, just as it has smashed all regional and legal barriers, and all corporate restrictions of the Middle Ages that maintained the quality of artisanal production, has also destroyed the autonomy and quality of places.'

The key term of the present global chaos is de- or re-localisation. This does not only refer to the practice of moving production to wherever labour is cheapest and regulations minimal. It also contains the offshore demented dream of the new ongoing power: the dream of undermining the status and confidence of all previous fixed places, so that the entire world becomes a single fluid market.

The consumer is essentially somebody who feels, or is made to feel, lost, unless he or she is consuming. Brand names and logos become the place-names of the Nowhere.

In the past a common tactic employed by those defending their homeland against invaders was to change the road signs so that the one indicating ZARAGOZA pointed in the opposite direction, towards BURGOS. Today it is not defenders but foreign invaders who switch signs to confuse local populations, confuse them about who is governing who, the nature of happiness, the extent of grief, or where eternity is to be found. And the aim of all these misdirections is to persuade people that being a client is the ultimate salvation.

Yet clients are defined by where they check out and pay, not by where they live and die.

5

Extensive areas which were once rural places are being turned into zones. The details of the process vary according to the continent – Africa or Central America or Southeast Asia. The initial dismembering, however, always comes from elsewhere and from corporate interests pursuing their appetite for ever more accumulation, which means seizing natural resources (fish in Lake Victoria, wood in the Amazon, petrol wherever it is to be found, uranium in Gabon, and so on), regardless of to whom the land or water belongs. The ensuing

exploitation soon demands airports, military and paramilitary bases to defend what is being syphoned off, and collaboration with the local mafiosi. Tribal war, famine and genocide may follow.

People in such zones lose all sense of residence: children become orphans (even when they are not), women become slaves, men desperadoes. Once this has happened, to restore any sense of domesticity takes generations. Each year of such accumulation prolongs the Nowhere in time and space.

6

Meanwhile – and political resistance often begins in a meanwhile – the most important thing to grasp and remember is that those who profit from the present chaos, with their embedded commentators in the media, continuously misinform and misdirect. Their declarations will get nobody anywhere.

Yet, at the same time, the information technology developed by the corporations and their armies so they could dominate their Nowhere more speedily is being used by others as a means of communication throughout the Everywhere they are struggling towards.

The Caribbean writer Edouard Glissant puts this very well: 'The way to resist globalisation is not to deny globality, but to imagine what is the finite sum of all possible particularities and to get used to the idea that, as long as a single particularity is missing, globality will not be what it should be for us.'

We are establishing our own landmarks, naming places, finding poetry. Yes, in the Meanwhile poetry is to be found. Gareth Evans:

> As the brick of the afternoon stores the rose heat of
> > the journey
> as the rose buds a green room to breathe
> and blossoms like the wind
> as the thin birches whisper their stories of the wind
> > to the urgent
> in the trucks
> as the leaves of the hedge store the light
> the day thought it had lost

as the nest of her wrist beats like the chest of a sparrow
 in the turning air
as the chorus of the earth find their eyes in the sky
and unwrap them to each other in the teeming dark
hold everything dear

7

Their Nowhere generates a strange because unprecedented awareness of time. Digital time. It continues for ever uninterrupted through day and night, the seasons, birth and death. As indifferent as money. Yet, although continuous, it is utterly single. It is the time of the present kept apart from the past and future. Within it only the present is weight-bearing; the other two lack gravity. Time is no longer a colonnade, but a single column of ones and zeros. A vertical time with nothing surrounding it, except absence.

Read a few pages of Emily Dickinson and then go and see Von Trier's film *Dogville*. In Dickinson's poetry the presence of the eternal is attendant in every pause. The film, by contrast, remorselessly shows what happens when any trace of the eternal is erased from daily life. What happens is that all words and their entire language are rendered meaningless.

Within a single present, within digital time, no whereabouts can be found or established.

8

Let's take our bearings within another time-set. The eternal, according to Spinoza, is *now*. It is not something awaiting us, but something we encounter during those brief yet timeless moments when everything accommodates everything and no exchange is inadequate.

In her urgent book, *Hope in the Dark*, Rebecca Solnit quotes the Sandinista poet Gioconda Belli describing the moment when they overthrew the Somoza dictatorship in Nicaragua: 'two days that felt as if a magical, age-old spell had been cast over us, taking us back to Genesis, to the very site of the creation of the world'. The fact that the

United States and its mercenaries later destroyed the Sandinistas in no way diminishes that moment existing in the past, present and future.

9

A kilometre down the road from where I'm writing, there is a field in which four burros graze, two mares and two foals. They are a particularly small species. The black-bordered ears of the mares when they prick them come up to my chin. The foals, only a few weeks old, are the size of large terrier dogs, with the difference that their heads are almost as large as their sides.

I climb over the fence and sit in the field with my back against the trunk of an apple tree. They have made their own tracks across the field and some pass under very low branches where I would have to stoop double. They watch me. There are two areas where there is no grass at all, just reddish earth, and it is to one of these rings that they come many times a day to roll on their backs. Mare first, then foal. The foals already have their black stripe across their shoulders.

Now they approach me. They smell of donkey and bran – not the smell of horses, more discreet. The mares touch the top of my head with their lower jaws. Their muzzles are white. Around their eyes are flies, far more agitated than their own questioning glances.

When they stand in the shade by the edge of the wood the flies go away, and they can stand there almost motionless for half an hour. In the shade at midday time slows down. When one of the foals suckles (ass's milk is the closest to human milk), the mare's ears lie right back and point to her tail.

Surrounded by the four of them in the sunlight, my attention fixes on their legs, all sixteen of them. Their slenderness, their sheerness, their containment of concentration, their surety. (Horses' legs look hysterical by comparison.) Theirs are legs for crossing mountains no horse could tackle, legs for carrying loads which are unimaginable if one considers only the knees, the shanks, the fetlocks, the hocks, the cannon-bones, the pastern-joints, the hooves! Donkeys' legs.

They wander away, heads down, grazing, their ears missing nothing; I watch them, eyes skinned. In our exchanges, such as they are, in

the midday company we offer one another, there is a substratum of what I can only describe as gratitude. Four burros in a field, month of June, year 2005.

10

Yes, I'm still among other things a Marxist.

34.

Stones (Palestine, June 2003)

EQBAL AHMED WAS, I think, a man who saw life whole. He was cunning, quick, had little time to spare for fools, loved cooking, and was the opposite of an opportunist – of somebody who fragments life. I once wrote an account of his childhood in Bihar at the time of the partition of India and Pakistan. It was a version on paper of what he told me one night in a bar in Amsterdam. He asked me when he read it to change his name. Which I did. The story was about what made him decide, at the age of seventeen, to become a revolutionary. Now he's dead, I return his name to him.

Influenced by the writings of Frantz Fanon – and particularly by *The Wretched of the Earth* – he became deeply involved in several liberation struggles, including that of the Palestinians. I remember him talking to me about Jenin. Towards the end of his life, Eqbal set up a freethinking university in Pakistan named after the great fifteenth-century philosopher Ibn Khaldun, who imagined the discipline of sociology before it existed.

Eqbal learnt early on that life inevitably leads to separations. Everybody recognised this before the category of the tragic was discarded as garbage. Eqbal, though, knew and accepted the tragic. And, consequently, he spent much of his prodigious energy on forging links – of friendship, political solidarity, military loyalty, shared poetry,

hospitality – links which had a chance of surviving after the inevitable separations. I still remember the meals he cooked.

I didn't expect to encounter Eqbal in Ramallah. Although, oddly, the first book I picked up and opened there had a photo of him on the third page. No, I wasn't looking for him. Yet he had been beside me when I decided to visit the city, and he left me a message which I saw like an SMS on the tiny screen of my imagination.

Look at the stones! it said.

OK, I replied, the stones, in my own way.

<div align="center">౪</div>

CERTAIN TREES – PARTICULARLY the mulberries and medlars – still tell the story of how long ago, in another life, before the Nakba, Ramallah was, for the well-off, a town of leisure and ease, a place to retreat to from nearby Jerusalem during the hot summers, a resort. The Nakba refers to the 'catastrophe' of 1948, when ten thousand Palestinians were killed and 700,000 were forced to leave their country.

Long ago, newly married couples planted roses in Ramallah gardens as an augury for their future life together. The alluvial soil suited the roses.

Today there is not a wall in the town centre of Ramallah, now the capital of the Palestinian Authority, which is not covered with photographs of the dead, taken when alive and now reprinted as small posters. The dead are the martyrs of the Second Intifada, which began in September 2000. The martyrs include all those killed by the Israeli army and settlers, and those who decided to sacrifice themselves in suicidal counter-attacks. These faces transform the desultory street walls into something as intimate as a wallet of private papers and pictures. The wallet has a pocket for the magnetic ID card issued by the Israeli security services and without which no Palestinian can travel even a few kilometres, and another pocket for eternity. Around the posters, the walls are scarred with bullet and shrapnel marks.

There is an old woman, who might be the grandmother in several wallets. There are boys in their early teens, there are many fathers. Listening to the stories of how they met their death, one is reminded of what poverty is about. Poverty forces the hardest choices which lead to almost nothing. Poverty is living with that *almost*.

Most of the boys, whose faces are on the walls, were born in refugee camps, as poor as shantytowns. They left school early to earn money for the family or help the father with his job, if he had one. A few dreamt of becoming wizard soccer players. A fair number of them made catapults of carved wood, twined rope and twisted leather for hurling stones at the occupying army.

Any comparison between the weapons involved in these confrontations returns us to what poverty is about. On one hand Apache and Cobra helicopters, F16s, Abrams tanks, Humvee jeeps, electronic surveillance systems, tear gas; on the other hand catapults, slingshots, mobile telephones, badly used Kalashnikovs and mostly handmade explosives. The enormity of the contrast reveals something which I can feel between these grief-stricken walls but which I cannot put a name to. If I was an Israeli soldier, however well-armed I was, I might finally be frightened of this something. Perhaps it's what the poet Mourid Barghouti noticed: 'Living people grow old but martyrs grow younger.'

Three stories from the walls.

Husni Al-Nayjar, fourteen years old. He worked helping his father, who was a welder. Whilst flinging stones, he was shot dead with a bullet to the head. In his photo he gazes calmly and unwaveringly into the middle distance.

Abdelhamid Kharti, thirty-four years old. Painter and writer. When young, he had trained as a medical nurse. He volunteered to join a medical emergency unit for rescuing and taking care of the wounded. His corpse was found near a checkpoint, after a night when there had been no confrontations. His fingers had been cut off. A thumb was hanging loose. An arm, a hand and his jaw were broken. There were twenty bullets in his body.

Muhammad Al-Durra, twelve years old, lived in the Breij Camp. He was returning home with his father across the Netzarim checkpoint in Gaza, and they were ordered to get out of their vehicle. Soldiers were already shooting. The two of them took immediate cover behind a cement wall. The father waved to show they were there and was shot in the hand. A little later Muhammad was shot in the foot. The father now shielded his son with his own body. More bullets hit both, and the boy was killed. Doctors removed eight bullets from the father's body, but he remained paralysed as a consequence of the wounds and could no

longer work, remaining unemployed. Because the incident happened to be filmed, the story is told and retold across the world.

CR

I WANT TO do a drawing for Abdelhamid Kharti. Very early in the morning we go to the village of Ain Kinya, and beyond it there's a Bedouin encampment, near a *wadi*. The sun is not yet hot. The goats and sheep are grazing more or less between the tents. I've chosen to draw the hills looking eastwards. I sit on a rock near a small blackish tent. I have only a notebook and this pen. There's a discarded plastic mug on the earth and it gives me the idea of fetching some water from the trickle of the spring to mix, when necessary, with my ink.

After I've been drawing for a while, a young man (every invisible person in the camp has of course noticed me) approaches, undoes the entrance to the tent behind me, enters and comes out holding up a decrepit white plastic stool which, he indicates, might be more comfortable than the rock. I guess that before he found it, it must have been thrown out into the street by some pastry shop or ice-cream parlour. I thank him.

And sitting on this customer's stool in the Bedouin camp, as the sun gets hotter and the frogs in the almost dry riverbed begin to croak, I go on drawing.

On a hilltop, a few kilometres to the left, is an Israeli settlement. It looks military, as if it were part of a weapon designed for quick handling. Yet it's small and faraway.

The near limestone hill facing me has the form of a gigantic sleeping animal's head, the rocks scattered on it like burrs in its matted hair. Suddenly frustrated by my lack of pigment, I pour water from the mug onto the dust at my feet, dip my finger into the mud and smear colour across the drawing of the animal's head. The sun is hot now. A mule brays. I turn the pages of the notebook to begin another and another. Nothing looks finished. When the young man eventually returns, he wants to see my drawings.

I hold up the open notebook. He smiles. I turn a page. He points. Ours, he says, our dust! He's pointing at my finger, not the drawing.

Then we both look at the hill.

CR

I AM AMONG not the conquered but the defeated, whom the victors fear. The time of the victors is always short and that of the defeated unaccountably long. Their space is different too. Everything in this limited land is a question of space, and the victors have understood this. The stranglehold they maintain is first and foremost spatial. It is applied, illegally and in defiance of international law, through the checkpoints, through the destruction of ancient roads, through the new by-passes strictly reserved for Israeli settlers, through the fortress hilltop settlements, which are really surveillance and control points of the surrounding plateaux, through the curfew which obliges people to stay indoors night and day until it is lifted. During the invasion of Ramallah last year, the curfew lasted six weeks, with a 'lifting' of a couple of hours on certain days for shopping. There was not even enough time to bury those who died in their beds.

The dissenting Israeli architect Eyal Weizman has pointed out in a courageous book that this total terrestrial domination begins in the drawings of district-planners and architects. The violence begins long before the arrival of the tanks and jeeps. He talks of a 'politics of verticality', whereby the defeated even when 'at home' are being literally *overseen* and *undermined*.

The effect of this on daily life is relentless. As soon as somebody one morning says to himself 'I'll go and see – ' he has to stop short and check how many crossings of barriers the 'outing' is likely to involve. The space of the simplest everyday decisions is hobbled, with its foreleg tethered to its hind leg.

In addition, because the barriers change unpredictably from day to day, the experience of time is hobbled. Nobody knows how long it will take this morning to get to work, to go and see Mother, to attend a class, to consult the doctor, nor, having done these things, how long it will take to get back home. The trip, in either direction, may take thirty minutes or four hours, or the route may be categorically shut off by soldiers with their loaded submachine guns.

The Israeli government claims that they are obliged to take these measures to combat terrorism. The claim is a feint. The true aim of the stranglehold is to destroy the indigenous population's sense of temporal and spatial continuity so that they either leave or become indentured servants. And it's here that the dead help the living to

resist. It's here that men and women make their decision to become martyrs. The stranglehold inspires the terrorism it purports to be fighting.

<div align="center">

☞

</div>

A SMALL ROAD of stones, negotiating boulders, descending into a valley south of Ramallah. Sometimes it winds between olive groves of old trees, a number of them perhaps dating from Roman times. This rocky track (very hard on any car) is the only means of access for Palestinians to their nearby village. The original asphalt road, forbidden to them now, is reserved for Israelis in the settlements. I walk ahead because all my life I have found it more tiring to walk slowly. I spot a red flower among the shrubs and stop to pick it. Later I learn it is called Adonis aestivalis. Its red is very intense and its life, the botanical book says, brief.

Baha shouts to warn me not to head towards the high hill on my left. If they spot someone approaching, he shouts, they shoot.

I try to calculate the distance: less than a kilometre. A couple of hundred metres away in the unrecommended direction I spot a tethered mule and horse. I take them as a guarantee and I walk there.

Where I arrive, two boys – aged about eleven and eight – are working alone in a field. The younger one is filling watering cans from a barrel buried in the earth. The care with which he does so, not spilling a drop, shows how precious the water is. The elder boy takes the full can and carefully climbs down to a ploughed plot where he is watering plants. Both of them are barefoot.

The one watering beckons to me and proudly shows me the rows of several hundred plants on the plot. Some I recognise: tomatoes, aubergines, cucumbers. They must have been planted during the last week. They're still small, searching for water. One plant I don't recognise and he notices this. Big light, he says. Melon? Shumaam! We laugh. His laughing eyes fixed on me don't waver. (I think of Husni Al-Nayjar.) We are both – God knows why – living at the same moment. He takes me down the rows to show me how much he has watered. At one moment we pause, look around and glance at the settlement with its defensive walls and red roofs. As he points with his chin in its direction there is a kind of derision in his gesture, a derision which he wants to

share with me, like his pride in watering. A derision which gives way to a grin – as if we had both agreed to piss at the same moment at the same spot.

Later we walk back towards the rocky road. He picks some short mint and hands me a bunch. Its pungent freshness is like a draught of cold water, water colder than that in the watering can. We are going towards the horse and mule. The horse, unsaddled, has a halter with reins but neither bridle nor bit. He wants to demonstrate to me something more impressive than an imaginary piss. He leaps onto the horse whilst his brother reassures the mule, and almost instantly he is galloping, bareback, down the road from which I came. The horse has six legs, four of its own and two belonging to its rider, and the boy's hands control all six. He rides with the experience of several lifetimes. When he returns, he is grinning and, for the first time, looks shy.

I rejoin Baha and the others, who are a kilometre away. They are talking to a man, who is the boy's uncle, and who is likewise watering plants which have been recently bedded out. The sun is going down and the light is changing. The brownish yellow earth, which is darker where it has been watered, is now the primary colour of the whole landscape. He is using the last of the water in the bottom of a 500-litre dark blue plastic barrel.

On the surface of the blue barrel eleven patches – like those used for mending punctures but larger – have been carefully stuck. The man will explain to me that this is how he repaired the barrel after a gang from the settlement of Halamish, the settlement with red roofs, came one night, when they knew the water containers were full of spring rain, and slashed them with knives. Another barrel, lying on the terrace below, was irreparable. Further off on the same terrace stands the gnarled stump of an olive tree, which, to judge by its girth, must have been several hundred, perhaps a thousand, years old.

A few nights ago, the uncle says, they cut it down with a chain saw.

I quote again from Mourid Barghouti: 'For the Palestinian, olive oil is the gift of the traveller, the comfort of the bride, the reward of autumn, the boast of the storeroom and the wealth of the family across centuries.'

Later, I find a poem by Zakaria Mohammed called 'The Bit'. It talks about a black horse without a bridle which has blood dripping

from its lips. With Zakaria's horse too there is a boy, astonished by the blood.

> What is the black horse chewing?
> he asks,
> What does it chew?
> The black horse
> is biting
> a bit forged from steel
> a bit of memory
> to be champed on
> champed on until death.

If the boy who gave me the short mint was seven years older, it wouldn't be hard to imagine why he joined Hamas, ready to sacrifice his life.

CR

THE WEIGHT OF the smashed concrete slabs and fallen masonry of Arafat's wrecked compound in the centre of Ramallah has taken on a symbolic gravity. Not, however, in the way the Israeli commanders imagined. Smashing the Muqata with Arafat and his company in it was for them a public demonstration of his humiliation, just as in the private apartments which the army systematically raided and searched, the tomato ketchup smeared on to clothes, furniture and walls was a private warning of worse to come.

Arafat still represents the Palestinians more faithfully perhaps than any other world leader represents his people. Not democratically but tragically. Hence the gravity. Due to the many errors committed by the PLO, with him at its head, and due to the equivocations of the surrounding Arab states, he has no room left for political manoeuvre. He has ceased to be a political leader. Yet he remains defiantly here. Nobody believes in him. And many would give their lives for him. How is this? No longer a politician, Arafat has become a rubble mountain, but a mountain of the homeland.

CR

I HAVE NEVER seen such a light before. It comes down from the sky in a strangely regular way, for it makes no distinction between what is distant and what is close. The difference between far and near is one of scale, never of colour, texture or precision. And this affects the way you place yourself, it affects your sense of being here. The land arranges itself around you, rather than confronting you. It's the opposite of Arizona. Instead of beckoning, it recommends never leaving.

And so I am here, a figure in a dream that some of my ancestors in Poland, Galicia and the Austro-Hungarian Empire must have nurtured and spoken about for at least two centuries. And here I unhesitatingly identify myself with the just cause and the pain of those whom the state of Israel (and cousins of mine) are afflicting to a degree that is tragically totalitarian.

<p style="text-align:center">❧</p>

RIAD, WHO IS a teacher of carpentry, has gone to fetch his drawings to show me. We are sitting in the garden of his father's house. The father with his white horse is harrowing the field opposite. When Riad comes back he's carrying the drawings like a file taken out of an old-fashioned metal filing cabinet. He walks slowly, and the chickens move out of his way more slowly. He sits opposite me and hands me the drawings one by one. They are drawn with a hard-lead pencil, from memory and with great patience. Stroke upon stroke in the evenings after work, until the blacks become as black as he wants, the greys remaining silvery. They are on quite large sheets of paper.

A drawing of a water pitcher. A drawing of his mother. A drawing of a house which was destroyed, of windows that gave on to rooms which have gone.

When I at last put the drawings down, an older man, with the enduring face of a peasant, addresses me. It sounds as if you know about chickens, he says. When a hen falls ill, she stops laying. Little to be done. One day though, she wakes up and feels Death approaching. One day she realises she's going to die, and what happens? She begins laying again, and nothing but death can stop her. We are like that hen.

<p style="text-align:center">❧</p>

THE CHECKPOINTS FUNCTION as interior frontiers imposed on the Occupied Territories, yet they do not resemble any normal frontier-post. They are constructed and manned in such a way that everyone who passes is reduced to the status of an unwanted refugee.

Impossible to underestimate the importance for the stranglehold of Décor, used as a constant reminder of who are the victors and who should recognise that they are the conquered. Palestinians have to undergo, often several times a day, the humiliation of playing the part of refugees in their own homeland.

Everyone crossing has to walk on foot past the checkpoint, where soldiers, loaded guns at the ready, pick on whoever they wish to 'check'. No vehicles can cross. The traditional road has been destroyed. The new obligatory 'route' has been strewn with boulders, stones and other minor obstacles. Consequently, all, even the fit, have to hobble across.

The sick and elderly are pushed in wooden boxes on four wheels (boxes originally made for carting vegetables in the market) by young men, who earn a small living like this. They hand each passenger a cushion to soften the bumps. They listen to their stories. They always know the latest news. (The barriers alter every day.) They offer advice, they lament and they are proud of the little aid they offer. They are perhaps the nearest to a Chorus of the tragedy.

Some 'commuters' walk with the aid of a stick, some even on crutches. Everything which normally would be in the boot of a vehicle has to be hoicked across in bundles carried by hand or on the back. The distance of a crossing can change overnight from anything between 300 metres and 1.5 kilometres.

Palestinian couples, except for certain more sophisticated young ones, generally observe in public the decorum of a certain distance. At the checkpoints couples of all ages hold hands as they cross, searching with each step for a foothold, and calculating exactly the right pace for hobbling past the pointing guns, neither too fast – hurrying can arouse suspicion, nor too slow – hesitation can provoke a 'game' for relieving the guards' chronic boredom.

CR

THE VINDICTIVENESS OF many (not all) Israeli soldiers is particular. It has little to do with the cruelty which Euripedes described and

lamented, for here the confrontation is not between equals, but between the all-powerful and the apparently powerless. Yet this power of the powerful is accompanied by a furious frustration: the discovery that, despite all their weapons, their power has an inexplicable limit.

ଓ

I WANT TO change some euros for shekels – the Palestinians have no currency of their own. I walk down the Main Street passing many small shops, and, occasionally, a man sitting on a chair, where there would once have been a pavement before the invasion of the tanks. In their hands these men hold wads of bank notes. I approach a young one and say I want to change a hundred euros. (For that amount one could buy in one of the gold shops a small bracelet for a child.) He consults a child's pocket calculator and hands me several hundred shekels.

I walk on. A boy who, age-wise, might be the brother of the girl with the imaginary golden bracelet, holds out some chewing gum for me to buy. He is from one of the two refugee camps in Ramallah. I buy. He's also selling plastic covers for the magnetic ID cards in the wallet. His scowl suggests I buy all the chewing gum. I do.

Half an hour passes and I'm in the vegetable market. A man is selling garlic the size of electric light-bulbs. There are many people close together. Somebody taps me on the shoulder. I turn round. It's the money-changer. I gave you, he says, fifty shekels too little, here they are. I take five notes of ten. You were easy to find, he adds. I thank him.

The expression in his eyes as he looks at me reminds me of an old woman I have seen the day before. An expression of great attention to the moment. Calm and considered, as if it could conceivably be the last moment.

The money-changer then turns and begins his long walk back to the chair.

I met the old woman in the village of Kobar. The house was concrete, unfinished and sparse. On the walls of the bare salon were framed photographs of her nephew, Marwan Barghouti. Marwan as a boy, an adolescent, a man of forty. Today he is in an Israeli prison. If he survives, he is one of the few political leaders of the Fatah with whom it will be essential to consult concerning any solid peace agreement.

Whilst we were drinking lemon juice and the Aunt was making coffee, her grandchildren came out into the garden: two boys aged about seven and nine. The younger one is called Homeland and the elder one Struggle. They ran around in every direction and would suddenly stop, looking intently at one another, as if they were hiding behind something and peering out to see whether the other one had spotted them. Then they would move again to another invisible hide-out. A game they had invented and played together many times.

The third child was four years old. On his face were red and white daubs as on a clown's, and he stood apart like a clown, wistful, jokey, unsure when it would be over. He had chickenpox and knew he should not approach visitors.

When it came to saying goodbye, the Aunt held my hand, and in her eyes there was this same special expression of attention to the moment.

If two people are laying a tablecloth on a table, they glance at one another to check the placing of the cloth. Imagine the table is the world and the cloth the lives of those we have to save. Such was the expression.

ɾɞ

A SMALL BRASS bowl called a Fear Cup. Engraved with filigree geometric patterns and some verses from the Koran arranged in the form of a flower. Fill it with water and leave it outside under the stars for a night. Then drink the water whilst praying that it will alleviate the pain and cure you. For many sicknesses the Fear Cup is clearly less effective than a course of antibiotics. But a bowl of water which has reflected the time of the stars, the same water from which every living thing was made, as is said in the Koran, may help to resist the stranglehold . . .

ɾɞ

TWO WEEKS AFTER leaving Ramallah I am in Finistère in northwest France, looking out to sea. The contrast of climate and vegetation cannot be greater. The only thing in common is an abundance of brambles – *toot il alliq*. The Finistère coast is green with ferns, until it falls to the rocks. And it is broken into countless small islands by the impact of an ocean which changes its colour every half-hour. The

239

western coast of Europe from Cornwall to Spanish Galicia has been named Land's End. Here the land ends in ferns and islets like boulders.

I have come to see the most ancient built monument in the world, constructed a thousand years before the earliest pyramids. It too was constructed as a funerary monument. What I'm looking at, Eqbal, is a pile of stones. The guide books call it a cairn.

Yet it's far more than a cairn; it's a highly articulated sculpture. Every forty centimetres of it has been, as it were, hand-written. It's over seventy metres long, about twenty-five metres wide and eight or ten metres tall, and in each direction each stone joins the following one intentionally, as if the stones were hand-written words.

Imagine the deck of a ship. She's heading northeast to get out of the bay of Morlaix, and then she can go west towards America. This ship with her Homeric prow (local legend has it that Odysseus passed by this coast on his way to Cork), this ship is made of stones, and naturally she is married to the earth!

According to the carbon datings, she was built at least six thousand years ago, on two separate occasions. First the stern was made with greenish metamorphic dolerite stones, such as abound along the coast with its acid earth beneath the ferns. Then, a century or two later, the prow was added, made mostly with oat-coloured granite, which came from the little island of Sterec.

There was a third construction which may have been a second ship of death, but this was utterly destroyed in the 1950s, when the whole site, which had long since been overgrown and covered with earth, was being exploited as a quarry, and the stones used for making gravel.

Archaeologists deduce that each part of the ship, on the two occasions, was built within a few months. And this, given the labour involved, presumes that a whole settler community of several hundred people worked together on it.

Most of the stones are the size and weight of what a strong man might carry between his two arms. There are also smaller ones, small as a fist, for filling in the recalcitrant spaces left in the otherwise perfect fitting together of the larger ones.

The ship's decks are smooth, not cobbled. And there are a few megaliths, taller than a man, used as lintels over the entrances to

passageways, or, sometimes, as a table-roof for vaulted chambers. On the lower deck, twenty-two dry-stone passages, from port and starboard, lead to eleven vaulted cabins, where the dead were placed.

I follow one such passage, which is like a sentence leading to a centre, and here, in the half-destroyed sanctuary, I gaze at the stones corbelling out. They are the same as millions of other stones on the beaches of this coast, except that here they speak and are eloquent, due to their arrangement.

Chaos perhaps has its reasons, but chaos is dumb. From the human capacity to arrange, to place, come language and communication. The word *place* is both verb and noun. The capacity of arrangement and the capacity to recognise and name a site. Aren't both inseparable in their origin from the human need to respect and defend their dead?

A strange comparison occurs to me. What inspired hundreds of people to work together for several months to build this ship of stones is perhaps quite close to what inspires kids in Palestine to hurl stones at the tanks of an occupying army.

35.

Meanwhile

THE WONDERFUL AMERICAN poet Adrienne Rich pointed out in a recent lecture about poetry that 'This year, a report from the Bureau of Justice Statistics finds that one out of every 136 residents of the United States is behind bars – many in jails, unconvicted.'[1]

In the same lecture she quoted the Greek poet Yannis Ritsos:

> In the field the last swallow had lingered late,
> balancing in the air like a black ribbon on the sleeve
> of autumn
> Nothing else remained. Only the burned houses
> smouldering still.[2]

ও

I PICKED UP the phone and knew immediately it was an unexpected call from you, speaking from your flat in the Via Paolo Sarpi. (Two days after the election results and Berlusconi's comeback.) The speed with which we identify a familiar voice coming out of the blue is comforting, but also somewhat mysterious. Because the measures, the

1 Adrienne Rich, *Poetry and Commitment* (London: W. W. Norton & Co., 2007).

2 Yannis Ritsos, 'Romiosini', in *Selected Poems 1938–1988* (Rochester, NY: BOA, 1989). Translation by Kimon Friar.

units we use in calculating the clear distinction that exists between one voice and another, are unformulated and nameless. They don't have a code. These days more and more is encoded.

So I wonder whether there aren't other measures, equally uncoded yet precise, by which we calculate other givens. For example, the amount of circumstantial freedom existing in a certain situation, its extent and its strict limits. Prisoners become experts at this. They develop a particular sensitivity towards liberty, not as a principle, but as a granular substance. They spot fragments of liberty almost immediately whenever they occur.

<div align="center">℞</div>

ON AN ORDINARY day, when nothing is happening and the crises announced hourly are the old familiar ones – and the politicians are declaring yet again that without them there would be *catastrophe* – people as they pass one another exchange glances, and some of their glances check whether the others are envisaging the same thing when they say to themselves: so this is life!

Often they *are* envisaging the same thing, and in this primary sharing there is a kind of solidarity before anything further has been said or discussed.

I'm searching for words to describe the period of history we're living through. To say it's unprecedented means little because all periods were unprecedented since history was first discovered.

I'm not searching for a complex definition – there are a number of thinkers, such as Zygmunt Bauman, who have taken on this essential task. I'm looking for nothing more than a figurative image to serve as a landmark. Landmarks don't fully explain themselves, but they offer a reference point that can be shared. In this they are like the tacit assumptions contained in popular proverbs. Without landmarks there is the great human risk of turning in circles.

<div align="center">℞</div>

THE LANDMARK I'VE found is that of prison. Nothing less. Across the planet we are living in a prison.

The word *we*, when printed or pronounced on screens, has become suspect, for it's continually used by those with power in the demagogic

claim that they are also speaking for those who are denied power. Let's talk of ourselves as *they*. They are living in a prison.

What kind of prison? How is it constructed? Where is it situated? Or am I only using the word as figure of speech?

No, it's not a metaphor, the imprisonment is real, but to describe it one has to think historically.

Michel Foucault has graphically shown how the penitentiary was a late eighteenth- and early nineteenth-century invention closely linked to industrial production, its factories and its utilitarian philosophy. Earlier, there were jails that were extensions of the cage and the dungeon. What distinguishes the penitentiary is the number of prisoners it can pack in – and the fact that all of them are under continuous surveillance thanks to the model of the Panopticon, as conceived by Jeremy Bentham, who introduced the principle of accountancy into ethics.

Accountancy demands that every transaction be noted. Hence the penitentiary's circular walls with the cells arranged around the screws' watchtower at the centre. Bentham, who was John Stuart Mill's tutor at the beginning of the nineteenth century, was the principal utilitarian apologist for industrial capitalism.

Today in the era of globalisation, the world is dominated by financial, not industrial capital, and the dogmas defining criminality and the logics of imprisonment have changed radically. Penitentiaries still exist and more and more are being built. But prison walls now serve a different purpose. What constitutes an incarceration area has been transformed.

CR

TWENTY YEARS AGO Nella Bielski and I wrote *A Question of Geography*, a play about the Gulag. In act two, a *zek* (political prisoner) talks to a boy who has just arrived about choice, about the limits of what can be chosen in a labour camp:

> When you drag yourself back after a day's work in the taiga, when you are marched back, half dead with fatigue and hunger, you are given your ration of soup and bread. About the soup you have no choice – it has to be eaten whilst it's hot, or whilst it's at least warm.

About the 400 grams of bread you have a choice. For instance, you can cut it into three little bits: one to eat now with the soup, one to suck in the mouth before going to sleep in your bunk, and the third to keep until next morning at ten, when you're working in the taiga and the emptiness in your stomach feels like a stone.

You empty a wheelbarrow full of rock. About pushing the barrow to the dump you have no choice. Now it's empty you have a choice. You can walk your barrow back just like you came, or – if you're clever, and survival makes you clever – you push it back like this, almost upright. If you choose the second way you give your shoulders a rest. If you are a *zek* and you become a team leader, you have a choice of playing at being a screw, or of never forgetting that you are a *zek*.[3]

The Gulag no longer exists. Millions work, however, under conditions that are not very different. What has changed is the forensic logic applied to workers and criminals.

During the Gulag political prisoners, categorised as criminals, were reduced to slave-labourers. Today millions of brutally exploited workers are being reduced to the status of criminals.

The Gulag equation 'criminal = slave labourer' has been rewritten by neoliberalism to become 'worker = hidden criminal'. The whole drama of global migration is expressed in this new formula: those who work are latent criminals. When accused, they are found guilty of trying at all costs to survive.

Fifteen million Mexican women and men work in the United States without papers and are consequently illegal. A concrete wall of 1,200 kilometres and a 'virtual' wall of 1,800 watchtowers are being planned along the frontier between the United States and Mexico. Ways around them though – all of them dangerous – will of course be found.

Between industrial capitalism, dependent on manufacture and factories, and financial capitalism, dependent on free-market speculation and front-office traders, the incarceration area has changed.

3 John Berger and Nella Bielski, *A Question of Geography* (London: Faber & Faber, 1987).

Speculative financial transactions add up, each day, to $1,300 billion – fifty times more than the sum of commercial exchanges. The prison is now as large as the planet, and its allotted zones vary and can be termed worksite, refugee camp, shopping mall, periphery, ghetto, office block, favela, suburb. What is essential is that those incarcerated in these zones are fellow prisoners.

❧

IT'S THE FIRST week in May, and on the hillsides and mountains, along the avenues and around the gates, in the northern hemisphere, the leaves of most of the trees are coming out. Not only are all their different varieties of green still distinct, people also have the impression that each single leaf is distinct, and so they are confronting billions – no, not billions (the word has been corrupted by dollars), they are confronting an infinite multitude of new leaves.

For prisoners, small visible signs of nature's continuity have always been, and still are, a covert encouragement.

❧

TODAY THE PURPOSE of most prison walls (concrete, electronic, patrolled or interrogatory) is not to keep prisoners in and correct them, but to keep prisoners out and exclude them.

Most of the excluded are anonymous – hence the obsession of all security forces with identity. They are also numberless, for two reasons. First because their numbers fluctuate; every famine, natural disaster and military intervention (now called *policing*) either diminishes or increases their multitude. And second, because to assess their number is to confront the fact that they constitute most of those living on the surface of the earth – and to acknowledge this is to plummet into absolute absurdity.

❧

HAVE YOU NOT noticed small commodities are increasingly difficult to remove from their packaging? Something similar has happened with the lives of the gainfully employed. Those who have legal employment and are not poor are living in a very reduced space that allows them fewer and fewer choices – except the continual

246

binary choice between obedience and disobedience. Their working hours, their place of residence, their past skills and experience, their health, the future of their children, everything outside their function as employees has to take a small second place beside the unforeseeable and vast demands of liquid profit. Furthermore, the rigidity of this house rule is called *flexibility*. In prison words get turned upside down.

The alarming pressure of high-grade working conditions has recently obliged the courts in Japan to recognise and define a new coroners' category of 'death by overwork'.

No other system, the gainfully employed are told, is feasible. There is no alternative. Take the elevator. The elevator is a small cell.

Somewhere in the prison I'm watching a five-year-old girl have a swimming lesson in a municipal indoor swimming pool. She's wearing a dark blue costume. She can swim but doesn't yet have the confidence to swim alone without any support. The instructor takes her to the deep end of the pool. The girl is going to jump into the water whilst grasping a long rod held out towards her by her teacher. It's a way of getting over her fear of water. They did the same thing yesterday.

Today she wants the girl to jump without clutching the rod. One, two, three! The girl jumps, but at the last moment seizes the rod. Not a word is spoken. A faint smile passes between the woman and the girl, the girl cheeky, the woman patient.

The girl clambers up the ladder out of the pool and returns to the edge. *Again!* she hisses. She jumps, hands to her sides, holding nothing. When she comes up to the surface, the tip of the rod is there in front of her very nose. The girl swims two strokes to the ladder without touching the rod.

Am I proposing that the girl in the dark blue costume and the swimming instructor in her sandals are prisoners? Certainly at the moment when the girl jumped without the rod, neither of them was in prison. If I think, however, of the years to come or look back at the recent past, I fear that, notwithstanding what I describe, both of them risk becoming or re-becoming a prisoner.

CR

LOOK AT THE power structure of the surrounding world, and how its authority functions. Every tyranny finds and improvises its own set of controls. Which is why they are often, at first, not recognised as the vicious controls they are.

The market forces dominating the world assert that they are inevitably stronger than any nation-state. The assertion is corroborated every minute. From an unsolicited telephone call trying to persuade the subscriber to take out private health insurance or a pension, to the latest ultimatum of the World Trade Organization.

As a result, most governments no longer govern. A government no longer steers towards its own chosen destination. The word 'horizon', with its promise of a hoped-for future, has vanished from political discourse – on both right and left. All that remains for debate is how to measure what is there. Opinion polls replace direction and replace desire.

Most governments herd instead of steer. (In US prison slang, 'herders' is one of the many words for jailers.)

In the eighteenth century, long-term imprisonment was approvingly defined as a punishment of 'civic death'. Three centuries later, governments are imposing – by law, force, economic threats and their buzz – mass regimes of civic death.

CR

WASN'T LIVING UNDER any tyranny in the past a form of imprisonment? Not in the sense that I'm describing. What is being lived today is new because of its relationship with space.

It's here that the thinking of Zygmunt Bauman is illuminating. He points out that the corporate market forces now running the world are ex-territorial, that's to say 'free from territorial constraints – the constraints of locality'. They are perpetually remote, anonymous, and thus never have to take account of the territorial, physical consequences of their actions. He quotes Hans Tietmeyer, president of the German Federal Bank: '[T]oday's stake is to create conditions favourable to the confidence of investors'. The single supreme priority.

Following this, the control of the world's populations, who consist of producers, consumers and the marginalised poor, is the task allotted to the obedient national governments.

The planet is a prison and the obedient governments, whether of right or left, are the herders.

ᘓ

THE PRISON SYSTEM operates thanks to cyberspace. Cyberspace offers the market a speed of exchange which is almost instantaneous, and used across the world day and night for trading. From this speed, the market tyranny gains its ex-territorial licence. Such velocity, however, has a pathological effect on its practitioners: it anaesthetises them. No matter what has befallen, 'business as usual'.

There is no place for pain in that velocity; announcements of pain perhaps, but not the suffering of it. Consequently, the human condition is banished, excluded from those operating the system. They are alone because utterly heartless.

Earlier, tyrants were pitiless and inaccessible, but they were neighbours who were subject to pain. This is no longer the case, and therein lies the system's probable weakness.

> The tall doors swing back
> We're inside the prison yard
> in a new season.[4]

They (we) are fellow prisoners. That recognition, in whatever tone of voice it may be declared, contains a refusal. Nowhere more than in prison is the future calculated and awaited as something utterly opposed to the present. The incarcerated never accept the present as final.

Meanwhile, how to live this present? What conclusions to draw? What decisions to take? How to act? I have a few guidelines to suggest, now that the landmark has been established.

On this side of the walls experience is listened to, no experience is considered obsolete. Here survival is respected, and it's a commonplace that survival frequently depends upon solidarity between fellow

4 Tomas Tranströmer, 'Prison: Nine Haiku Poems from Hällby Juvenile Prison' (1959), in *New Selected Poems* (London: Bloodaxe, 1987). Translation by Robin Fulton.

prisoners. The authorities know this – hence their use of solitary confinement, either through physical isolation or through their buzz, whereby individual lives are isolated from history, from heritage, from the earth and, above all, from a common future.

Ignore the jailers' talk. There are of course bad jailers and less bad. In certain conditions it's useful to note the difference. But what they say – including the less evil ones – is bullshit. Their hymns, their shibboleths, their incanted words *security, democracy, identity, civilisation, flexibility, productivity, human rights, integration, terrorism, freedom,* are repeated and repeated in order to confuse, divide, distract and sedate all fellow prisoners. On this side of the walls, words spoken by the jailers are meaningless and are no longer useful for thought. They cut through nothing. Reject them even when thinking silently to oneself.

By contrast, prisoners have their own vocabulary with which they think. Many words are kept secret and many are local, with countless variations. Small words and phrases, small yet containing a world: *I'll-show-you-my-way, sometimes-wonder, pajarillo, something's-happening -in-B-wing, stripped, take-this-small-earring, died-for-us, go-for-it,* and so on.

Between fellow prisoners there are conflicts, sometimes violent. All prisoners are deprived, yet there are degrees of deprivation and the differences of degree provoke envy. On this side of the walls life is cheap. The very facelessness of the global tyranny encourages hunts to find scapegoats, to find instantly definable enemies among other prisoners. The asphyxiating cells then become a madhouse. The poor attack the poor, the invaded pillage the invaded. Fellow prisoners should not be idealised.

Without idealisation, simply take note that what they have in common – which is their unnecessary suffering, their endurance, their cunning – is more significant, more telling than what separates them. And from this, new forms of solidarity are being born. The new solidarities start with the mutual recognition of differences and multiplicity. *So this is life!* A solidarity, not of masses but of interconnectivity, far more appropriate to the conditions of prison.

ᏨᏒ

THE AUTHORITIES DO their systematic best to keep fellow prisoners misinformed about what is happening elsewhere in the world prison. They do not, in the aggressive sense of the term, indoctrinate. Indoctrination is reserved for the training of the small elite of traders and managerial and market experts. For the mass prison population the aim is not to activate them, but to keep them in a state of passive uncertainty, to remind them remorselessly that there is nothing in life but risk, and that the earth is an unsafe place.

This is done with carefully selected information, with misinformation, commentaries, rumours, fictions. Insofar as the operation succeeds, it proposes and maintains a hallucinating paradox, for it tricks a prison population into believing that the priority for each one of them is to make arrangements for their own personal protection and to acquire somehow, even though incarcerated, their own particular exemption from the common fate. This image of mankind transmitted through a view of the world is truly without precedent. Mankind is presented as cowardly; only winners are brave. In addition, there are no gifts; there are only prizes.

Prisoners have always found ways of communicating with one another. In today's global prison, cyberspace can be used against the interests of those who first installed it. Like this, prisoners inform themselves about what the world does each day, and they follow suppressed stories from the past, and so stand shoulder to shoulder with the dead.

In doing so, they rediscover little gifts, examples of courage, a single rose in a kitchen where there's not enough to eat, indelible pains, the indefatigability of mothers, laughter, mutual aid, silence, ever-widening resistance, willing sacrifice, more laughter . . .

The messages are brief, but they extend in the solitude of their (our) nights.

The final guideline is not tactical but strategic.

The fact that the world's tyrants are ex-territorial explains the extent of their overseeing power, yet it also indicates a coming weakness. They operate in cyberspace and they lodge in guarded condominiums. They have no knowledge of the surrounding earth. Furthermore, they dismiss such knowledge as superficial, not profound. Only extracted resources count. They cannot listen to the earth. On the ground they are blind. In the local they are lost.

For fellow prisoners the opposite is true. Cells have walls that touch across the world. Effective acts of sustained resistance will be embedded in the local, near and far. Outback resistance, listening to the earth.

Liberty is slowly being found not outside but in the depths of the prison.

<div align="center">಄</div>

NOT ONLY DID I immediately recognise your voice, speaking from your flat in the Via Paolo Sarpi, I could also guess, thanks to your voice, how you were feeling. I sensed your exasperation or, rather, an exasperated endurance combined – and this is so typical of you – with the quick steps of our next hope.

Acknowledgements

VERSO GRATEFULLY ACKNOWLEDGES the publishers of the following works from which the texts collected here were drawn: 'Kraków', *Here Is Where We Meet* (London: Bloomsbury, 2005); 'To Take Paper, to Draw', *Harper's*, 1 September 1987; 'The Basis of All Painting and Sculpture Is Drawing', *Permanent Red: Essays in Seeing* [1960] (London: Writers & Readers, 1979); 'Frederick Antal – A Personal Tribute', *Burlington Magazine*, 96 (1954); 'An Address to Danish Worker Actors on the Art of Observation', Bertolt Brecht, *Poems on the Theatre*, translated by John Berger and Anya Bostock (Northwood: Scorpion Press, 1961); 'Revolutionary Undoing [Review of Max Raphael, *The Demands of Art*]', *New Society*, 13 (1969); 'Antiquarian and Revolutionary', *New Society* (1970), *The Look of Things: Selected Essays and Articles*, ed with an introduction by Nikos Stangos (Harmondsworth: Penguin, 1972); 'The Storyteller', *The White Bird: Writings*, ed Lloyd Spencer (London: Chatto & Windus, 1985); 'A Philosopher and Death', *New Society*, 22 (1972); 'The Secretary of Death Reads It Back', *New Society*, 61 (1982); 'Inside the Mask', *New Society*, 41 (1977); 'Forthflowing on a Joycean Tide', *Guardian*, 15 June 1991; 'A Gift for Rosa Luxemburg', *New Statesman*, 17 September 2015; 'The Ideal Critic and the Fighting Critic', *Permanent Red*; 'Terrain' (2000), from *John Berger: Collected Poems* (Middlesbrough:

Smokestack Books, 2014); 'The Clarity of the Renaissance', *Permanent Red*; 'The Dilemma of the Romantics', *Permanent Red*; 'The Victorian Conscience', *Permanent Red*; 'The Moment of Cubism', *The Moment of Cubism* (London: Weidenfeld and Nicolson, 1969); *Parade*, 1907, *The Success and Failure of Picasso* (Harmondsworth: Penguin, 1965); 'Judgment on Paris', *New Statesman and Nation* 46: 1169, 1 August 1953; 'Soviet Aesthetic', *New Statesman and Nation* 47: 1196, 6 February 1954; 'The Biennale', *Permanent Red*; 'Art and Property Now', *The Moment of Cubism*; 'The Changing View of the Man in the Portrait' [published here as 'No More Portraits', *The Look of Things*; 'The Historical Function of the Museum', *The Moment of Cubism*; 'The Work of Art', *The White Bird*; 'Preface (1968/1979)', *Permanent Red*; 'Historical Afterword', *Pig Earth* (London: Writers and Readers Publishing Cooperative, 1979); 'The White Bird', *The White Bird*; 'The Soul and the Operator', *Keeping a Rendezvous* (London: Bloomsbury, 1992); 'The Third Week of August 1991', *Keeping a Rendezvous*; 'Ten Dispatches About Place' [June 2005], *Hold Everything Dear* (London: Verso, 2008); 'Stones (Palestine, June 2003)', *Hold Everything Dear*; 'Meanwhile' (London: Drawbridge, 2008).